LINCOLN'S
Springfield Neighborhood

LINCOLN'S
Springfield Neighborhood

BONNIE E. PAULL & RICHARD E. HART
Foreword by Dr. Wayne C. Temple

THE
History
PRESS

NEIGHBORHOOD MAP LEGEND

1. *Dr. Samuel Melvin and family. The Melvins had five boys who were friends of the Lincoln boys, and they had a daughter they named Mary Lincoln Melvin.*

2. *Henry Remann Sr. and Mary Remann were good friends of the Lincolns. Henry Remann Jr. was a best friend of Willie Lincoln. Josie eventually married one of Mary's nephews, thus becoming a relative. Mary Remann's sister-in-law, Elizabeth Black, stayed with the family for a year.*

3. *Jesse Kent and family lived where the Conference Center now stands. His son Joseph and his brothers helped the Lincolns and played with Willie and Tad.*

4. *George and Eliza Wood and family built the first home here. He was a tailor on the square. Amos Worthen, state geologist, occupied the home at the time of Lincoln's election.*

5. *James Gourley was a shoemaker who often came to help Mary when she was frightened and alone at home.*

6. *The Arnold House originally belonged to Reverend Francis Springer and family. His English and Classical School was the first school in the neighborhood.*

7. *Jameson Jenkins, drayman and Underground Railroad conductor, bought this property from his brother-in-law, James Blanks. Their mother-in-law, Auntie Jane Pellum, lived in this house or in one at the back of the property.*

8. *James Blanks, the brother-in-law of Jameson Jenkins, owned this lot but did not build on it.*

9. *The George Shutt House was the property of Mason Brayman, who lived there after renting from the Lincolns when they were in Washington, D.C., in 1848.*

10. *Thomas Lushbaugh built a home on this lot. When he moved to Mt. Pulaski, he rented the home, eventually selling it to William Burch. Some of his renters were Reverend Noyes W. Miner, Hannah and John Shearer and Abner Wilkinson.*

11. *Ira Brown rented this property to the Wheelocks. Adelia "Delie" often helped with the boys.*

12. *Grace Evangelical Lutheran Church was originally founded by Reverend Francis Springer. During Lincoln's time, his brother-in-law, Dr. William Wallace, lived here with his wife, Frances, Mary Lincoln's sister.*

13. *Stephen Smith and family rented here. Dudley, their infant son, was a favorite of Lincoln's. C.M. Smith, his brother, was married to Mary's sister Ann.*

14. *Charles and Harriet Dallman lived here. Mary helped nurse their newborn child.*

15. *The Central Academy, the neighborhood's second school, operated at this site between 1853 and 1858.*

16. *John McClernand was a politician and Civil War general. Although opponents politically, Lincoln and he were good friends.*

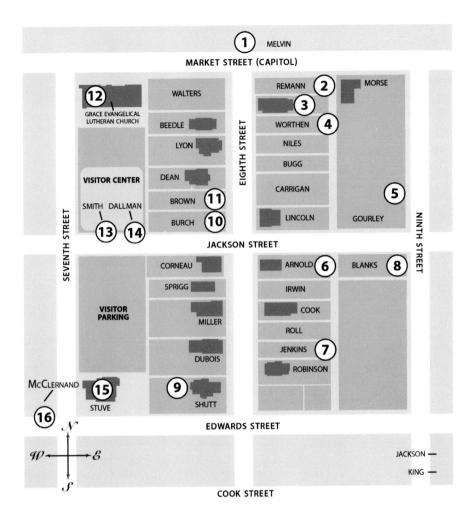

This map is based on the one designed by the Lincoln Home National Historic Site to orient visitors to the area. It designates owners and/or renters of the historic structures and lots in 1860, when Lincoln became president and just before the family departed for Washington, D.C. We have expanded the map to include others who figure prominently in this book and who lived in some of the houses or on the periphery of the immediate neighborhood during the Lincolns' seventeen-year tenure there. The map is not definitive in that it does not include every neighbor or servant mentioned in the book as living in the vicinity of the Lincoln Home during this time. The Lincoln neighbors reflect the diversity of Springfield at this time. The Carrigans were Irish immigrants; the Buggs and Dallmans, English immigrants. Henry Remann and his sister Julia Sprigg were German immigrants, and Jameson Jenkins, James Blanks, David King and John Jackson and their families were African Americans. We hope that this will make it easier for you, the reader, to relate the rather extensive cast of characters to the geography of the neighborhood. The shaded forms of buildings indicate where original historic structures or ones built by the Park Service still stand.

Published by The History Press
Charleston, SC 29403
www.historypress.net

Front cover: Richard Schlecht's historically researched modern renderings of the Lincoln neighborhood in 1860. *Courtesy of the National Park Service*; An ambrotype (photograph) of Abraham Lincoln taken on August 13, 1860, by Preston Butler of Springfield, Illinois. *Courtesy of the Abraham Lincoln Presidential Library & Museum.*

Back cover: Elizabeth Black (Mrs. William Black) and Jesse K. Dubois, neighbors and friends of the Lincolns. *Courtesy of the Abraham Lincoln Library & Museum.*

Frontispiece: Map and Legend of the Lincoln Home Neighborhood. *Courtesy of the National Park Service and graphic designer Katrina Crocker.*

First published 2015

Manufactured in the United States

ISBN 978.1.62619.951.4

Library of Congress Control Number: 2014956341

Notice: The information in this book is true and complete to the best of our knowledge. It is offered without guarantee on the part of the authors or The History Press. The authors and The History Press disclaim all liability in connection with the use of this book.

To the generations—our parents, our children and our grandchildren—
Will, Mimi, Wes, R.E., Sena and Osselyn and Hayden.

In a frontier community folks have to cooperate.
In every neighborhood, in every city of the world now,
we have to learn how to cooperate again.

—Pete Seeger
In His Own Words

CONTENTS

FOREWORD

Mr. Lincoln's Springfield neighborhood probably influenced him more than he influenced the neighborhood. As Richard E. Hart has shown through years of research, this area contained a mix of numerous ethnic groups. He has listed them with their places of nativity. In addition, he has compiled special inventories for those large segments of the population from Ireland and Germany, as well as those of African American descent.

Some young Irish girls worked for the Lincolns as housemaids. Others labored in the homes of the affluent or moderately affluent, which included the Lincolns. Those who were wealthier often had two or more maids living with them. A scattering of black families lived in proximity to the Lincolns. Some did chores for them, and one even cut Lincoln's hair. Certainly, the future president saw what motivated those working poor who sought advancement in life with more pay because, as a youth, he had experienced some of their lot. Thus, he could sympathize with the struggling Irish, Germans and African Americans when he became a lawmaker in Washington.

This type of study has never before been done in such a wide scope. Previously, only those families living in the four-square-block area of the Lincoln Home National Historic Site in the 1850s have been examined by such scholars as Edwin C. Bearss of the National Park Service. Paull and Hart successfully expand their study beyond four blocks and cover a longer period of time.

The authors go back to the founding of Springfield and not just to the years when Abraham Lincoln became a noted lawyer among its citizens.

Then they travel forward in time to tell, in some detail, the story of the Lincoln family and their place in the neighborhood. Those with special Lincoln connections receive brief biographies. This information makes for very interesting reading and should prove valuable to anyone visiting the Lincoln Home National Historic Site, planning a future visit or just seeking to know more about the Lincolns, their friends, their neighbors and Springfield before they left for Washington.

Congratulations to both authors for adding to our understanding of the sixteenth U.S. president. From such books, people can come to know the Lincolns and their neighbors more intimately, and better history can be written and enjoyed. *Lincoln's Springfield Neighborhood* is a most welcome addition to the Lincoln saga, which grows in magnitude each year.

DR. WAYNE C. TEMPLE
Chief Deputy Director
Illinois State Archives

PREFACE

In front of the Lincoln-Herndon Law Offices facing the old State Capitol is an arresting group of statues. Commissioned by the City of Springfield and created by sculptor Larry Anderson in 2004, it includes Mary and Abraham Lincoln and two of their sons. Most of the many Lincoln statues around the country depict him alone as orator/statesman or as prairie rail-splitter. Anderson's statues differ in that they freeze in time a domestic moment in Lincoln's family life, not a familiar subject in public statuary, but one very familiar to his neighbors at Eighth and Jackson Streets.

On my first visit to Springfield, I was struck by such an unusual and personal work of public art. On his way to the State House to deliver a speech, Lincoln is dressed in his usual black cloth swallow-tailed coat, black satin vest with collar turned down over a black silk neckerchief, stovepipe hat in hand. Mary in her bonnet, shawl and hoop skirt stands before her husband straightening his lapels in a motherly fashion. Near his parents, their son Willie waves goodbye to the eldest son, Robert, who, at some distance from the group, waves back as he leaves for school with his books.

Embedded in a circle of tiles surrounding the figures of Mary, Abraham and Willie are the famous words from Lincoln's farewell speech when he left Springfield to assume his position as the sixteenth president of the United States: "To this place and the kindness of these people, I owe everything."

It is significant to me that the City of Springfield chose this sculpture of the Lincolns as a family for its town square. They remain an enduring part of the life of the town amongst the friends and neighbors they loved and

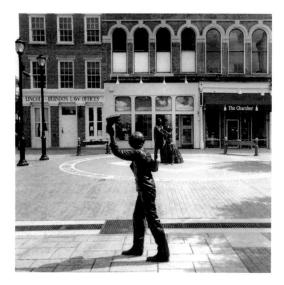

Larry Anderson's *Springfield's Lincoln* statues depicting the Lincoln family in front of the Lincoln-Herndon Law Offices on the south side of the Springfield public square. *A photograph taken by and courtesy of Ron Schramm of Chicago, Illinois.*

where they were the happiest. Lincoln the president may belong to the ages, but Lincoln the husband and father belongs to Springfield. The message seems to be, "They are ours, now and forever."

As a visitor to Springfield and the Lincoln neighborhood, I was inspired to know more about the family as real people in the intimate environment of their neighborhood. I wanted to meet those neighbors of such diverse backgrounds whose kindness Lincoln acknowledged with so much feeling.

Now, after months of researching and writing, those adults and children have become my friends. As a result, I know better Mary, Abraham, Robert, Eddie, Willie, Tad and even Fido the dog. I hope you, the reader, will feel the same.

BONNIE E. PAULL

ACKNOWLEDGEMENTS

Perhaps no other residential neighborhood in America has the rich history of the Lincoln Home National Historic Site. The people who tend that history have been most generous in revealing and sharing the records of their institutions with us. Individually, each of them has also shared his or her particular knowledge of Lincoln's Springfield. We thank them all for their assistance and inspiration.

The collections of the Abraham Lincoln Presidential Library were generously shared, and their most helpful keepers are respectfully acknowledged: James Cornelius, curator, Lincoln Collection; Kathryn M. Harris, chief librarian; Gwenith Podeschi, reference librarian; Jennifer Ericson, Mary Michals and Roberta Fairburn, audio visual curators; and Cheryl Schnirring, manuscript manager.

Curtis Mann, director, and Linda Garvert, librarian, guided us in our searches through the vast historical resources of the Sangamon Valley Collection at the Lincoln Library in Springfield, and we thank them for their help to us and to all of those who daily visit this wonderful collection.

The Lincoln-era Sangamon County records housed at the Illinois Regional Archives Depository, Brookens Library, University of Illinois–Springfield are the best primary source materials for learning about the particulars of Lincoln's neighborhood. We thank Thomas J. Wood, university archivist and director of the depository, who was most helpful in finding the exact document sought and encouraging us on our journey.

Jeffrey Bridgers, librarian in the Prints and Photographs Division of the Library of Congress, gave generously of his time and help, as did Kara S. Vetter, Jane Gastineau and Adriana Maynard of the Indiana State Museum and Historic Site.

Our manuscript in draft form was read and critiqued by Dr. Wayne C. Temple, chief deputy director of the Illinois State Archives, and Timothy Townsend, historian at the Lincoln Home National Historic Site. Each contributed invaluable comments and corrections, and we thank both for taking their time to do so.

Special thanks to our understanding and always helpful editor Ben Gibson, to senior production editor Jaime Muehl and to the staff at The History Press; Sylvia Rodrigue, editor at the Southern Illinois University Press, who steered us in the right direction; Sheila Sullivan, Dick's secretary, who proofed the manuscript with her sharp eye and pen; Kristina Crocker, graphic designer; John Welch and Andi Menaul for their computer expertise; and Jerri Menaul for her great assistance preparing the photo images.

A special thanks to Bruce Silton, who improved the manuscript by his many readings and suggestions, and to all the other wonderful friends and relatives who helped in many ways, encouraged and advised: Carol Woodruff, Lynne Wever, Mike and Bev Paull, Barb Totschek, Paul Rubinstein, Judy and Ben Kugler, Jeffrey Levine, Suzie Nemer, June and Jim Ullom, Rosie Freihoff, Ralph Criscione, Rosemary Delderfield, Laurie Anspach, Susan Arnold, Jeff Bradshaw, Ingrid Gudenas, Crystal Ware Bender, Mike Heiney, Betsy Putterman, Randy Meyers, Suzanne Vandermerwe, Yinka Olatunji, Peggy Cote, Mike Alkema, Arnell Burghorn, Kathy Jackson, Dave Lubinsky, Carol Orbach, Molly and Craig Burton, Mary and Nick Duda, Louise Caputo and Angie and Greg Moore.

Over the years, the Springfield community has been central in protecting the Lincoln Home and neighborhood. We give special thanks and acknowledgment to those of that community who, together with the State of Illinois and the Lincoln Home National Historic Site, saved the Lincoln Home neighborhood for future generations. Beginning with Robert Todd Lincoln's gift of the home to the State of Illinois in 1887, the passionate commitment by so many people over so many years has ensured the preservation of this unique time capsule for our pleasure and understanding.

We encourage you, if you have not already done so, to experience the Lincoln neighborhood today. The spirit of the Lincoln family among their Springfield neighbors of 1860 will remain with you forever.

INTRODUCTION

G ood neighbors are an important part of our lives. They are similar to members of our family. Although we did not pick them, they are there. We can learn to appreciate them even though we might not choose them as friends if they didn't live in our neighborhood. We see them and talk to them as friends and neighbors.

And so it was with the Lincoln family, who appreciated their neighbors when they lived in the area now known as the Lincoln Home National Historic Site. Over the years, bits and pieces of the Lincoln family's relationship with their neighbors have been reported, but until now they have not been gathered into a full story of the neighborhood. Putting the bits and pieces together allows us to see the Lincolns and their neighbors with a more focused lens, and a most remarkable story unfolds.

Abraham is revealed as a much-loved favorite among the neighborhood children. He often took them on adventures, such as to the circus. He tolerated their pranks with a smiling face that revealed his abiding love and patience for them.

Because Mary was a wife and mother, she was home more than Abraham and relied more heavily on neighbors to keep her company while Lincoln was at the office or riding the legal circuit. The story of her relationships with her female neighbors and friends is more available than her husband's. She was a loving and nurturing lady. She was solicitous of the health and welfare of her close neighbors. In an unequivocal act of love, she even nursed a neighbor's baby when the mother was unable to do so. She was a good neighbor.

Perhaps the most remarkable fact about the Lincoln neighborhood is that it was a diverse cauldron of people, a microcosm of Greater Springfield. There were people of foreign and domestic origins and of different races, education, wealth and marital status, as well as opposing political beliefs. There were African Americans, Germans, Irish, French, southerners, northerners, comfortable and less comfortable economically, educated and not educated, families and single persons, Republicans and Democrats—all living as neighbors. There was no residential or cultural segregation as we have come to understand those terms in modern America.

Lincoln's neighborhood was not the modern-day, tightly controlled subdivision of persons having similar life experiences, race, education and wealth. Lincoln's neighborhood was not "a house divided." It was much more the inclusive America that Lincoln described in his famous speeches than what unfortunately exists today in much of our stratified America. Lincoln's neighborhood was democratic and loving, fostering tolerance and acceptance of people and cultures unlike one's own.

This environment, in my opinion, nurtured the tolerance and compassion Lincoln so frequently displayed as president. Just as Lincoln was nurtured, so too can we learn from and be nurtured by the examples of his neighbors and their lives together in this neighborhood.

This little neighborhood was witness to some of the most historic events in our national journey. It was here that Lincoln thought and wrote and received well-wishers and celebrants when he was first nominated and then elected president. And it was here that his neighbors watched silently as the hearse bore his remains past his old home at Eighth and Jackson before burial in the peaceful setting of Oak Ridge Cemetery. They were Lincoln's neighbors.

RICHARD E. HART

Lincoln's Farewell Address

My friends, no one not in my situation can appreciate my feeling of sadness at this parting. To this place, and the kindness of these people, I owe everything. Here I have lived a quarter of a century, and have passed from a young to an old man. Here my children have been born, and one is buried. I now leave, not knowing when, or whether ever, I may return, with a task before me greater than that which rested upon Washington. Without the assistance of the Divine Being who ever attended him, I cannot succeed. With that assistance I cannot fail. Trusting in Him who can go with me, and remain with you, and be everywhere for good, let us confidently hope that all will yet be well. To His care commending you, as I hope in your prayers you will commend me, I bid you an affectionate farewell.

—Delivered on February 11, 1861, upon Lincoln's departure from Springfield

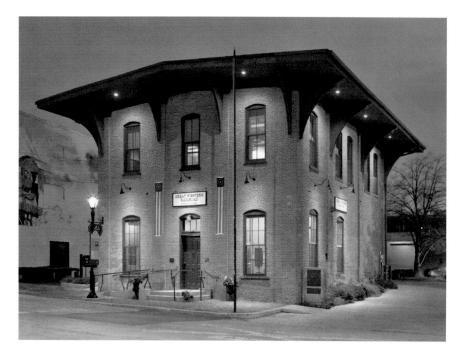

A contemporary photograph of the Great Western Railway Station where Abraham Lincoln delivered his Farewell Address to the citizens of Springfield on February 11, 1861. The photograph is by Benjamin Halpern of Champaign, Illinois. *Courtesy of Pinky Noll, Springfield, Illinois.*

1

LINCOLN'S SPRINGFIELD

The Beginning of the Town

I now felt firmly rooted, and determined to seek no further, as I believed I was then in the center of the most extensive body of the richest land in the United States, or perhaps in the world; and don't yet think I was mistaken.[1]
—*Elijah Iles*

Nine years before Thomas Lincoln and his family migrated north from Indiana to Macon County, Illinois, Elijah Iles, a twenty-five-year-old pioneer, arrived on horseback in what is now Springfield. In 1821, only nine settlers populated this area of maple, hickory and elm groves surrounded by thousands of acres of prairie. Among them was John Kelly—the first man to build a cabin in Springfield on what are now Jefferson and Second Streets.

An enterprising adventurer, Iles left his Kentucky home for St. Louis. He remained there for three years, learning to trade, to keep shop and to buy and sell land. Still restless and in search of his ideal home, he traveled from Missouri through the waving grass of the prairie to the rich land of the Sangamo Country in central Illinois. Iles, being the visionary that he was, saw its potential and decided to settle down here permanently. He boarded with the Kelly family while he established the first store in this tiny wilderness settlement. He eventually came to be known as the "Father of Springfield."

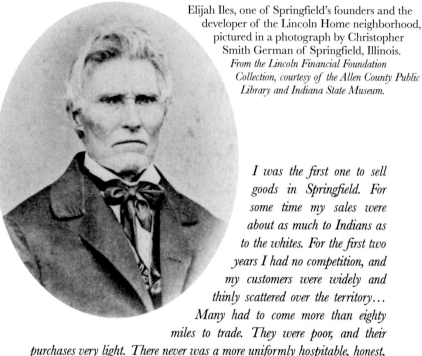

Elijah Iles, one of Springfield's founders and the developer of the Lincoln Home neighborhood, pictured in a photograph by Christopher Smith German of Springfield, Illinois. *From the Lincoln Financial Foundation Collection, courtesy of the Allen County Public Library and Indiana State Museum.*

I was the first one to sell goods in Springfield. For some time my sales were about as much to Indians as to the whites. For the first two years I had no competition, and my customers were widely and thinly scattered over the territory... Many had to come more than eighty miles to trade. They were poor, and their purchases very light. There never was a more uniformly hospitable, honest, and industrious class of first settlers [who] ever settled new country.[2]

In 1823, the federal land office opened at Springfield, then a small village of twenty or thirty log cabins stretched along Jefferson from First to Fourth Streets. When parcels of land were offered for sale, Elijah Iles and three of his friends—Pascal P. Enos, Thomas Cox and John Taylor—purchased four adjoining parcels for $1.25 an acre and had them surveyed into lots that became the original Town of Springfield. They then proceeded to sell the lots.[3]

They named the town's first streets for American presidents—Monroe, Adams, Washington, Jefferson and Madison—and the village itself "Calhoun" after the popular South Carolina senator John C. Calhoun. When the little village was legally incorporated in 1832, the name was changed to that of a nearby creek, a name preferred by the residents: Springfield.

In 1824, Springfield was selected as the permanent county seat of Sangamon County. The census recorded just five hundred residents. By now, many transients had left for "less populous" areas where they could not see the smoke from a neighbor's home; it was in this same year that Iles built his first home from logs.

Springfield Becomes the Capital

By 1837, thanks to the efforts of Lincoln and "the Long Nine," a group of legislators all over six feet tall, the state capital was moved from Vandalia to Springfield, closer to the geographic center of the state. This move, which was completed by 1839, would alter forever the history of this frontier village now grown to two thousand inhabitants.

Naturally, a state capital demanded an appropriate building, so the county courthouse on the public square was demolished, making way for the new capitol, and a new courthouse was erected on the east side of Sixth Street.

Iles continued promoting the rich agricultural potential of the area, but it was his town real estate ventures that made him a millionaire. Shrewdly anticipating the town's growth as the new capital, he began the construction, in 1836, of Springfield's first luxury hotel at the southeast corner of Sixth and Adams Streets, and the American House opened its doors in 1838.

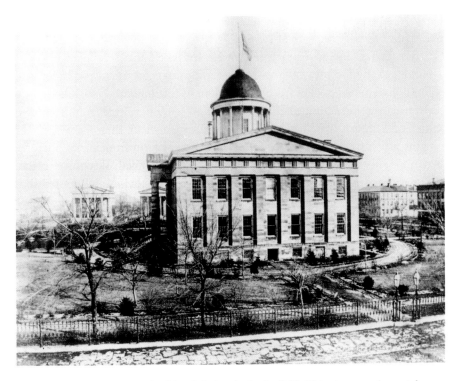

The Illinois State House during Lincoln's time in Springfield. This photograph was taken by an unknown photographer from a building on Fifth Street looking east. *Courtesy of the Sangamon Valley Collection, Lincoln Library, Springfield, Illinois.*

A visiting Ohio editor remarked somewhat sarcastically of Iles's hotel that "everything inside puts you in mind of the Turkish splendor: the carpeting, the papering and the furniture, weary the eye with magnificence."[4] Its popularity was instant. In one week alone in 1839, when the legislature was in session, 158 people registered at the grand American House. Many of them were legislators who lived too far away for frequent visits home.

With his typical foresight and energy, while the American House was still under construction, Iles began the first of several housing additions (now called subdivisions) that came to bear his name. One contained 436 lots and covered a twenty-seven-block radius. It was here that the now famous Lincoln Home was built in 1839 and also Iles's own second home.

Mary Todd and Abraham Lincoln Arrive in Springfield

In 1837, Mary Todd made her second visit to Springfield as a guest of her eldest sister, Elizabeth, wife of Ninian Wirt Edwards, son of Ninian Edwards Sr., first territorial governor of Illinois. In this same year, Lincoln was admitted to the bar and rode with two saddle bags, his borrowed horse and seven dollars in his pocket from New Salem to Springfield. Now a bona fide lawyer, he planned on launching his first law practice with Mary's cousin, John Todd Stuart.

This was also a year of other notable events. Eighteen-year-old Victoria became Queen of England and reigned for the next sixty-three years; Chicago incorporated as a city; the electrical telegraph, which later became a great help to Lincoln, was patented; and a financial panic hit, the worst since the country's founding, creating a major recession. Unemployment soared, banks collapsed and many businesses failed.

Despite the country's financial plunge, Mary and Abraham were young and hopeful about the future. But they were disappointed in Springfield. It was nothing like the sophisticated Lexington, Kentucky—the "Athens of the South"—where Mary was born and brought up. Lincoln wrote to Mary Owens, whom he had courted in New Salem, that he found the town "a busy wilderness."[5]

Earlier in the decade, the poet William Cullen Bryant, passing through Springfield, had departed with a negative impression: "The houses are not so good…a considerable portion of them being log cabins and the whole town having an appearance of dirt and discomfort."[6]

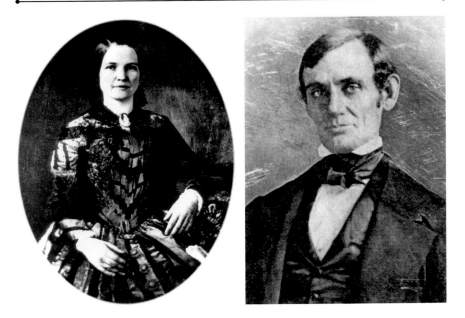

Left: Mary Lincoln pictured in a circa 1846 daguerreotype (photograph) by Nicholas H. Shepherd of Springfield, Illinois. This is the earliest confirmed photographic image of Mary Lincoln. *Courtesy of the Abraham Lincoln Presidential Library & Museum. The original is in the Library of Congress.*

Right: Abraham Lincoln pictured in a circa 1846 daguerreotype (photograph) by Nicholas H. Shepherd of Springfield, Illinois. This is the earliest confirmed photographic image of Abraham Lincoln. *Courtesy of the Abraham Lincoln Presidential Library & Museum. The original is in the Library of Congress.*

In the absence of sidewalks and paved streets, the pig population wandered freely through the often muddy streets. While pro-hog and anti-hog factions argued, the porcine population continued to enjoy its freedom, rooting in the dirt and wallowing in the mud. Chickens and dogs sometimes joined in the fun. And in wet or wintry weather, carriages routinely got stuck in the dark sludge of the roadways.

Meanwhile, Simeon Francis, editor of the *Sangamo Journal* and the man who was to bring together Mary and Abraham after their romantic breakup, was optimistic, enthusiastically promoting the exciting growth of the new capital:

> *The owner of real estate sees his property rapidly enhancing in value; the merchant anticipates a large accession to our population and a corresponding additional sale for his goods; the mechanic already has more contracts offered him for building and improvement than he can execute; the farmer*

anticipates, in the growth of a large and important town, a market for the varied products of his farm; indeed every class of our citizens look to the future with confidence that we trust, will not be disappointed.[7]

From the small square at Second and Jefferson where Iles's store and the first courthouse had stood, Springfield's new town center expanded its boundaries. The State House moved toward completion. Assisting was brick mason Jared Irwin, later a neighbor of the Lincolns and one of many workmen lured from the East by job opportunities in Springfield. One- to three-story buildings were constructed on Fifth Street south from the corner of Washington, as well as along Hoffman's Row, where Lincoln shared an upstairs office with John Todd Stuart. Craftsmen's signs in growing numbers invited customers to purchase hats, shoes, leather goods and clothing.

Further, the administration of state government and the growing community required more service providers: clerks, doctors, lawyers, mechanics, hoteliers, builders and shopkeepers. Even a bookstore appeared, a sure sign that culture was coming to the prairie.

Robert Irwin opened a general store where Lincoln's close friend Joshua Speed had once done business and where Lincoln had made his first home in the community. Irwin's welcomed frequent customers like Mary Todd—a serious shopper who delighted in choosing from among the variety now available of lovely fabrics, ribbons, straw hats, coffee and tea.

At the same time, Springfield was becoming a town of politically aware and involved citizens. On every street corner, in shops on the square and in new drinking establishments, lively political discussions took place. During presidential campaigns, tempers ran high. In 1839, during the election campaign of William Henry Harrison and Martin Van Buren, both the Whigs and the Democrats arrived by the thousands to hold their state conventions in the new capital. Speaking tournaments went on for hours followed by torchlight parades, singing and barbecues until midnight.

Mary Todd and Abraham Lincoln flourished in this milieu. "This fall," she wrote, "I became quite a politician, rather an unladylike profession, yet at such a *crisis*, whose heart could remain untouched while the energies of all were called in question?"[8]

And people partied! When in session, the legislature included many eligible bachelors. This meant a lively social life attracting marriageable young women like Mary Todd and her sisters. The home of her sister Elizabeth and brother-in-law Ninian Wirt Edwards was a popular venue for many entertaining gatherings of what Mary called the "the coterie,"

including awkward Abraham Lincoln, his friend Joshua Speed and the brilliant young politician Stephen A. Douglas. Isaac Arnold, a legislator, remembering Springfield of those early capital days, said, "We read much of 'Merrie England,' but I doubt if there was ever anything more 'merrie' than Springfield in those days."[9]

The Lincolns Buy a Home

As the city grew, so did the churches and their need for bigger and better buildings and new ministers. The local Episcopal Church, seeking a new pastor, contacted Reverend Charles Dresser of Virginia. He accepted the position and moved with his wife, Louisa, and two sons to Springfield in 1838. The following year, he decided to build a home and purchased Lot 8 in Block 10 of the Elijah Iles's Addition (subdivision). The lot Dresser purchased had been owned originally by Elijah Iles. It was bought by Dr. Gershom Jayne, Springfield's first physician, who then sold it to the Dressers. In order to accommodate the building plans, Dresser paid ninety dollars to Francis and Emeline M. Wester Jr. for an additional ten-foot-wide strip off the south side of the lot.[10]

The home Dresser built faced Eighth Street and was a modest cottage of one and a half stories that extended 150 feet north, down Jackson Street. It stood on a rise above the unpaved street. Shutters flanked the set of two windows on each side of the walnut front door.

On the ground floor, the home contained a parlor, a sitting room with fireplaces for heating and a kitchen. Above, in the half loft, there were two low-ceilinged bedrooms under the slanting roof. Reverend Dresser added an outhouse and possibly a barn in the back, along with a well and cistern for collecting rainwater.

By November 4, 1842, Mary Todd and Abraham Lincoln had passed through their stormy courtship and engaged Reverend Dresser to perform their marriage ceremony in her sister's parlor. At this time, Reverend Dresser had his own problems. He was struggling with debts and eager to sell his Eighth and Jackson property. Lincoln would most certainly have visited the home and probably found it to his liking, but the time was not right for him to make this kind of financial commitment.

Rather than become homeowners, the newlyweds took up residence at the Globe Tavern, an inn and stagecoach office where Mary's sister Frances

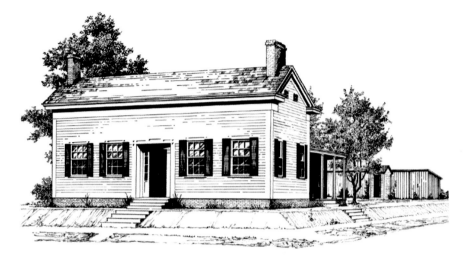

A twentieth-century drawing by artist Xavier C. Meyer of his conception of the one-and-a-half-story Lincoln Home in 1844. *Courtesy of the Illinois State Historical Society.*

and her husband, Dr. William Wallace, had lived for a time as well. However, after a year and the birth of Robert Todd Lincoln, the family rented somewhat larger quarters, a three-room cottage nearby on the east side of South Fourth Street between Adams and Monroe. Here Mary was able to afford help, and she enjoyed some space of her own.

In 1844, Reverend Dresser was still in financial difficulties and unsuccessful in selling his home. Mary's father helped solve the problem for Dresser and Lincoln. On his only visit to Springfield to see his daughters, Robert Todd of Lexington, Kentucky, made possible the purchase of the Dresser home by a generous monetary gift honoring the birth of Robert Todd Lincoln. He wished his grandson well with the words, "May God bless and protect my little namesake."[11]

On Tuesday, January 16, 1844, Abraham Lincoln, age thirty-five, and the Reverend Charles Dresser entered into a contract for the sale of Dresser's house at Eighth and Jackson Streets. Lincoln agreed to pay Dresser $1,200 in cash and to convey a lot worth $300 on Adams Street in the business section that he and Stephen T. Logan had acquired two years earlier.

On May 2, 1844, Reverend Charles Dresser deeded the property to the Lincolns. And so it was that the Lincolns purchased the only house they would ever own.[12] It was hardly "an upper class existence in an upper class environment," as a biographer once described the locale, but it was a delighted Mary who, in the lovely spring of that year, babe in arms, passed

over the threshold of her modest new home. She had all the basics for a happy domestic life: "a nice home, a loving husband and precious child."[13]

Lincoln was now practicing law with his new partner, William Herndon, in the Tinsley Building on the square. He must have been pleased that his new home was an easy six-block walk to work.

At this time, the neighborhood was on the outskirts of town, mostly empty lots, owned but not improved. This would come in the next decade. The streets were still unpaved and muddy, and no sidewalks or gutters appeared until Lincoln and neighbor Charles Arnold, then sheriff of the county, agitated for improvement. Until 1851, when an ordinance forced livestock to be penned, Springfield allowed pigs and other farm animals to roam freely in the unpaved streets. Mary remarked to a domestic, "At least my guests won't have to wade through cow and hog tracks to get to my parties, thus ruining my carpets. The law has taken a hand and made those folks who have hogs and cows keep them home."[14]

Although not the elegant mansion of her native Lexington, Mary was delighted to have a place of her own at last. For Lincoln, who cared little for physical comfort, who had grown up in woods and log cabins, slept on plank floors and shared beds in boardinghouses with other itinerant lawyers, it must have felt a bit strange mounting the plaque "A. Lincoln" on his door. He may have felt some pride of ownership for he wrote to his father-in-law, Robert Smith Todd, "that he was going to housekeeping."[15]

First Neighbors of the Lincolns

At the time the Lincolns moved in, a family of three—Reverend Francis Springer; his wife, Mary; and one child—lived across Jackson on the southeast corner of Eighth. By 1844, Reverend Springer had officially closed the English and Classical School that he ran from this home. It is thought, but not proven, that a young Robert may have studied briefly with Reverend Springer there. Lincoln and Springer established an enduring friendship that continued during the Civil War, when Springer was an army chaplain. (For more information on Reverend Springer, see Chapter 6.)

Lincoln already knew his neighbors George and Eliza Wood, who in 1842 built their family home on Eighth near Market (Capitol) Street just a few doors north of the Lincoln Home. This is where five of their nine children were born. Wood was a tailor who established Springfield's first ready-made

clothing store with his brother-in-law, Edmund R. Wiley. In 1838, as a young lawyer, Abraham Lincoln, with his senior partner John Todd Stuart, had defended the tailoring firm of Wiley and Wood in a debt case. Part of the fee was paid by a coat made especially for John Todd Stuart.

As dedicated Whigs, the Woods also shared political allegiances with the Lincolns. (Lincoln belonged to the Whig Party but later joined the newly formed Republican Party.) Edward W. Wood, the fifth child of George Wood, remembered seeing Lincoln rattle his cane along the fence as he walked by on his way to work, sometimes leaning over the fence into the yard to pat one or more of the many Wood children on the head as he passed.[16]

Another early neighbor was Thomas Lushbaugh, the son of a German immigrant. He migrated from Maryland to Springfield, where in 1845 he built a small brick home on the west side of Eighth Street directly across the street from the Lincolns. In her memoirs, the Lushbaughs' daughter, Elizabeth Lushbaugh Capps, told how every morning Mr. Lincoln crossed the street in his shirtsleeves and slippers to get a shovel of coal to start his fire. When matches were invented but still scarce, her grandmother offered to give one to Mr. Lincoln in place of the live coals. His response was, "I never would have thought of matches."[17]

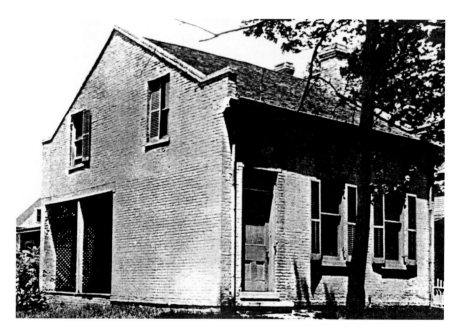

A photograph of the Thomas Lushbaugh House (also known as the Burch House) across the street from the Lincoln Home. *Courtesy of the Abraham Lincoln Presidential Library & Museum.*

Elizabeth's daughter, the Lushbaughs' granddaughter, described how her grandmother kept a cow and sold milk to Mrs. Lincoln, who "demanded cream she could cut with a knife." She also mentioned that their son Robert Lincoln spent a great deal of time in this home as the playmate of her mother.[18]

When Thomas relocated his family to Mt. Pulaski, he rented out the property and in 1859 sold it to widower William Burch. When Lincoln was in the Mt. Pulaski area riding the legal circuit, he stayed at the Lushbaugh home. When he became president, he appointed Thomas Lushbaugh as Indian agent for Nebraska.

In the early 1840s, Mary Ann and William Walters were among the first to construct a house in the Iles's subdivision, across the street from what was then the Dresser home, near the northwest corner of the block. Mr. Walters was the founder of the *Illinois State Register*, one of the two major local newspapers of the Lincoln era. This was not the Walterses' primary residence but rather an income property for them. Over the years, renters moved in and out, including William Beedle, a fireman on the Great Western Railroad, who lived there in 1860 and whose name now designates the home at the Lincoln Home National Historic Site.

Another early neighbor of the Lincolns was Jameson Jenkins, who purchased a lot from his brother-in-law, James Blanks, on Eighth between Jackson and Edwards Streets in 1848. Although the house no longer stands, a plaque designates the original owner, a conductor on the Underground Railroad, at the Abraham Lincoln National Historic Site.

The Iron Horse Arrives

Encouraged by word of mouth and enthusiastic invitations by Simeon Frances in the *Sangamo Journal* to come out and enjoy the good life in this region, more adventurers from the South and Northeast settled in and around Springfield, as did immigrants fleeing the political unrest and famine in parts of Europe. By the late 1840s and early '50s, Springfield's population had doubled from 2,500 to 5,000.

Contributing to the economic expansion of Springfield were the products of the industrial age with its advances in technology, most importantly the railroad. Unfortunately, due in part to the financial crisis of 1837, early attempts to connect Springfield by rail with other Illinois towns, as well as St. Louis, Toledo and points east, were largely unsuccessful. The only portion

actually put in operation was the section of the Northern Cross between Springfield and the town of Meredosia.[19]

Finally, in 1850 work began on what was to become a successful railroad line between Alton and Springfield. By September 1852, cheering crowds in the capital city welcomed the arrival of the first train from the "river city" of Alton. The completion of what became known as the Chicago, Alton & St. Louis Railroad, along with the extension of the Great Western Railroad's connection to Toledo, gave Lincoln, his neighbors and his friends cause for local pride and exuberant celebration.

James H. Matheny, fellow lawyer and friend of Lincoln's, referred to the extension of railroad lines as "the most important event to Springfield... The completion of that road breathed into us a new life and, lately, the extension of the Great Western Railroads connection to Toledo has been of incalculable benefit to our city." One newspaper editor exclaimed, "It was a glorious sight—the careening of the passenger train over our prairies! The railroads of Illinois will hasten our state to her brilliant destiny!"[20]

Coming to an end was the era of uncomfortable and often unpredictable travel by stagecoach at the mercy of the seasons—torrential rains in spring that washed away bridges and left the roads a muddy quagmire or winter storms that could delay both passengers and the mail for days. Legislators, cautious of hopping a stagecoach home for a short visit, enthusiastically welcomed more reliable train travel.

These new farming and manufacturing machines, such as John Deere's steel plough and Cyrus McCormick's reaper, transformed the efficiency and volume of production, expanding Springfield's agricultural and industrial base. Flour or grist milling, as it was called—an industry that dated to the earliest years of the community—boomed between 1845 and 1865, as did the woolen mills and ironworks.

Railroads provided the means for exporting this abundance far beyond the Springfield prairie to markets in St. Louis, Toledo, Chicago and Cincinnati and for importing manufactured goods and delicacies—such as Lincoln's favorite, oysters—from the North and East. Local farmers enjoyed a new affluence, and local shoppers like Mary Lincoln delighted in the purchase of exotic teas and spices and cheap, ready-made goods for household and personal use.

Farmland in Sangamon County escalated from three to eight dollars an acre to fifteen to thirty dollars an acre by 1853.[21] Lincoln and Stephen Douglas were featured speakers at the first state fair, organized by the newly formed Sangamon County Agricultural Society to celebrate the wonderful advances in farming and technology. Springfield was booming!

The Lincolns' Neighborhood Grows with Springfield

Mary and Abraham Lincoln participated in the evolution of Springfield from a prairie outpost to a center of commerce and the bustling capital he helped create. In the 1850s, thanks to the newly planked sidewalks, Lincoln's boots could remain free from mud as he walked the six blocks from his office on the square to Eighth and Jackson. Downtown was illumined by gaslight, but the subdivisions still remained in darkness once the sun went down.

When Elijah Iles had his general store, Lincoln would have done one-stop shopping there for most of his needs, but by the 1850s, specialty shops provided products. Now, on his way home for dinner, Lincoln could stop by Corneau and Diller's Pharmacy for his family's medical needs, E.B. Pease & Co. for Mary's cutlery or Watson's confectionery for a little treat for the boys. He might drop in at Jacob Bunn's bank at the southeast corner of Fifth and Adams to discuss financial matters and, afterward, play a few rounds of handball in the alley near the newspaper office or visit Billy the Barber for a trim.

The sounds and smells of rural Springfield mingled with those of a farm town moving into the industrial age. Lincoln was part of this changing world,

The north side of the public square in 1860. This photograph is by Frederick W. Ingmire of Springfield, Illinois. *Courtesy of Lance Ingmire, Saratoga, New York.*

and he may have thought of this as he walked home, head down, tilted slightly to the left in his meditative manner. Passing Iles's American House livery stable, he would have heard the neighing of horses and smelled the hay stacked up; he would have heard the crowing of roosters and the mooing of cows roaming in pastures still open but awaiting new housing; and surely he would also have heard the cries of peddlers in the streets mixed with the hissing of gaslight and steam engines in the mills and the mournful sound of a train departing the Great Western Station.

The four hundred private residences springing up around them in 1856 may have inspired the Lincolns to enlarge their own modest home. Mary's sister and brother-in-law continued to hold court in their elegant home near those of banker Jacob Bunn and pharmacist Roland Diller. These stood on land originally owned by Elijah Iles. "Almost palaces of homes have been reared since you were here," Mrs. Lincoln wrote to her sister in 1857. "Hundreds of houses have been going up this season and some of them very elegant."[22]

The Neighborhood as a Microcosm of Springfield

There were only a few homes in the subdivision when Mary, Abraham and baby Robert arrived in the spring of 1844. The Lincolns' neighborhood grew along with the rapidly expanding Springfield of the late 1840s and mid-1850s. Most of the homes still standing in the National Historic Site—the Arnold House in 1840, the Corneau House in 1849, the Cook and the Shutt Houses in 1850, the Sprigg House in 1851, the Lyon House in 1853, the Allen Miller and James Morse Houses in 1855 and the Dubois House in 1858—were built in this short period of time. (The original owners were not, in all cases, the persons living there in 1860, the year chosen by the U.S. National Park Service to represent the Lincoln neighborhood as preserved today.)

The little neighborhood at Eighth and Jackson was a kind of microcosm of the larger community of Springfield, attracting an ethnic and professional diversity of homeowners and renters. Over the years, families moved in and out, but the diversity continued—artisans, clerks, farmers, shopkeepers, government servants and purveyors of transport of French, German, Irish, Portuguese and African American ethnicity. (For further information on the diversity of Springfield and this neighborhood, see Chapters 4 and 5.)

Consider the occupations and origins of some of these neighbors during the seventeen years the Lincolns lived there: Jameson Jenkins, a southern African American drayman from North Carolina, Ed Bugg, a teamster from England; and Jessie Kent, a wagon and carriage builder; Jared Irwin, a bricklayer; and Solomon Allan, a gunsmith—all from the Midwest and Northeast.

Lawyers Mason Brayman and George Shutt migrated from New York and Virginia, minister and teacher Reverend Francis Springer from Maryland and Henry Carrigan, a hotel owner, from Ireland.

Charles Corneau owned a pharmacy. Allen Miller sold leather goods. Henson Lyon was a farmer. The railroad-employed William Beedle was a railroad fireman on the Great Western, and Lotus Niles was a ticket agent for the Chicago, Alton & St. Louis. Later, he became a clerk in the office of state auditor Jesse Dubois, another neighbor whose family came originally to Indiana and Illinois from Quebec, Canada.

Even widows who could not easily find employment in a man's world showed industry by teaching in their homes or taking in boarders, as did

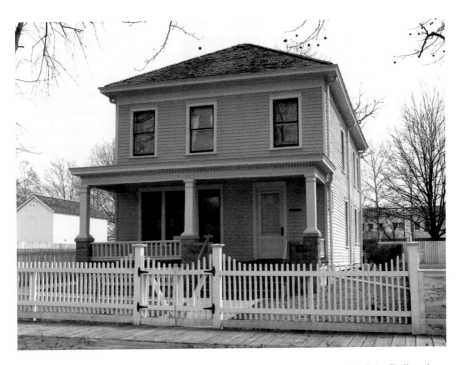

A contemporary photograph of the Eighth Street home built originally by John Roll and rented to photographer Sarah Cook during the time the Lincolns lived in the neighborhood. *Courtesy of the National Park Service.*

Harriet Dean, Julia Sprigg, Mary Remann and Sarah Cook. Mrs. Cook ran her own photography business for a time.

The Lincolns' neighbors over the years were also public servants, people like Jesse Dubois, state auditor; Amos Worthen, state geologist; and sheriff Charles Arnold. For a time, Jesse Kent was a municipal judge, and James Morse was a county employee.

By 1860, as the Lincolns prepared to leave for Washington, forty-six buildings stood in the four-block area that, not long before, had been empty lots. The census taker of July 1860 recorded twenty-two adults and twenty-five children living in thirteen homes on just the two blocks between Market and Jackson and Eighth and Ninth Streets.[23]

During the family's seventeen-year residence at Eighth and Jackson, Lincoln matured from a young professional to a respected attorney, politician, presidential candidate and president-elect of the United States. His income had risen accordingly. Yet, there is no indication that he and Mary yearned to leave their neighbors for a fancier neighborhood. They remained loyal to this place and to the kindness of these people where they had made their start in life together.

The little western prairie town that first welcomed Mary Todd of Lexington and Abraham Lincoln of New Salem had grown to a population of 9,400. The Lincolns and their Springfield friends and neighbors were witnessing the passing of their pioneer era, and many felt nostalgia for "the good old days."

2

MARY TODD LINCOLN AND HER NEIGHBORS

She was the very creature of excitement.[1]
—*James Conkling*

Mary Lincoln needed people around her; she needed relatives, friends and neighbors. As a young girl growing up in Robert Todd's affluent Kentucky home, she was surrounded by members of a large family, by prominent political figures like Henry and Cassius Clay and by Mammy Sally and other slaves who catered to her needs. She studied French, history, etiquette and dancing in Madame Mentelle's Finishing School and Mrs. Ward's Academy—totaling twelve years of schooling, unusual for young women of this time.

The third daughter of her father's first family of seven by Eliza Parker (he eventually had fifteen children when his second wife, Elizabeth "Betsey" Humphreys, added another eight), Mary was intelligent, volatile and high spirited. She sought her father's admiration. She liked being the center of all eyes and was adept at attracting attention. And she grew up ambitious. She determined early on to marry a president. The times did not welcome women in politics, but as the wife of the president, she would have an acceptable entrée into the social milieu and male-dominated halls of government. She determined to find the man most likely to fulfill this dream.

By 1837, Springfield had become the new capital of Illinois. The community was alive and growing, fed by the influx of young men

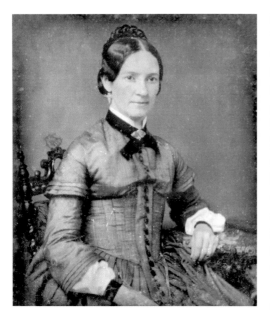

A photograph of Elizabeth Todd Edwards (Mrs. Ninian Edwards), Mary Lincoln's sister. *Courtesy of the Abraham Lincoln Presidential Library & Museum.*

serving in the legislature or working for the state. Mary's eldest sister, Elizabeth, now married to Ninian Edwards, son of the former state governor, had settled in a brick mansion on South Second Street. Elizabeth quickly became the town's leading hostess with her elegant parties under crystal chandeliers, sparkling with fine china and silver amidst fragrant bouquets of flowers from her conservatory.

Into this "gay world," she introduced her three marriageable sisters, Mary, Frances and Ann. When Mary arrived from Lexington, she became the magnetic center of this world of eligible young men and women. Her brother-in-law Ninian once said of Mary that "she could make a bishop forget his prayers," her charm and culture attracting and beguiling many young suitors.[2]

Courtship and Marriage

One such suitor was the ambitious, talented and brilliant politician Stephen A. Douglas. Mary flirted with him but set her sights on Abraham Lincoln, a young lawyer on the rise, a man different from her in most respects. Never mind that his coat and shirt were rumpled and his pants too short for his long legs or that his frontier manners could be uncouth. He was a man on the move. Mary had confidence that, given time, she could "civilize" him. Mary's sister quoted her as saying that she wanted to marry "a good man—a man of mind—with a hope and bright prospects ahead for position—fame & power than to marry all the houses [might be "horses"]—gold and bones in the world."[3] Lincoln qualified.

If opposites attract, then surely this was true of Abraham and Mary. He was tall and thin; she was short and plump. He was patient, reflective, reserved, charitable to others and given to melancholy; she was impulsive, emotional, outgoing, quick to judge and slow to forgive. But in their desire to leave their mark on the world, they shared a driving ambition and the belief that politics was the way to achieve this end. They both loved and admired the Kentucky statesman Henry Clay, they both were fervent Whigs and they both regarded politics as the greatest show on earth.[4] Having perhaps more confidence in his future than Lincoln himself had, Mary made a decision that theirs would be a shared destiny.

By November 4, 1842, Mary and Abraham had navigated the rough waters of their stormy courtship. Reverend Dresser performed the ceremony in a hastily arranged marriage held in the Edwardses' parlor.

Mary found herself a wife and, shortly after, a lonely expectant mother. Lincoln could afford no home for his bride. A four-dollar-a-week, eight-by fourteen-foot room in the bustling, noisy Globe Tavern on East Adams Street had to suffice. Here they shared meals with other guests, long term or transient, in a common dining room downstairs.

This was hardly the dignified, elegant environment to which Mary had been accustomed. She was living a life foreign to her and isolating for one so recently the belle of the ball. Like so many married, pregnant women of this period, Mary left her wedding altar to disappear from view.

Lincoln, on the other hand, resumed life as he'd known it as a bachelor, tending to his legal practice and riding circuit throughout eight Illinois counties, covering thousands of miles of rural Illinois.[5] When his tall, gangly form appeared on his horse or atop a rickety carriage, he was a popular and welcome sight to rural prairie folk who relied on a traveling judge and lawyers for legal assistance, as well as entertainment. Lincoln found out about his future fatherhood not from Mary but from his friend Joshua Speed, to whom a mutual friend had relayed the news. He wrote back, "I had not *heard* one word before I got your letter."[6]

Then, in August 1843, Mary gave birth to Robert Todd Lincoln, delivered by a local doctor or possibly a midwife in her cramped little room at the tavern. Mary left no written record of that time. During her labor, she must have heard the bell on the roof announcing the arrival of stagecoaches and the constant banging of the blacksmith next door. Most certainly, Widow Beck, mistress of the tavern, was in attendance and perhaps a tavern guest, but not her sisters. They disapproved of her marrying "beneath her." We can only imagine what fears this experience must have conjured up for the young, emotional bride.

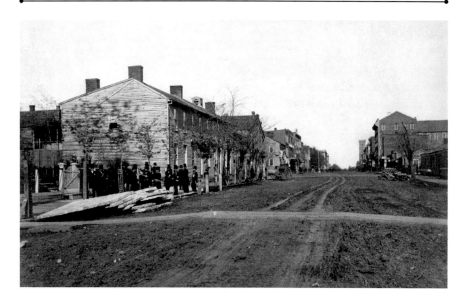

A photograph of the funeral committee for Lincoln's funeral gathered at the Globe Tavern on the morning of May 3, 1865, by Ira Hough, a photographer with Samuel W. Fassett of Chicago, Illinois. *Courtesy of the Library of Congress.*

Mary's own mother had died after the birth of her seventh child, leaving Mary bereft at the age of six. But her husband had returned and was smiling down at her with little Robert Todd Lincoln in her arms. Her wedding ring was on her finger, inscribed, "A.L. to Mary, Nov. 4, 1842, Love is Eternal."[7]

A Home of Her Own

After a year's residence at the Globe, the Lincolns moved into a three-room cottage nearby on the east side of South Fourth Street between Adams and Monroe. Here Mary was able to afford help prior to the purchase of their Greek Revival cottage from Reverend Dresser on the corner of Eighth and Jackson.[8] On Robert Todd's first and only visit to Springfield, Mary's father helped make this possible by a welcome monetary gift in honor of his namesake's birth.[9]

With few neighbors nearby, Mary had to depend on her sisters—Elizabeth; Frances, married to Dr. William Wallace, who lived at Seventh and Market (Capitol); and Ann (all busy raising their own children)—and her closest friends, Mercy Levering and Julia Jayne.

By the end of the 1840s, the neighborhood had begun attracting new families and homes. Mary and her husband welcomed them. And they knew how to be neighborly. The cultivation of friendships between neighbors then was more than a matter of mere courtesy and sociality. It was a matter of necessity.

Mary Runs a Household

In mid-century Springfield, births, illnesses and deaths were frequent, usually occurring in private homes. There were no hospitals, and medical care was primitive. People needed one another's support and help. With Lincoln away from home for months at a time on the circuit, spending long hours in his office or on speaking tours, Mary Lincoln was often a single parent.

Emotional Mary felt her husband's absence acutely, but his presence in the home did not mean he was accessible for communication with her. Frequently, he removed himself mentally, absorbed in his private thoughts. To get his attention, allegedly Mary once startled him out of his reverie by striking him on the nose with a piece of firewood. This may or may not have happened, as there were no witnesses present to confirm the story.[10] While Lincoln could be emotionally supportive to Mary, he "was *not* a demonstrative man, when he felt most deeply, he expressed the least."[11]

Thunder and lightning frightened her, the house settling in the wind worried her and strange boyfriends of her domestics panicked her. She needed neighbors to comfort and reassure her. Frequently, she invited neighborhood children to stay over. Adelia Wheelock, across the street, helped, as did Julia Sprigg's daughter in later years. Sometimes Mary called out for James Gourley, a shoemaker whose property backed up to the Lincolns at Ninth and Jackson. It was not uncommon for him to hear Mary's voice hollering from the back door, "Mr. Gourley—Come—do Come and Stay with me all night." A true neighbor, Gourley came to Mary's aid whenever he could.[12]

Mary was an accomplished seamstress with a sophisticated fashion sense, adept at creating clothing, curtains and bedding for herself and her family's needs and a natural home decorator and hostess with a sense of beauty and decorum. For her supplies of fabric, buttons, thread, etc., she frequented Irwin & Co., Springfield's main dry goods store.

But when the Lincolns married, Mary knew little to nothing about cooking or managing the many tasks required in running a household. Her mother, Eliza Parker Todd, at age eighteen may well have expressed her daughter's sentiment when she wrote to her grandfather about the burdens of housekeeping: "I had no idea it was attended with so much trouble, it is almost enough to deter girls from getting married. We intend residing in Lexington, it would never do for me to go far from Mama as I shall stand so much in need of her instruction."[13]

Mary had no "Mama" on whom to rely. She depended on her sisters, neighbors and women's help books such as Catharine Beecher's *Treatise on Domestic Economy* and Miss Leslie's *Complete Cookery: Directions for Cooking in Its Various Branches*. Much to her credit, Mary, the southern belle, did not shun hard work. She cooked, cleaned and scrubbed. She pumped the water in the backyard and hauled it into the house for heating. She kept the home fires burning in the kitchen and living room by bringing in wood from the back, chopped by Lincoln, the rail splitter. She tended to the constant needs of Robert and her other boys, nursing them through many illnesses.

It is difficult for the wife and mother of today to imagine such a life as Mary and her contemporaries led, a life without the benefits modern women take for granted—central heating, air conditioning, electric lights, washers, dryers, dishwashers, garbage disposals, toasters, coffee makers and indoor plumbing. The only labor-saving devices at the time came in the form of domestic help, and Mary, like other middle-class women of her day, had her share of troubles in this area.

Mary was demanding and quick to anger, a characteristic that often got the better of her. She suffered remorse after her frequent outbursts but felt helpless to resist them. She struggled with domestics, particularly young Irish immigrants, who did not appreciate her directions and demands. She wrote to a friend that "Mary, the same girl, I had last winter, is still with me, a very faithful servant, has become as submissive as possible."[14]

A cousin of Lincoln's, Harriet Hanks, lived with them while attending school in Springfield in exchange for household help. When she left, she had nothing but good things to say about Abraham and declined to share her thoughts on Mary.

Mariah Vance—"Aunt Mariah," as she was called by the Lincolns—an African American woman who lived locally with her husband and twelve children, did better than most with Mary, first as a laundress and later as a general helpmate. In her ten years with the family, she grew to understand Mary and appreciate her finer qualities.

A neighbor in the mid-1850s, Reverend Noyes W. Miner, praised Mary; he considered her a "delightful neighbor, always kind, obliging, affable, full of sympathy and benevolence."[15]

As Mary aged and her responsibilities mounted, she increasingly suffered the agony of debilitating headaches. At such times, only rest in a darkened room and medicines brought her relief from pain.

Eddie Lincoln Arrives, and the Lincolns Leave for Washington

In March 10, 1846, Edward Baker Lincoln was born, named for a brilliant political colleague of Lincoln. The year after, the Lincolns rented their cherished home and left the neighborhood for Washington, D.C., where Lincoln would spend a term as the elected congressman from the 30th District. Once again, Mary found herself cooped up in a single room, but this time it was in the Sprigg boardinghouse near the Capitol, not the old Globe Tavern.

Very few wives accompanied their husbands to Washington during congressional sessions, and even fewer brought children. Lincoln was "getting the hang of the House."[16] He became totally immersed in his new life as a congressman, meeting old colleagues and some new ones, former president John Quincy Adams among them.

Mary, meanwhile, tended to her baby and chased after Robert, a rambunctious four-year-old. Other than the occasional receptions; shopping, which for Mary was always a diversion of

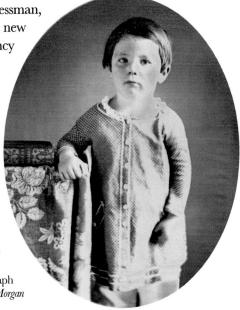

Three-year-old Edward "Eddie" Baker Lincoln in a photograph taken about 1849 by Nicholas H. Shepherd of Springfield, Illinois. This is the earliest known photograph of a presidential child. *Courtesy of the Keya Morgan Collection, LincolnImages.com.*

choice; and attendances at the theater with Lincoln, life was quite unbearable in this strange city without her friends or neighbors. She soon departed with Robert and Eddy in tow for her childhood home in Lexington.

Back Home Again with New Neighbors

After her eventual return to Springfield and a second stay at the Globe while Lincoln finished his last session of Congress, the family moved back to their home at Eighth and Jackson Street in the spring of 1849. They were welcomed by their new neighbors, the Deans and the Remanns.

In March 1849, pioneer Springfield resident Peter Van Bergen had sold the house across the street to Frederick S. and Harriet W. Dean and their eighteen-year-old son. At the same time, "gold fever" reached Springfield, and ten days after moving in, Frederick rapidly departed for California and the gold fields in the company of twenty other men, who together formed the Illinois and California Mining Mutual Insurance Company. This ad in

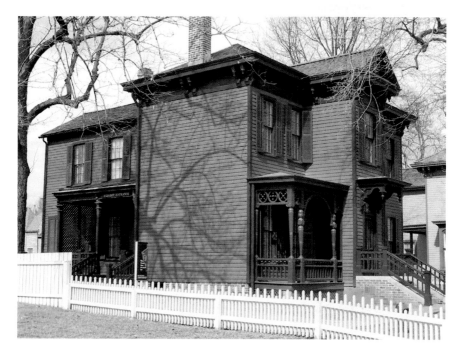

A contemporary photograph of the Harriet Dean House across the street from the Lincoln Home. *Courtesy of the National Park Service.*

the *Illinois Register* may well have ignited their passion: "Who is bound for California? All persons who feel interested in the California Expedition will meet in the courthouse Sat. evening at early candlelight."[17]

The *Illinois Daily Journal* published Frederick's letters home, which were eagerly read by Springfield residents. The one printed in March 27, 1849, gives a picture of the travels of those who, like the ill-fated Donner Party, left Springfield to make their fortunes in California:

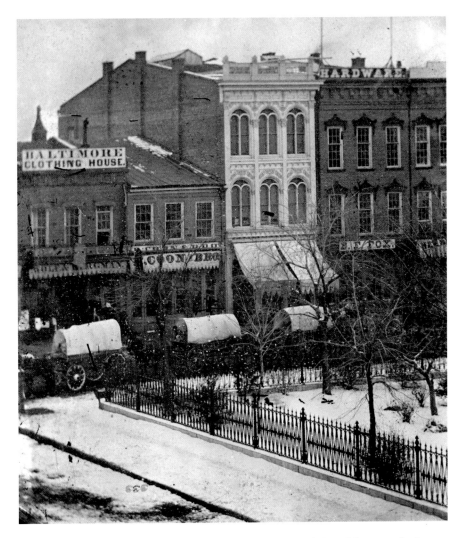

A photograph of covered wagons gathered on the north side of the public square in the 1840s. Perhaps they are preparing to go west. *Courtesy of the Abraham Lincoln Presidential Library & Museum.*

There are about 500 teams ahead of us, and as many more behind us. The road is full of teams while I am writing. some stop on Sundays; others do not; but they will all have to stop and rest their teams. When the road gets harder and the weather hotter, the ox teams will have to be driven slower. I fear that there will be a good deal of suffering before all the emigrants get through; but we hope for the best.[18]

Frederick returned home briefly in 1850, only to disappear and, apparently, never to be heard from again. Since divorce was frowned on and a divorced woman not easily accepted in polite society, Harriet Dean referred to herself as "the Widow Dean." Being resourceful, she taught handcrafts in her home to women and took in boarders, as was customary among widowed ladies in economic straits.

In 1848, Henry Remann, a German immigrant, and his wife, Mary Black Remann, moved into a home at the north end of the block near Market (Capitol). Lincoln and Henry Remann were already friends from Vandalia, and the two Marys now became close as well, sharing birthdays and holidays together. Henry even encouraged Abraham to study German.

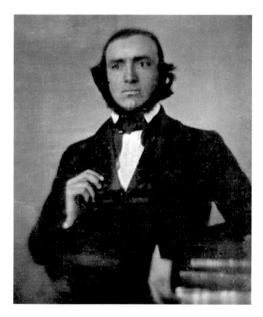

A daguerreotype (photograph) of Henry Christian Remann Sr., neighbor and close friend of Lincoln. *Courtesy of the Abraham Lincoln Presidential Library & Museum.*

Unfortunately, the period of happy family life was suddenly interrupted for the Remanns. In 1849, pregnant with son Henry Jr., Mary became another neighborhood widow when Henry, at thirty-two years of age, died of tuberculosis. This disease, then called consumption, was the number one cause of death in children and adults in mid-century America. It was not until 1882, when Robert Koch, a German physician and scientist, discovered the source of the disease, that a cure was possible. In 1905, he received the Nobel Prize for his great contribution to humanity.

After lingering between life and death for fifty-two days,

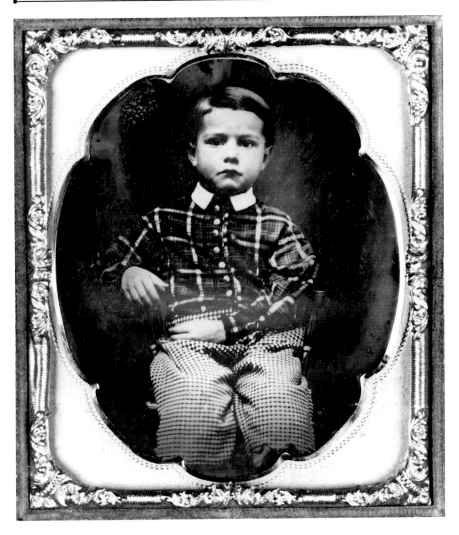

A daguerreotype (photograph) of Henry Remann Jr. in Eddie Lincoln's tartan. Henry was a childhood friend of William Lincoln. *Courtesy of the Meserve-Kunhardt Foundation.*

Eddie Lincoln, on the eve of his fourth birthday, also succumbed to the same dreaded disease. The *Illinois Daily Journal* published this announcement: "DIED—In this city, on yesterday morning, at 6 o'clock, EDWARD, second son of Hon. A. Lincoln, aged 4 years. The Funeral will take place this morning at 11 0'clock from the residence of Mr. Lincoln."[19]

During this time of mutual sorrow and loss, Mary Lincoln and Mary Remann spent time together, finding comfort in each other's company. One evening,

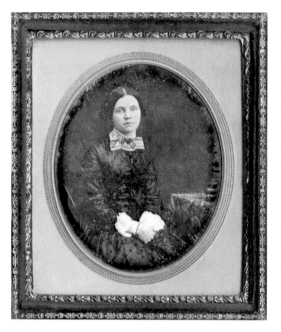

A daguerreotype (photograph) of Mary Black Remann, Mary Lincoln's close friend and neighbor. *Courtesy of the Abraham Lincoln Presidential Library & Museum.*

when Mary Lincoln arrived at the Remann home, she found her friend sitting in candlelight, sewing a little suit for Henry. Overcome with emotion, Mary urged her to go to her home and remove Eddy's clothes from the upstairs bureau to give to Henry. She could not bear to see or touch them.

This same son later became the closest friend of Willie, the Lincolns' third son. Until his death, Willie wrote letters to Henry, such as this one, on his Chicago trip with his father:

This town is a very beautiful place. Me and father went to two theatres the other night. Me and father have a nice little room to ourselves. We have two little pitcher[s] on a washstand. The smallest one for me the largest one for father. We have two little towels on top of both pitchers...We have two little beds in the room. The smallest one for me, the largest one for father...The weather is very very fine here in this town. Was this exhibition on Wednesday before last.[20]

Many years later, in a collection of Lincoln memorabilia belonging to Mary Remann's granddaughter, there was found a touching Christmas gift, a token of Mary's affection for Mrs. Remann. It is a memory book with pressed flowers and four-leaf clovers from the Lincolns' yard inscribed, "Mary Remann, Dec. 25th, '56 from Mary Lincoln."[21]

Departures and Arrivals in the 1850s

The 1850s saw an expansion of Springfield and all its neighborhoods. Eighth and Jackson was no exception. Empty lots gave way to modest homes that housed new families, often with many children.

While Eddie was failing, Mary received terrible news from Lexington. Both her beloved father and adored maternal grandmother Parker had died. The news devastated her and left her even more emotionally fragile. Unlike Lincoln, Mary did not hide her feelings. The sight and wailing sounds of her grieving became familiar to her neighbors, who came quietly to her home, offering food and assistance at this time of bereavement.

The birth of a healthy third son, William Wallace—"Willie," as he came to be known—on December 21, 1850, lifted the Lincolns' spirits. Mary chose the name of her brother-in-law, her sister Frances's husband, a doctor who helped the family through illnesses and physical loss. Like all three of her sons after Robert, Willie was born at home.

Elizabeth Black

Another joy for Mary was the arrival of Mary Remann's sister-in-law. Pregnant Elizabeth Black and her husband came to Springfield from Pennsylvania via Vandalia, Illinois. Elizabeth stayed with the Remanns for a year in 1851 while her

Elizabeth Black (Mrs. William M. Black), a photograph by the Genelli Photographic Studio of St. Louis, Missouri. Elizabeth Black stayed for a while in the Lincoln neighborhood with her sister-in-law Mary Remann and became a friend to Mary Lincoln. *Courtesy of the Abraham Lincoln Presidential Library & Museum.*

A photograph of William M. Black, Elizabeth Black's husband, who visited the neighborhood while he was establishing his business in St. Louis, Missouri, by Thomas Cummings of Lancaster, Pennsylvania. *Courtesy of the Abraham Lincoln Presidential Library & Museum.*

husband was away in St. Louis, establishing a new business. History has preserved a little pocket diary of Elizabeth's from five months of her stay with the Remanns.

This diary provides a glimpse of the support system that neighborhood women created to sustain them through life's trials. In it, she tells of giving birth to a baby boy, Samuel Dale Black, of yearning for her husband and of sharing social and spiritual moments with Mary Lincoln and neighbors Harriet Dean and Julia Sprigg, who later moved to the neighborhood following the death of her husband in 1852.

"Took Tea at Mrs. Lincoln's"

Sharing tea and sympathy, the women met and talked of babies and knit or embroidered. On occasion, they traveled together in Lincoln's old carriage to the First Presbyterian Church at the southeast corner of Third and Washington. Here Reverend James Smith, whose funeral sermon for little Eddy had impressed Lincoln, preached hope and the Christian promise of reunion with lost loved ones in heaven. In the warmth of the church and the comfort of one another's company, the neighbor women found compassion and understanding to sustain them through births, separations and deaths of family members. And they had fun: "We laughed all the way home together."[22]

Elizabeth's diary notes the birth of Samuel Dale Black on January 6 and her shopping for a bonnet for the baby on February 9, followed by walks through the snow and wind, babe in arms, to visit Mrs. Lincoln and Mrs. Sprigg in the days following.

Then, on Friday, March 24, Elizabeth records the simple words: "Samuel Dale Black died." And two days later, "The baby was buried at 10 oc [loc] k." Grieving for the loss of her infant boy and missing her husband, who had paid a brief visit, Elizabeth expressed her tortured feelings: "—in bitter anguish I cried unto the Lord to prepare me for death and take me from this world of suffering."[23]

To help her through this troubled time, she called on Julia Sprigg in the morning to accompany her to a prayer meeting, and some weeks later, she took Mary to church with two-year-old Willie to be baptized by Dr. Smith. Still mourning the loss of her own son, father and grandmother, Mary Lincoln insisted that Elizabeth come and pass time in her home and participate in prayer with Dr. Smith. Elizabeth complied: "Took my work and went down to Mrs. Lincoln's awhile."[24]

After a year's stay in the Lincolns' Springfield neighborhood, Mary Black joined her husband, William, in St. Louis. Mary maintained her friendship with her and, in a letter of September 17, 1853, made an interesting request of Mrs. Black, revealing her sense of style and dress, which later became her trademark as the wife of a president:

> *May I trouble you to undertake the purchase of a white fur hat, for a boy of 6 months...I should like white trimmings & white feather, if you find any to your taste, of the prettiest quality. Would you be kind enough also, to have me a drawn satin bonnet made of this brown, lined with white, I have some small brown feathers for the outside, also inside trimming.*[25]

In 1853, Julia Ann Sprigg purchased a home a block south of the Lincolns shortly after her husband's death. With her seven children, she became an active member of the neighborhood and one of Mary's closest friends. Her daughter Julia often babysat for the Lincoln boys. The bond between these women remained throughout Mary's life, as verified by their ongoing correspondence during the White House years and throughout Mary's widowhood.

After Willie's death in the White House, Mary wrote to her dear friend back in Springfield, "What would I give to see you and talk to you, in our crushing bereavement, if any one's presence could afford comfort—it would be yours...You were always a good friend & dearly have I loved you."[26]

The Births of the Lincoln and Dallman Sons

Tad (Thomas) Lincoln, named for Lincoln's father and the last of the Lincoln children, was born in 1853. Now the house on Eighth and Jackson had seen the birth of three sons and the death of one. At about the same time, in a red brick cottage on the north side of Jackson Street, a few doors west of Eighth, Harriet Dallman, the ailing wife of Charles, gave birth to Charles Dallman Jr.

Charles Dallman, an architect and builder, emigrated from England to Springfield, where he became a noted builder, participating in the construction of the new State House. His carpenter shop stood at East Monroe, across the street from the Great Western Station where Lincoln gave his Farewell Address. Charles became an alderman and active member of the Springfield community.

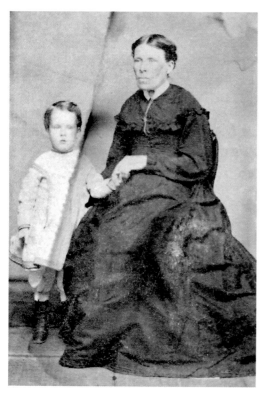

With Harriet too weak and sick to nurse her own newborn, Charles Jr., the Dallmans sought help from their neighbors, and Mary Lincoln responded by offering herself as a wet nurse and her husband as a courier.

Mrs. Dallman, who died in 1916 at the age of eighty-five, described the tall, gaunt figure of Abraham Lincoln walking across the street from his home, knocking at her door and entering with gentle steps, cautious not to disturb the sick mother. Then he gathered up the little mite of a newborn child, formed a basket with his big brawny hands and carried the infant across the street to Mary:

Lincoln neighbors Harriet (Mrs. Charles) Dallman and her child, Charles Jr., in a photograph taken circa 1858 by Christopher Smith German of Springfield, Illinois. *Courtesy of Richard E. Hart, Springfield, Illinois.*

Soon he would return in the same eloquent silence with a tender expression of profound sympathy upon his picturesque countenance as he deposited the little child in a cradle. Often, she said, this humanitarian whose life later gave inspiration to the world, would sit beside the cradle and rock it gently with his toe as he seemed to be in deep meditation about some great problem of human service that he was planning to render.[27]

Despite Mary's efforts and that of local physicians, the baby did not survive past early childhood. When the family returned from the funeral, the Lincolns again were there for them with a generous supper brought by Mr. Lincoln on one of Mary's finest silver trays.

The Brayman and Dubois Families Become Neighbors

Before the Lincolns left for Washington, D.C., in 1847, Cornelius Ludlum, a Democrat who voted against Lincoln in his congressional race and a Northern Cross Railroad man, leased their home. However, he fell on hard times and needed more modest quarters. To help him out, a young lawyer, Mason Brayman, assumed the lease and moved into the home with his wife, Mary, and daughter Ada. Brayman knew and admired Lincoln (see Chapter 7 for more on Brayman.) Once their lease was up, rather than leave the neighbors they had come to know and love, they purchased a home from John Larimore at the corner of Edwards and Eighth, now designated as the Shutt House. The home stood on land originally owned by the Lincolns' brother-in-law, Ninian Edwards.

Mary continued her friendship with Mary Brayman. In a letter to Mrs. Brayman she said, "If your health will admit of venturing out, in such damp weather, we would be much pleased to have you, Mr. B and the young ladies come round, this eve about seven & pass a social evening also any friend you may have with you."[28]

The population of boys in the neighborhood increased with the arrival of the Duboises. Jesse Dubois, Lincoln's close political ally and state auditor, moved to South Eighth Street with his wife, Adelia, and four boys, several of whom became good friends of the younger Willie and Tad. With the promise of cookies and doughnuts, Mary would often encourage the boys' friendship. (For more information on Jesse Dubois, see Chapter 7.)

The Lincoln boys loved pranks, and together with the Dubois boys they managed to concoct quite a few of them, much to the dismay of their

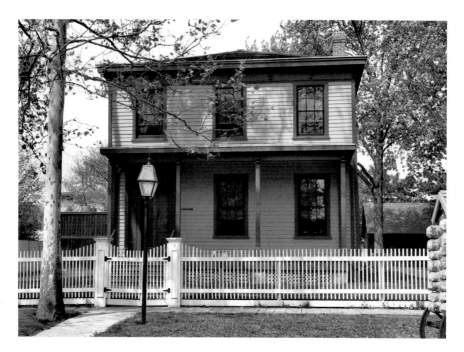

A contemporary photograph of the Jesse K. and Adelia Dubois House on Eighth Street between Jackson and Edwards Streets. *Courtesy of the National Park Service.*

parents. Mrs. Lotus Niles, two doors up the street, heard the wailing of boys' voices. The mothers arrived on the scene to find the Dubois boys, along with Willie and Tad, ill from smoking cigars behind the barn. Seeing the boys so miserable and sick, they took pity on them. Their sickness was punishment enough and a good lesson.[29]

Mary wrote of her surprise at discovering Adelia Dubois's pregnancy, so well had she hidden it under her wide crinoline skirts. In an October 1859 letter to a neighbor, Mary shared the latest gossip on Mrs. Dubois:

> *One of the seven wonders has taken place. Mrs. Dubois has a daughter, born two or three days since. Until the last hour no one suspected her, as she looked smaller, than she ever had done. I thought her countenance had changed, but that was all. She is doing well and much pleased.*[30]

The Shearers and the Melvins

In 1856, Hannah Rathbun, a widow with two sons, Edward and James, moved to Springfield to live with her brother and sister-in-law, the Reverend and Mrs. Noyes W. Miner. The Miners were renting the Lushbaugh home directly across from the Lincolns on what is now known as the Burch lot at the intersection of Eighth and Jackson Streets. At this time, Reverend Miner was the pastor of the First Baptist Church at Seventh and Adams Streets.

The Lincolns shared a close friendship with the Noyes family and helped them in their church work by sometimes loaning them their carriage and occasionally housing some of their guests when space ran short.[31] Reverend Noyes remained friends with the Lincolns throughout the years, visiting them in Washington after Willie's death and helping Mary to increase her pension from Congress as her husband's widow.

Not long after Hannah's arrival, both her sons had mishaps requiring medical attention. Dr. John Henry Shearer arrived at the home to attend to them. His help led to a friendship that eventually led to marriage with Hannah. The Miners moved to other quarters, leaving the newlyweds as Lincoln neighbors during 1858–59.

Hannah was very attractive and a sparkling conversationalist like Mary herself. She was also musical and had a good sense of humor. Mary and Hannah began a friendship that endured over the years and into Mary's widowhood. Dr. Shearer became good friends with Lincoln and accompanied him on several trips during the campaign against Stephen A. Douglas in 1858. When the Shearers moved to Pennsylvania in an attempt to cure Henry's tuberculosis, a correspondence developed between the women. And in 1861, the Shearers named their third son William Lincoln after Willie Lincoln.[32]

In a later letter to Hannah on April 24, 1859, Mary mentioned the Dubois family visiting for tea several evenings at her home and their plans to travel together to Council Bluffs.[33] In one of her darker moods, she lamented to Hannah on June 26, 1859, "What would I not give, for a few hours conversation, with you this evening. I hope you may never feel as lonely as I sometimes do, surrounded by much that renders life desirable."[34]

The Lincolns and Shearers met again on the presidential train when they traveled together from Philadelphia to Harrisburg, and Hannah visited with Mary during her years as first lady.

Dr. and Mrs. Samuel Melvin and their five boys became neighbors when they moved into a home on the northeast corner of Eighth Street,

a few houses away from the Lincolns. Their big backyard was a favorite playground for the Melvin and Lincoln boys. Lincoln frequently stopped by there on the way home from his office to inquire, "Are my boys here?"[35] Mrs. Melvin felt a strong bond with her neighbor Mary. If the baby she expected in early 1861 were a girl, she planned on naming her Mary in honor of her departing friend.

The morning after a social event and the day of the expected birth, Mary sent the Melvins her centerpiece from the last party in their home, a pyramid of macaroons. Later, from the White House, Mary sent Sarah Melvin a photo of Tad and Willie and a little bonnet for her namesake.[36]

Prior to the departure for Washington, Mary sold some pieces of furniture to the Melvins. They remained in the Melvin family for many years. Dr. Melvin, trained as a physician but a practicing pharmacist and successful businessman, was one of the delegation of eleven who accompanied Lincoln's body on the train to Springfield from Washington. As a prominent civic leader, he was also one of the directors of the Lincoln National Monument Association along with Jesse Dubois.

Farewell to Springfield

As wife of the sixteenth president of the United States and as Lincoln's widow, Mary did her best to maintain the important friendships she had nurtured during her years at Eighth and Jackson. But after leaving Springfield, she was never again to know this intimate warmth of trusted friends down the block who loved her for her generous spirit and forgave her faults. For a first lady, there are no neighbors.

3

LINCOLN, HIS BOYS AND THE NEIGHBORHOOD CHILDREN

Mary: They [children] *all adore you.*
Abe: Well, I always seemed to get along well with children. Probably it's
because they never want to take me seriously.
Mary: You understand them—that's the important thing.[1]
—Abe Lincoln in Illinois *by Robert Sherwood*

The better part of one's life," Lincoln wrote in 1849, "consists of his friendships."[2] He valued neighbors and friends. His interest in others, his kindliness and his endless fund of humorous stories attracted young and old to him. His friend from New Salem days Bill Greene said that Lincoln could "make a cat laugh."[3] Those friendships, easily made, endured over long periods of his life.

Lincoln grew up a child of the wilderness, son of a pioneer father. Unable to prove clear title to his land, Thomas Lincoln left Kentucky for Indiana, eventually settling in Coles County, Illinois. Unlike the wealthy, social and gregarious Mary Todd, the boy Lincoln became accustomed to being alone in the wilderness with his own melancholy thoughts.

The poet and Lincoln historian Carl Sandburg expresses this beautifully when he says, "It was the wilderness loneliness he became acquainted with…He lived with trees, with the bush wet with shining raindrops, with the burning bush of autumn, with the lone wild duck riding a north wind."[4]

"Friend" became an important word to Lincoln, one he used frequently in letters and speeches. Noah Brooks, journalist, recorded Lincoln as

A photograph of Robert Todd Lincoln, circa 1858. *From the Lincoln Financial Foundation Collection, courtesy of the Allen County Public Library and Indiana State Museum.*

saying about a much-criticized Civil War general that he was his "friend because nobody else was."[5]

At Eighth and Jackson, some of Lincoln's very best friends and companions were children, his own and those of his neighbors. By the 1850s, as new families moved in, the number of children climbed. The streets rang with the shouts of rollicking youngsters—Robert, Willie and Tad Lincoln; Fred and Lincoln Dubois; Frederick Sprigg; Josie Remann; Delie Wheelock; Joseph Kent; and Alfred Arnold, to name but a few—and of course, their other friends nearby like Isaac Diller, son of an owner of the Corneau and Diller's Pharmacy.

In fair weather, they rolled hoops, chased dogs and cats and played ball, and in the winter months, they sledded across the snow-covered mud streets. Of course, they also got into their share of mischief. All three Lincoln boys were pranksters, especially the youngest two, who were often the ringleaders in neighborhood shenanigans.

Tad, Willie and Robert

Tad, the Lincolns' fourth son, had a malformation of the mouth that may have been a cleft palate, an abnormal opening in the roof of the mouth, or a condition known as "tongue tied," caused by an unusually short, thick or tight band of tissue holding the tip of the tongue too closely to the floor of the mouth. Correct diagnosis followed by surgical correction of the condition was unheard of in the 1850s when he was born.

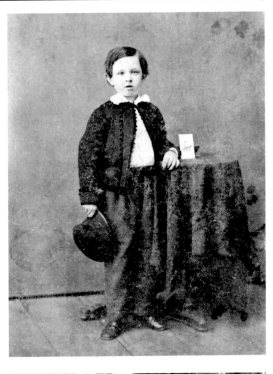

A photograph of Thomas "Tad" Lincoln. *Courtesy of the Abraham Lincoln Presidential Library & Museum.*

A contemporary photograph of the Julia Sprigg House on South Eighth Street. Julia Sprigg was a neighbor and close personal friend of Mary Lincoln. *Courtesy of Richard E. Hart, Springfield, Illinois.*

This defect presented many problems for the little boy, making it difficult for him to chew and to speak clearly without a lisp. As a result, Tad's diet consisted of items he did not have to bite into or chew very much. Since blenders and other modern conveniences weren't available, much advance preparation of Tad's meals was needed before he could eat them. Because of his own disability, Tad displayed compassion for others in need.

Tad at "Mith Spwigg's"

Tad was a frequent visitor to neighbor Julia Sprigg—"Mith Spwigg," as he called her with his speech impediment. He would hide under the furniture if he knew his father was looking for him. "Where is that bad boy?" Lincoln would exclaim in mock bewilderment.

"I do not think he is so very bad. You are surely mistaken, Mr. Lincoln," replied the smiling Mrs. Sprigg.

"Perhaps you are right, Mrs. Sprigg," responded Lincoln. "Tad's really not very bad, but I don't want him to become unwelcome over here, and I want to keep track of his whereabouts." Then she would silently point to where Tad was hiding. Squealing with delight, Tad would allow his father to pull him up, hoist him on his shoulders and carry him home.[6]

Delie Wheelock

Adelia Wheelock—"Delie," as she was called—frequently helped the Lincolns with the younger boys. She lived across the street in a home the family rented from Ira Brown. Lincoln often dropped in to visit her grandfather, an invalid. Despite his busy schedule, Lincoln took time to relax on the front porch and talk over the political news of the day with Grandpa.

When the Lincolns and their son Robert went together to Alton for the Lincoln-Douglas debate, they left Tad at the Wheelocks to be tended to by their eighteen-year-old daughter Delie. She found him to be a restless and very determined young man greatly interested in his father's election. Willie shared this enthusiasm.

Delie's son Philip Wheelock Ayres related stories from his mother's life as a Lincoln neighbor. She described the boys standing on the terrace

of their home, encouraging passersby to "Vote for Old Abe." Like his father, Willie became a good little speechmaker and would, at his friends' urging, stand up and proudly deliver a speech after parades.[7]

Delie Wheelock told her son another tale of Lincoln and his lively boys. Neighbors and good friends Jesse Dubois, Illinois state auditor, and his wife, Adelia, invited the Lincolns to attend a reception at their home down the street. Mary arranged for Delie to come over and help her

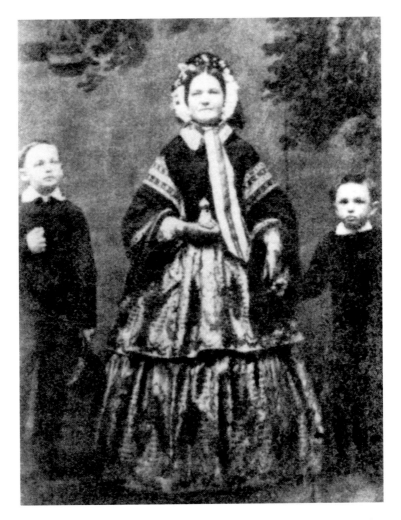

Mary Todd Lincoln and sons William Wallace and Thomas in a photograph taken in November 1860 by Preston Butler of Springfield, Illinois. *From the Lincoln Financial Foundation Collection, courtesy of the Allen County Public Library and Indiana State Museum.*

dress in her canary yellow satin gown with the large hoop skirt. Robert agreed to stay at home with Tad and Willie.

Arriving home from a "candy-pull" (a candy-making party) covered with sticky molasses from head to foot, the boys heard of these plans and began kicking and screaming in protest. Mary did not waver, but to keep the peace, Lincoln proposed, "This will never do. Mary, if you will let the boys go, I will take care of them."

"Why, Father, you know that is no place for boys to be. When people give a party like that it is no place for children." By now, the boys had stopped their screaming and were eagerly awaiting their lawyer father's closing argument.

"But," said Lincoln, "I will take them around the back way, and they can stay in the kitchen." Mary deferred to Lincoln, who then gave the boys a little talk about proper conduct. Scrubbed and dressed for the event by Robert and Delie, the triumphant little boys accompanied their father, not to the Duboises' kitchen, as promised, but to the adult reception.[8] Did they follow their father's rules of proper conduct? Probably not.

Lincoln's Attitude Toward Children

In Lincoln's day, the idea that "children should be seen and not heard" was the norm among parents. Lincoln and, to a lesser degree, Mary did not agree with this. He was patient, indulgent and permissive with his own and others' children. The antics of the "dear codgers" amused him and rarely aroused his anger. William H. Herndon, Lincoln's law partner, in an interview with Mary, quoted her as saying that her husband believed "it is my pleasure that my children are free, happy and unrestrained by parental tyranny. Love is the chain whereby to bind a child to its parents."[9]

Whereas Lincoln was relaxed and easygoing with children, Mary could alternate between indulgence and hysterical anxiety, more the case after the death of her second son. Robert's pattern of running away from home fairly regularly terrorized Mary but amused Lincoln. The neighbors became accustomed to her outbursts of "Bobbie's lost! Bobbie's lost!" or "Bobbie will die! Bobbie will die!" when he put his fingers in the lime box to taste the forbidden substance.[10]

The neighbors also recalled the hilarious sight of the laughing Lincoln in hot pursuit of naked son Willie as he made his escape from the hated bath into

the freedom of the fields east of their home. Lincoln scooped him up like a greased pig, kissed his pink face and took him home to face his outraged mother.[11]

When Lincoln was home, not traveling on the legal circuit, the neighbors often saw him heading for the fields nearby. Willie and Tad trailed after him en route to the railway tracks. Here they would walk and talk together. Lincoln listened respectfully to their excited chatter and they to him as he taught little lessons in life and entertained them with his endless stories.

A familiar scene on Eighth Street and in town was Lincoln with a child on his shoulders and another one or more tagging behind or holding on to his coattails.

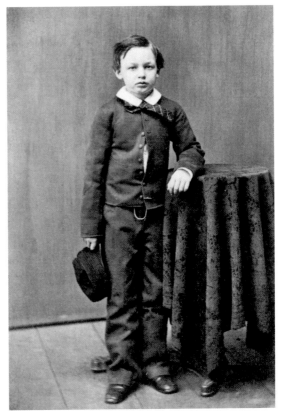

William Wallace "Willie" Lincoln, the third son of Mary and Abraham Lincoln, in a photograph taken circa 1855. *From the Lincoln Financial Foundation Collection, courtesy of the Allen County Public Library and Indiana State Museum.*

Mr. Roland Diller, of Corneau and Diller, the pharmacy the Lincolns frequented, described hearing the great noise of children crying outside. When he stepped out of his door, there was Mr. Lincoln striding by with his boys, both of whom were wailing loudly.

"Why, Mr. Lincoln, what's the matter with the boys?" he asked.

"Just what's the matter with the whole world," Lincoln replied. "I've got three walnuts and each wants two."[12]

Dudley Smith was one of Lincoln's favorite little neighborhood boys. As the son of Stephen Smith, the brother of Clark Smith, husband of Mary Lincoln's sister Ann, little Dudley was a relative of Lincoln. Between 1858 and 1860, the family lived in a rental home at the northeast corner of

Jackson and Seventh, where the Lincoln Home Visitor's Center now stands. On occasion, when Lincoln was out riding the circuit, the Smith family stayed with Mary to comfort her.

The neighbors must have enjoyed the amusing sight of Lincoln strolling down the street rehearsing his thoughts and speeches. Sometimes, he stopped by the Smiths, hoisted the baby onto his broad shoulders and continued his walk. In this manner, Dudley may have become the first to hear Lincoln's famous Cooper Union speech.[13]

Lincoln's Forgetfulness

Adults who, as children, knew Lincoln remembered touching cameos of him. One young man who passed Lincoln's home on the way to school recalled him "on the sidewalk drawing a child backward and forward in a little gig [two-wheeled cart meant to be pulled by a horse]. Without hat or coat, wearing a pair of rough shoes, his hands behind him holding to the tongue of the gig, his tall form bent forward to accommodate himself to the service, he paced up and down the walk forgetful of everything around him and intent only on some subject that absorbed his mind."[14]

It was not uncommon for Lincoln to tend to his boys with his thoughts on other matters. Once, while pulling his son Tad in a wagon, he lapsed into a reverie and failed to notice that the wagon was empty and the child on the ground. Mary, following behind, grabbed the ignored child, and Lincoln received quite a tongue-lashing.[15]

Joseph Kent and Fred Dubois Remember Lincoln

Of all the adults in the neighborhood, Lincoln was the most sought after by the children. When his familiar stooped figure with the stovepipe hat and black coat appeared on the block, children ran to greet him, often startling him from a reverie, and hung to his coattails or held his hand. No matter the age of a child, Lincoln treated each with respect, listening intently to what was being said and acknowledging the conversation with sincerity. Like the Pied Piper, he drew children to him. With Lincoln, they felt important; they felt loved.

For the boys in the neighborhood, a special treat was when Lincoln packed them into his carriage and headed to the Sangamon River for an afternoon of fishing, picnicking and storytelling.[16]

Later, in Washington, Lincoln had less contact with children, but the grandchild of Francis P. Blair Sr. recalled Lincoln fondly: "He entered into the spirit of the play as completely as any of us, and we invariably hailed his coming with delight."[17]

Joseph P. Kent, son of Jesse Kent, grew up in Lincoln's neighborhood five doors north of the Lincoln Home, where the Conference Center now stands. Of the neighborhood children who associated with the Lincolns, Joseph Kent left the richest collection of memories. They date from 1855, when he moved with his father, Jesse Kent, and family into the house on Eighth Street. He recalled Lincoln as "well liked by the boys of our neighborhood...He seemed to understand as well as enjoy boy nature perfectly."[18]

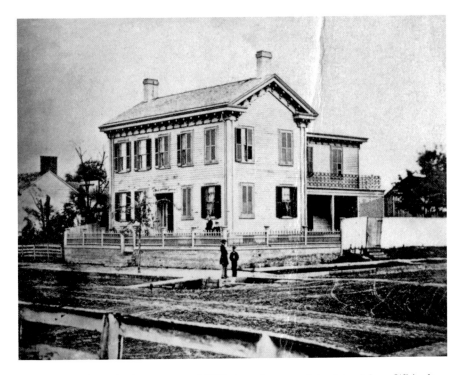

The Lincoln Home in the summer of 1860, in a photograph by John Adams Whipple of Boston, Massachusetts. Lincoln is shown standing outside of his home with his sons Willie, standing behind the fence, and Tad, peeking from behind the corner post. *From the Lincoln Financial Foundation Collection, courtesy of the Allen County Public Library and Indiana State Museum.*

From Joseph's words, we get a picture of Lincoln as a man who loved children, understood them and was tolerant and generous but not without limits. Joseph remarked, "My childish impression of Mr. Lincoln was that he was unlike any man I had ever known."[19]

Joseph was a friend of the Dubois boys down the street. He related a delightful incident involving Lincoln Dubois, or "Link," as he referred to him. The boys were trying to figure out how to come up with enough money to buy watermelons or ice cream. Spotting Mr. Lincoln heading home down Market Street, Link grew excited as visions of ice cream danced before him.

Link asked Joseph, "Did Mrs. Lincoln ever pay you that money?" referring to an earlier time when she had promised to pay Joseph fifty cents. Recalling the incident and his fear of confronting Mrs. Lincoln for what was due him, he replied in the negative. "There comes Old Abe now. You dun him; he'll pay you," Link urged Joseph, who, emboldened by his friend's enthusiasm, appeared before Lincoln to plead his case.

"He [Lincoln] immediately shoved his hand into his trousers' pockets and produced a handful of silver coin. Handing me a twenty-five-cent piece said, 'Here is a quarter for the Myers' errand, then another quarter saying, 'Here is for the horse you took to Dr. Wallace,' and then another quarter saying, 'This is for the interest on your money, seventy-five cents in all." Lincoln continued on home, leaving two very happy youngsters to enjoy the fruits of their boldness.[20]

Fred Dubois, Lincoln Dubois's brother, told of a favorite "trick" the boys loved to play on Lincoln. Returning home from the office, Mr. Lincoln pretended not to see the string stretching across the sidewalk to knock off his stovepipe hat. Letting his hat fall off, he looked around for the culprits. Then, with a great rush, laughing with delight, the boys emerged and ran up to grab his hands and legs, shouting loudly. Lincoln, in his loving, fatherly fashion, enjoyed the prank and "bought them cakes and nuts."[21]

Lincoln Had His Limits

There is, however, another, somewhat similar story related by Joseph Kent. Hiding behind the Kent fence one dark, stormy night, Joseph and the Dubois brothers knocked off a stovepipe hat without being certain whose it was. One argued that it belonged to Charles Arnold, and another insisted it was Lincoln's when the latter's voice startled the culprits: "'Yes, boys, it

was Lincoln.' He had secured his hat and appeared to enjoy our panic. He, however, told us he was not angry, but admonished us to discontinue such pranks, which we were glad to promise and I know we kept it, as far as concerned him in person."[22]

Joseph recalled Mary Lincoln asking his mother if he could help her during Lincoln's absences. She needed him to care for the horse and sometimes drive the carriage for her. Joseph also remembered Lincoln's stopping by his home before leaving town to tell him he was depending on him to assist Mrs. Lincoln.

In exchange for Joseph's help, Lincoln often granted him special favors. Urged on by older boys in the neighborhood, Joseph occasionally asked Lincoln to borrow his horse and harness. The request granted, the boys quickly hitched the horse to Mr. Alsop's flour delivery wagon and galloped off to hunt or to swim. One Sunday in 1859, however, Joseph, summoning up his courage, overstepped his limits and asked Mr. Lincoln to borrow his carriage along with his horse.

"Looking down on me with a broad smile of mirth, he said: 'No, Joseph, there are two things I will not loan, my wife and my carriage."[23]

Lincoln rarely displayed anger with a child. But one day, Robert and his friends put on a dog show in the family barn. To lift up the canines, the children tossed ropes over a rafter and then fastened them around the poor victims' necks, practically hanging them. Lincoln, hearing the howls, rescued the poor animals and expressed his outrage to Robert.[24]

(By the outbreak of the Civil War in 1861, many of the boys in the neighborhood were of age to volunteer for military service, and volunteer they did to fight for the Union, the president and their friend "Old Abe.")

The Neighborhood Girls and Lincoln

Although Lincoln had a natural understanding of boys, he loved the neighborhood girls as well. Josie Remann was a favorite of his, the daughter he never had. He delighted in carrying her in his arms, particularly to see the circus performers. Josie grew up and married a son of Elizabeth and Ninian Edwards, thus becoming a relative of Lincoln.

The daughter of near neighbors Emanuel and Justina Decrastos recalled visiting the house at Eighth and Jackson Streets. To her great delight, she was treated to special "hossy' rides" on Lincoln's leg.[25]

A daguerreotype (photograph) of Josie Remann, a favorite of Abraham Lincoln, by Christopher Smith German of Springfield, Illinois. *Courtesy of the Abraham Lincoln Presidential Library & Museum.*

Another little girl accompanied her father to call on Lincoln in his home. She had been forewarned, probably by her father, that Lincoln was a very homely man. After Lincoln put her on his knee and delighted her with his conversation, she exclaimed, "O, pa! He isn't ugly at all; he's beautiful!"[26]

After Lincoln's election as president but before he left for Washington, Delie Wheelock visited his office in Springfield to introduce him to her future husband. Her son describes the touching scene so typical of Lincoln's genial friendliness despite the heavy demands on his time: "Taking her hand in his large hand, which was always very reassuring, he said, 'This is my little friend Delie, Delie Wheelock' and gave a few moments of undivided attention."[27]

Lincoln Goes to the Circus

In Lincoln's time, there were no radios, movies, televisions, iPods, YouTube, CDs or DVDs. But there was the circus, a magical world for both children and adults. Between the years of 1844 and 1861, when the Lincolns left Springfield for Washington, E.F. Mabie & Co. Grand Olympic and U.S. Circus, Great United States Circus, Yankee Robinson's Big Show and fifty more circuses paraded exotic animals, trapeze artists and clowns through

the Springfield streets to the music of the calliope, promising an alluring escape from everyday life.[28]

The neighborhood children knew of Lincoln's love of the circus. If he were in town, they knew they could count on him to host them, carrying some on his back and shoulders or encouraging others to grab on to his coattails.

A Lincoln neighbor, Olivia Leidig (later Mrs. Olivia Whiteman), told of a circus day in Springfield as she remembered it, probably in the early 1850s:

> *Lincoln really became a king for the children of the neighborhood. It was his delight to seek out the boys and girls in reduced circumstances who were unable to purchase tickets, and with his own children would start out for the white tents. He would hold up the smaller children so they could get a good view of the animals and other attractions.*[29]

As a boy, Abe Lincoln barely knew childhood. His father, Thomas, needed him to cut wood, hoe, plant, harvest and build—not to play silly, childish games. But the adult Lincoln knew and understood children; and they loved and trusted him. To his own sons, particularly Willie and Tad, and the boys and girls of Eighth and Jackson, Lincoln was the jolly good giant. Reverend Noyes W. Miner said of Lincoln's relationship with neighbors young and old that "he was on good terms with all, and those who knew him best loved him most."[30]

4

A NEIGHBORHOOD OF DIVERSITY—FOREIGN BORN

The character of our population is extremely varied. We have representatives of almost every nationality beneath the sun; yet, varied as it may be, it meets and mingles in the struggles incident to existence, with perhaps as little discord as any people throughout the world. Every man in our midst who has evidenced a reasonable industry, coupled with care and prudence, has a home of his own, humble though it be, yet, nevertheless, it is a "home"—and what costly palace is more than that.[1]
—James H. Matheny, Lincoln's friend and prominent Springfield resident, 1857–58 Springfield City Directory

In the early spring of 1844, Mary and Abraham Lincoln were a young couple. Abraham was thirty-five and busy with his legal career. Mary was twenty-five and spent her days taking care of their home and infant son, Robert. In May, they moved to their own humble home, a modest cottage at the northeast corner of Eighth and Jackson Streets. Built in 1839, the six-room, one-and-a-half-story house was typical of hundreds of modest homes recently built and to be built in a booming Springfield during the next fifteen years. These homes would house the influx of new Springfield residents, including foreign born and African Americans.

The Resident Neighbors

The Lincolns' new house was located in a seven-year-old subdivision at the southeast edge of town that consisted of mostly empty lots, individually owned but not yet improved. Lincoln was familiar with this neighborhood, as six years earlier, on June 2, 1838, he had purchased two lots in the center of the block across the street from his new residence.[2]

Between the 1844 move to Eighth and Jackson and the 1861 departure for Washington, D.C., the Lincoln family saw their neighborhood transformed into a melting pot of a variety of races and ethnicities. African Americans from the South; white families from the upland South, the Middle Atlantic and New England states; and foreign born—Irish, English, Scottish, French, German and Portuguese—were either neighbors or worked as servants in homes within the neighborhood. A number of foreign languages—German, French and Portuguese and a variety of English dialects (British, Irish, Scottish, African American, American Southern and American Northern)—were spoken in the neighborhood.

The chart below shows the number of African Americans and foreign born living within a three-block radius of the Lincoln Home in 1860:

	LIVE IN NEIGHBORHOOD
African Americans	21
Irish	60
German	45
English/Scotch	19
Portuguese	2
French	1
Total	148[3]

Another characteristic of Lincoln's Springfield and neighborhood was the abundance of young people. By 1860, Springfield had a population of 9,320. The population of young people seventeen years and below in age was 6,902 and constituted 74 percent of Springfield's total population. Those eighteen years of age and older totaled 2,438 and constituted 26 percent of the population. Springfield was very young, as was the Lincoln neighborhood.

Adult Population	2,438	26%
Minor Population	6,902	74%
Total Population	9,320	100%

The Domestic Servants

To understand Lincoln's neighborhood and, indeed, Lincoln's Springfield, one must recognize the prevalence and importance of domestic servants. From his first days as an 1837 Springfield resident, Abraham Lincoln took his meals at the William Butler residence and was served there by an African American indentured servant. Mary Todd, the future Mrs. Lincoln, first experienced Springfield life with her relatives Ninian and Elizabeth Edwards and Dr. John and Elizabeth Todd; both families had servants in their homes.

The importance of Springfield's servants cannot be overstated. By 1850, nearly one out of every four Springfield households included a live-in female servant. They made many Springfield houses run. They cooked, cleaned, washed, served the table, sewed, cared for babies and children and nursed the family's sick. Other more menial duties included making fires, emptying chamber pots, cleaning lamps and carrying water from the well and cistern. As was the custom in most Springfield homes, Wednesday and Saturday were baking days, whereas Monday and Tuesday were devoted to washing and ironing—the most detested of labors.

The servants were usually under twenty-one but ranged from eight to seventy-five years old. They were diverse in origin and race and included German and Irish born, as well as African Americans and Portuguese. Most of the women were single or widowed. Their average pay was between $1.00 and $1.50 per week. Some worked for short periods, and some spent their entire lives in the service of one family. As with employees in all times and places, some were good and some were not. The same could be said of their employers.[4]

Servants at the Lincoln Home

Over the years, the Lincolns themselves employed a number of servants, as did most middle-class Springfield families. From their early Springfield days, through the birth of three more sons, the expansion of the home to double its size and the rise of Mr. Lincoln from successful attorney to president-elect and their 1861 departure for Washington, D.C., the Lincolns experienced and often personally relied on the service of domestic servants. Some of them lived in the Lincoln Home, and others were day servants who went home at the end of the day. These servants reflected the population

of Springfield, including recent immigrants from Ireland and Portugal, as well as African Americans and white employees who had lived in the United States for many years.[5]

Mary Lincoln has been subjected to intense scrutiny and judgment about her relationships with the domestic servants in her home. Her Springfield peers, however, have not undergone similar scrutiny, and it is, therefore, difficult if not impossible to conclude whether Mary differed from her peers in servant relationships. In addition, the descriptions of Mary's treatment of her servants varies. Some say she was good, and some say she was not good. In sum, the descriptions add up to a small number of inconsistent anecdotal instances culled from reminiscences. They are neither conclusive nor sufficient to reach any definitive judgment about Mary or her treatment of servants over the years she lived in Springfield. Mary, like all humans (including servants), had good and bad days.

> *Much has been made of Mary Lincoln's treatment of these servants, although a distinction must be made between those who were hired girls making a few dollars or, as Harriet Hanks did, serving as au pairs while attending school. Before her years in the White House Mary had no trained servants, and her impulsiveness and high temper were frequently displayed in her dealings with women who were not as efficient and faithful as the slaves of her Kentucky days. She could do things better herself, and did—earning a considerable reputation as a successful hostess and frugal housewife who was not above bargaining for lower prices.*
>
> *Like so much in the private life of the Lincolns, Mary's role as a housewife has been removed from the social history of the times. In fact, the relations of middle-class mistresses and untrained country girls resonated with conflict, and most of the manuals of the period emphasized the necessity of lowered expectations among employers who hired young women who did not intend to spend their lives in someone else's home. Moreover, as standards of elegance rose in Victorian America, the Mary Lincolns of the nation expected ladies' maids and got instead hired hands.*[6]

This chapter and the next one will examine the Lincoln family's foreign-born and African American neighbors and servants.

Foreign Born

In 1850, Springfield's population was 4,533. Of those residents, 816, or 18 percent of the total population, were foreign born. The foreign born included 255 Irish (5.6 percent of the total population) and 204 German (4.5 percent of the total population).

Between 1850 and 1860, Springfield's population doubled from 4,533 to 9,320, and its foreign-born population exploded from 816 to 3,140, an increase of 2,324 or 284.8 percent. Those 3,140 foreign-born residents were born in twenty-four countries outside of the United States and constituted 33.7 percent of the total Springfield population. In those ten years, Springfield had grown into a small city of great population diversity. The Lincoln Home neighborhood shared this rapid influx of foreign born as neighbors, servants and friends.

The following is a list of the 1860 foreign born by total population and percentage from each country:

	Population	% of All Foreign Born
Ireland	1,266	40.32%
Germany	1,059	33.73%
Madeira	268	8.54%
England	256	8.15%
Scotland	62	1.97%
Canada	59	1.88%
Norway	43	1.37%
France	39	1.24%
Switzerland	33	1.05%
Nassau	19	0.61%
Austria	9	0.29%
Holland	5	0.16%
Portugal	4	0.13%
Sweden	4	0.13%
Luxembourg	3	0.10%
Trinidad	2	0.06%
Wales	2	0.06%
Bermuda	1	0.03%
Gibraltar	1	0.03%

	POPULATION	% OF ALL FOREIGN BORN
East India	1	0.03%
Italy	1	0.03%
Russia	1	0.03%
South America	1	0.03%
West Indies	1	0.03%
Total	3,140	100.00%

The remainder of this chapter will explore the foreign-born neighbors of the Lincoln family—the Irish, Germans, Portuguese, English, Scottish and French.

Irish Neighbors and Servants

The coming of the Irish created not just a vague line of demarcation but a yawning chasm, one which their Catholic religion and their adamant loyalty to the Democratic party helped to widen. The Irish came with the railroads; they dug the roadbeds and laid the tracks for these symbols of progress that brought new trade and wealth...Most of these Irishmen were in their twenties, and most were either single or had left their wives back East as they worked for a season on the roads. They were distinguished even among the foreign-born for their poverty, their lack of job skills, and their low level of persistence in the community.[7]

In 1850, Springfield had a population of 4,533. Of that population, 255, or 5.6 percent of the total population, were born in Ireland.

Between 1850 and 1860, the Springfield population almost doubled, increasing from 4,533 to 9,320. Of those 9,320 residents, 1,266, or 13.6 percent of the total Springfield population, were born in Ireland. The increase in Irish-born residents between 1850 and 1860 was 1,011, or 396.5 percent.

The Springfield newspapers reported that the Irish residents celebrated the festival known as St. Patrick's Day, a Springfield custom that is continued even today. The *Springfield Journal* of Friday, March 17, 1854, reported:

To-day is the Festival known as St. Patrick's day. We see the R.c.B. Society out in their gala dress in procession, marching to the music of the Temperance Band, which does, indeed, discourse excellent music. This evening the Society dines at the Planter's Hotel, whereof, probably, we shall have more to say hereafter.[8]

On Saturday, March 17, 1860, the *Register* reported:

> *St. Patrick's Day.*
> *Our Irish citizens intend celebrating this anniversary in a style in every*
> *respect worthy of the occasion. The Catholic Institute will form a*
> *procession, and march through the principal streets of the city. At night a*
> *grand festival will come off at Concert Hall, with which the exercise of the*
> *day will be closed.*
> *Tickets may be had at Myer's and also at Hickey's*[9]

Irish Families Living in the Lincoln Neighborhood

In 1860, there were at least twelve Irish families living within a three-block radius of the Lincoln Home. Those twelve families had a total of sixty family members living with them. These sixty constituted 4.74 percent of Springfield's 1860 Irish population of 1,266. For a list of the twelve Irish families, see Appendix A.

The best example of the neighborly Irish family in the Lincoln neighborhood was that of Henry Carrigan, who lived on Eighth Street between Market and Jackson, next door and to the north of the Lincoln Home. Henry, who was fifty years old, and his wife, Susan, were both born in Ireland. Their twelve-year-old son, Henry, was born in Illinois.[10] Also living with this family was an older son, Hugh Carrigan, a twenty-four-year-old Irish-born livery stable operator at Moran & Carrigan Boarding.[11]

Irish Servants Living in the Lincoln Neighborhood

In 1860, there were at least thirty-three Irish domestic servants living with the families they served within a three-block radius of the Lincoln Home. For a list of those thirty-three Irish servants, see Appendix B.

> *Live-in domestics in the Lincoln home would have had their quarters in*
> *the east wing garret, over the original large Dresser kitchen retained by the*
> *Lincolns from 1844 until their 1856 remodeling, after which they occupied*
> *the maid's room, located at the head of the kitchen stair.*[12]

Over the years, the Lincolns had at least three Irish domestic servants living in their home.

In the 1850 census, Catherine Gordon, an eighteen-year-old woman from Ireland, was listed as a servant in the Lincoln Home:

The state census of 1855 indicates that a female between the ages of ten and twenty slept at the Lincolns'. Most likely, this was the feckless Catherine, who inspired Mary Lincoln's comment to her half sister Emilie, as quoted in Jean Baker's *Mary Todd Lincoln, A Biography*: "If some of you Kentuckians, had to deal with 'the wild Irish,' as we housekeepers are sometimes called upon to do, the south would certainly elect Mr. Fillmore [the anti-Catholic, anti-immigrant Know-Nothing presidential candidate] next time." And it was probably Catherine who left her window open at night in order to entertain her boyfriends.

Mary Fagan, a young Irish girl, remembered that she was taken out of school and worked for the Lincolns for a week when she was eight years old, and during that time, she saw jelly, pig feet and celery for the first time in her life.

In 1860, Mary Johnson, a woman of Irish descent, was listed as a servant living in the Lincoln Home.

German Neighbors and Servants

During the 1850s, Germans immigrated to the United States by the hundreds of thousands. They came by steerage passage across the Atlantic and into the Gulf of Mexico to New Orleans. Paddle-wheel steamers carried them up the Mississippi to St. Louis. Many stopped there.

Others, lured by promising descriptions of the Upper Mississippi Valley, cheap land and friends and family who had preceded them, continued up the Illinois River to Beardstown or Meredosia and then cross country by foot, wagon, stage and, later, train to the Sangamo Country and Springfield. By 1860, there were more than 1.2 million German-born people living in the United States, and during the Civil War, they would make up about 1 soldier in 10 in the Union army.

In 1850, Springfield had a population of 4,533. Of the total population, 204, or 4.5 percent, were born in Germany.

Between 1850 and 1860, Springfield's population almost doubled, from 4,533 to 9,320. Of the 9,320 in 1860, 1,059, or 11.4 percent, were born in

Germany. The increase in German population between 1850 and 1860 was 855, or 419 percent.

These Springfield German-born immigrants were a significant part of Springfield life and the Lincoln neighborhood in 1860. They played a key role in Lincoln's political life and his 1860 campaign for president. In 1860, there were at least forty-five German-born persons living within a three-block radius of the Lincoln Home. These forty-five constituted 4.25 percent of Springfield's 1860 German-born population of 1,059.

On May 30, 1859, Lincoln, being aware of the importance of the German vote in elections, purchased through his friend Jacob Bunn the type and other equipment of the *Illinois Staats-Anzeiger,* a German-language newspaper recently established in Springfield. He paid Springfield German Theodore Canisius $400 and offered him the position of editor as long as he supported the Republican Party platform:

> *Immigrants of the nineteenth century had generally shunned slavery and the South where it was prevalent. While there was no particular fondness for African Americans as such, Germans were appalled by "the peculiar Institution—slavery" and could not reconcile its existence with the lofty ideals of America.*
>
> *This predilection, however, did not mean that the Germans were abolitionists. Few were. There was a group known as the Forty-Eighters who made emancipation their own cause. They had been immigrated to the United States after participating in the unsuccessful European Revolutions of 1848. A man named Carl Schurz of Watertown, Wisconsin was one of them.[13] Many formerly German Democratic stalwarts joined in this new movement. Gustav Koerner, Lieutenant Governor of Illinois, was another one of those men. In 1860, the Republican party and in particular Abraham Lincoln were well aware of the crucial importance of the German vote in many localities. The Forty-Eighters followed Abraham Lincoln after he endorsed a liberal homestead law and an anti-nativist "Dutch plank."[14]*

German Families Living in the Lincoln Neighborhood

In 1860, nineteen families with a German head of household, at least fifty-five persons, lived within a three-block radius of the Lincoln Home. For a list of these families, see Appendix C.

One of those German families was headed by John Bressmer, who was born on June 8, 1833, in Wurtenburg, Germany. In 1848, John's father and mother sailed from Havre with seven children and landed at New Orleans sixty days later. John came up the Mississippi River to St. Louis, Missouri, and then up the Illinois River to Pekin, Illinois, which he reached on July 4, 1848. He then went cross country by wagon to Mt. Pulaski, Illinois. In 1860, John was in Springfield as a clerk at the Hurst and Matheny store, and he lived at 77 South Ninth Street, between Jackson and Edwards.[15]

Since July, 1848, John Bressmer has been a resident of Springfield and his first wages were earned in grading the street in front of the residence of Abraham Lincoln. While thus employed he often watched Lincoln go to and from his home and says that he learned to love the man even before he was able to converse with him, for at that time Mr. Bressmer could speak nothing but the German language. It followed as a natural sequence that he supported him by his ballot when his hero became a candidate for the presidency.[16]

Henry Remann, another German immigrant, born in Saxony, was a good friend and neighbor of the Lincolns until his untimely death in 1849. His sister, Julia Sprigg, also born in Germany, moved into the Lincoln neighborhood when she became a widow. She remained a friend of Mary Lincoln until her death.

German Servants Living in the Lincoln Neighborhood

In 1860, there were at least nine German servants living with the families they served within a three-block radius of the Lincoln Home. For a list of those nine German servants, see Appendix D.

German Servant in the Lincoln Home

It appears that the Lincolns had only one German servant living in their home over the years. The appearance comes from the account of John G. Weilein, although some have doubted his story of service to the Lincolns. Here is Weilein's story.

John G. Weilein was born in Bavaria, Germany, on September 27, 1841. After the death of his father, the family came to America. They first lived in

New York City and later moved to Buffalo, New York. At age fourteen, John accompanied his mother to Aurora, Illinois.[17]

In 1858, Weilein and three of his friends decided to work their way down the Mississippi River cutting timber and digging ditches. They eventually reached Lake Province, Louisiana, and were hired to dig a ditch on a plantation near Berry's Landing that belonged to Jefferson Davis.

On the way back north, the group split up. Upon reaching Springfield, Illinois, Weilein and a friend needed more money to reach home. On May 5, 1859, Weilein stopped at a house where a man was sitting on the porch sunning himself. Weilein asked for something to eat. The man on the porch took them in and had a good meal prepared for them. The man was Abraham Lincoln. He refused pay for the meal but offered work around the house to one of them. Weilein took the job for ten dollars per month, board and washing and worked for the Lincolns until the late fall of 1859, when he returned home.

Although a "hired hand," he always ate with the Lincoln family. On the day of his arrival, Lincoln turned him over to Mrs. Lincoln, and his first work was operating a washing machine. His duties from then on were of a general nature. He did chores about the house, fed stock, milked the cows, chopped wood and tended the garden. He often assisted Lincoln in splitting jack oak into fence posts and rails, which occupation later was to make Lincoln known throughout the world as the "rail-splitter from Illinois."

In late October 1859, Weilein left the employ and home of Lincoln and returned to his home in Aurora. He received in settlement for his services fifty-five dollars and a ten-dollar gold piece as a present for faithful service.

In his later years, Weilein was fond of telling of his experiences in the Lincoln Home, and one of the treasures he kept for more than a half century was a photograph of Lincoln. He stated that Lincoln was a great lover of flowers and wildlife.

It is interesting to note that he also worked a number of weeks' employment under Jeff Davis, who later was president of the Southern confederacy. This was in the winter of 1858–59, before there was any thought that these men would be the heads of the two great sections of the country in a deadly civil war.[18]

Some of Weilein's reminiscences ring true. He probably did work for the Lincolns, but some remembrances beyond that verge on being preposterous. I offer his story for your review and judgment and withhold my own regarding his specific recollections.

Portuguese Neighbors and Servants

In November 1849, 130 Portuguese came to Springfield from the island of Madeira, Portugal, to escape religious persecution.[19] They were Protestant, having been converted by a Scottish Presbyterian missionary. The number of converts grew large enough to cause the Catholic leaders of the island to repress any further growth of Protestantism. As the persecutions continued and intensified, Protestant Portuguese fled to the island of Trinidad in the Caribbean.

After an unhappy year in Trinidad, the Madeira refugees accepted an offer from the American Hemp Company to colonize a small agricultural community east of Jacksonville, Illinois. There, it was promised, they would be employed at fair wages and given ten acres of land for homes and gardens. The company reneged on this offer after the exiles were already en route to Illinois. Presbyterians in Jacksonville and Springfield rallied behind a plan to bring the Portuguese into their communities.[20] The Portuguese came to both towns, and the immigration continued during the years from 1849 to 1855. They were Lincoln's friends, neighbors and servants.

In 1860, at least three persons born in Portugal, 0.75 percent of Springfield's 1860 Portuguese-born population of 268, lived within a three-block radius of the Lincoln Home.

Portuguese Servants Living in Lincoln's Neighborhood

In 1860, there were at least three Portuguese servants living with the families they served within a three-block radius of the Lincoln Home. Those three Portuguese servants were:

Teresa Evellan, a seventeen-year-old domestic servant who was born in Portugal and lived in the household of William King at the northeast corner of Ninth and Cook Streets.[21]

Mary Nunes, a female native of Portugal, was a servant at the Martin Van B. Hickox residence at the northwest corner of Seventh and Cook Streets.

M.J. Tellestim, an eighteen-year-old female native of Portugal, was a servant at the John A. McClernand residence at the northwest corner of Edwards and Seventh Streets.[22]

Portuguese Servants in the Lincolns' Home

At other times she [Mary Lincoln] depended on Springfield's minorities. In 1849 a group of religious exiles from Portugal had settled in the community, and its wives and daughters were soon at work in low-paying domestic jobs. Mary Lincoln had a long relationship with one of these women, to whom she entrusted the dreaded Monday chore of washing and ironing. Later this woman described Mary Lincoln as "taking no sassy talk but if you are good to her, she is good to you and a friend to you."[23]

Emanual and Justina Martin Decrastos lived at 1407 East Adams, about a half mile north and east of the Lincoln Home neighborhood. Justina did laundry for the Lincolns during at least the later part of the 1850s. Their daughter, Lizzie, was born on August 21, 1856, and has many memories of Abraham Lincoln.

Lizzie's earliest recollection of Mr. Lincoln was in 1859, when Lizzie's father died as the result of being kicked by one of his farm mules. Abraham and Mary called on the Decrastos family at their home to offer condolences. Lizzie would have been about three years old at this time.

As a child, Lizzie was called Betty by Mary Lincoln and nicknamed "Firecracker" by Abraham Lincoln. The latter name came about as a result of a Fourth of July prank that occurred in Adams Street. Accounts of that incident as well as others follow:

She was dared by her brother Samuel, to put on his straw hat, in the ribbon or band of which he had stuck many firecrackers, and then let him touch them off. Lizzie dared, with startling and even alarming results. In the midst of the explosion of firecrackers Abe Lincoln came up and rescued her from the flaming headgear by knocking the hat off with his cane at the same time catching Samuel, raising him in mid air and holding him up by his suspenders. Abe said, "You might have burned little Betty to death, Samuel." As Mrs. Decrastos approached, Abe, reassured her saying, "Don't worry. I wrenched the hat from Betty before any harm was done." Thereupon Mrs. DeCrastos, seized the two boys, and was about to spank them when Abe interceded with the plea, "They probably did not realize the danger of their act." "She's safe— the little living firecracker," he added, pointing to the very frightened little girl. And thereafter even in the White House, he always addressed her by this name.

Lizzie also recalled most vividly when she used to go calling with her mother at the Lincoln home and Abe would give her a ride on his knee. These were what Abe called "Hossy" rides. They were not exactly a ride on the knee, for Betty was such a tiny tot that he would let her straddle his foot, and holding both her hands, give her an exciting bouncing up and down ride. And he had a bit of poetry he would chant as the imaginary horse proceeded on its way.

Trotting her gently on his leg and feet he would say, "This is the way the lady rides-"Nim-Nim-Nim!" Then increasing his motion, "This is the way the gentleman rides Brim-Brim-Brim!" Then "This is the way the countryman rides Giddy-up-Giddy-up-Giddy-up!" and this last one would be a wild, reckless ride, causing the little girl to utter shrieks of delight.

Abe often carried Lizzie piggy back down to the school and once on a fine winter day after a fresh snow fell some boys were busy tossing snow balls when one by chance missed Betty and knocked off Abe's tall hat, which ended in a free for all snowball battle by children, store keepers and just passers by.

Lizzie went on one occasion with her mother to the Lincoln home, and as they approached the house a rear door suddenly opened, and Abe came rushing out unceremoniously. Mrs. Lincoln was following him in an angry mood, and showering her wrath on her husband in the form of "very poorly pitched potatoes."

Lizzie recalled Abe as being "a big kindly man who had big soft eyes and he always had something nice to say to me and when I visited Mrs. Lincoln, at the White House, he called me aside and would inquire as to my health and that of my Family."[24]

Frances Affonsa De Freitas was a live-in domestic in the Lincoln Home for some time during the period from November 1849 to February 1861.[25]

Frances Affonsa, the black-eyed Portuguese woman who used to do the family washing for the Lincolns, had stayed on and become the regular cook. Her man, Manuel deFraita, who said he would sometime take her for a bride, used to come to see her. They often had supper together in the kitchen, looking off in the direction of the Great Western depot.

From May until August 1860, Charlotte Rodrigues De Souza was a seamstress for Mary Lincoln. Charlotte was born on the island of Maderia, Portugal. She and her family and three hundred others left Maderia and landed

at Trinidad in the West Indies. She remained there for several years before coming to America and Illinois in 1849 at age six. Charlotte; her father, Joseph Rodrigues, a carpenter; two sisters; and her brother settled in Waverly, Illinois.[26]

Charlotte worked on dresses that Mary Lincoln wore while entertaining guests during Lincoln's candidacy and while he was president-elect. While working for Mary Lincoln, she would arrive at the Lincoln Home at seven o'clock in the morning and remain until six o'clock in the evening. She is said to have eaten her noonday dinner with them and frequently a late breakfast.

In 1860, Charlotte married Manuel De Souza and lived to the age of ninety-two, dying on August 31, 1932.

Charlotte De Souza's

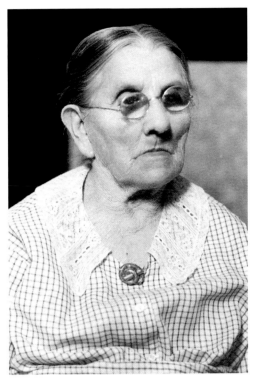

Charlotte Rodrigues De Souza, a seamstress for Mary Lincoln, photographed in Charlotte's old age. *Courtesy of the Sangamon Valley Collection, Lincoln Library, Springfield, Illinois.*

association with Abraham Lincoln was firsthand since, as a girl of twenty years, she spent her days during the months of May, June, July and August sewing at his home. Because these months fell between the time of the president's nomination and election, they were necessarily anxious ones for the family. Willie and Tad were schoolboys of twelve and eight years, respectively. Robert, then a young man, was a university student. "Under the influence of Mrs. De Souza's words, the entire family seemed almost re-embodied, for she knew them all."

"Mrs. Lincoln," she said, "was a nervous, highly-strung Woman who sometimes tried the unusually mild and gentle temperament of her husband. There will never in this world be a finer man than Abraham Lincoln," said Mrs. De Souza warmly. "I believe our people thought him a saint sent from heaven," she continued, referring to her native Portuguese, and her tone

implied that she also held the same opinion. Among the many dresses that Mrs. De Souza made for Mrs. Lincoln was the one she wore on the night of the fatal tragedy at the Ford Theatre in Washington, D.C., which is often seen in the much-produced picture of the president's wife and their son at his bedside. Mrs. De Souza, who knew the man in life, says that few of his pictures resemble him. She recalls him as a more handsome man than his pictures depict:

> *Lincoln did not discuss his business or politics in his home and never had she heard him make a remark about his opponent, Stephan A. Douglas.*
>
> *In that time when all stitches were taken by hand it would have been impossible for one person to have made all...required by Mrs. Lincoln and most of the underclothing was made at home by her mother.*

Remembering the return of Lincoln to his home in the evening, Mrs. De Souza pictured the lanky stride of the great emancipator, who never used his own front door, preferring the one to the rear of the house. On his arm would be a basket heaped with mail, and often he would sit down near the side window behind which she sewed to peruse his letters.

Often Mrs. Lincoln would greet him with an anxious inquiry on the probable outcome of the election.

"Oh, don't worry, Mama. If it is God's will I will be elected," the great man would wearily reply.

Never, it seemed, did this man forget God. Once, Mrs. De Souza heard someone ask him what he would do with the slaves when he had freed them. "With the help of God I will see to that," he responded with a large, unruffled faith. "He was one of the kindest and most pleasant creatures ever put into this world," continued Mrs. De Souza, with a respect very near worship.

"I have heard him tell poor people to go ahead and build their house—he would see that it was paid for. I know he gave his cook the money for her wedding dress. "Ah, but they were poor," his former seamstress resumed, then including his entire family. "They never had much, and he was always giving."

Then Mrs. De Souza described some of the things she made for them, the stiff-bosomed shirts for Mr. Lincoln, the endless fine linen underclothes, the ruffled petticoats and hoop skirts for his wife, who was preparing for her possible future in Washington.

Mrs. De Souza humorously remarked that if she had foreseen the great interest later evidenced in all things connected with the president, she would surely have saved many scraps from them.

The following newspaper article was written by J. Emil Smith, at the time an editor of the Springfield newspaper the *Illinois State Journal*:

> *Mrs. DeSouza made Mrs. Lincoln's inaugural clothes. They consisted of four silk dresses, and several French calico ones. It was with great reluctance that she said any more about the Lincolns.*
>
> *"My husband's second cousin was their hired girl and when she was to be married, Mr. Lincoln gave her enough money to buy a wedding dress. And when she died she was buried in that same dress. He was awfully good."*

As to Mrs. Lincoln, she remarked briefly, "We always got along very nicely together."[27]

Lincoln Loans Money to a Portuguese Woman

Abraham Lincoln made two small loans to Rita Angelica da Silva, a Portuguese woman. On August 11, 1854, Rita borrowed $125 from Lincoln and gave him her promissory note for $125 with interest at 10 percent, payable annually, the principal to be paid four years after that date. To secure the loan, Rita executed a mortgage on real estate described as Lot 5, Block 6, in Welles and Peck's Addition to Springfield. This forty-foot lot on the south side of Miller Street between Ninth and Tenth Streets, was in the neighborhood occupied by the Portuguese who settled in Springfield in 1849. Six months later, on February 20, 1855, Rita borrowed a second $125 on the same terms as the first loan, executing a second mortgage to the same property. Lincoln released the first mortgage on November 26, 1858, and the second on June 9, 1860.[28]

English and Scottish Neighbors and Servants

In 1860, Springfield's population included 318 persons born in England/Scotland, constituting 5.9 percent of Springfield's total population. At least 19 of the 318 English/Scottish-born lived within a three-block radius of the Lincoln Home. Close neighbor Charles Dallman was one of them. For a list of the 19 English and Scottish families, see Appendix E.

English Servants Living in the Lincoln Neighborhood

Thomas Howard was a twenty-six-year-old English-born servant living in the Dr. John Todd House on the east side of South Sixth Street between Monroe and Market (Capitol) Streets.[29]

R.A. White was an English-born servant living in the Jesse Kilgore Dubois House on the west side of South Eighth Street between Jackson and Edwards Streets.[30]

French Neighbors Living in the Lincoln Neighborhood

John (J.B.T.) Corneau, a seventy-nine-year-old gentleman born in France, was living with Stephen A. Corneau[31] at 91 South Sixth Street between Market (Capitol) and Jackson Streets.

Jesse Dubois, a close friend and neighbor, was of French-Canadian parentage.

Conclusion

Springfield is my home, and there, more than elsewhere, are my life-long friends.
—Abraham Lincoln, June 1863[32]

During the time the Lincoln family lived at Eighth and Jackson, their neighborhood and, indeed, Springfield became a melting pot of diverse ethnic and cultural milieus. Languages, dialects, food, trades and skills, religion, race, ethnicity, holidays and customs from African Americans and first-generation Western Europeans were thrown into the pot. Lincoln thrived on this diversity and welcomed people of all nationalities and races into his neighborhood and his life.

If New Salem was his college, then Springfield was his university, where he was exposed to this diversity of humanity. Lincoln did not resist the exposure; rather, he nurtured the melting pot. His knowledge of the diverse customs and practices of his neighbors helped him to understand and embrace the unique historical phenomena of a diverse America. These people were his neighbors.

A NEIGHBORHOOD OF DIVERSITY—AFRICAN AMERICANS

*The Shackels have fallen, and Bondmen have become freeman to Some extent
already under your Proclamation. And I hope ere long, it may be universal in all
the Slave States...and for that reason, I hope and trust, that you may be chosen
for a Second term to Administer the affairs of this Government.
And When these troubles Shall end, the Nation will rejoice, the Oppressed
will Shout the name of their deliverer, and Generations to Come, will rise up
and call you blessed.*[1]
—*William Florville to Abraham Lincoln, December 27, 1863* [Florville was
a Haitian who settled in Springfield and was Lincoln's barber]

On December 27, 1863, Springfield African American William
Florville, Abraham Lincoln's close friend and barber, wrote a letter
to President Lincoln. Florville praised Lincoln for freeing the slaves and
extended his belated condolences to the Lincoln family following the death
of William "Willie" Lincoln. Florville reported that his son, William Jr., had
married. Lincoln would have known William Jr., as well as his bride, Nancy
Jenkins, the daughter of Jameson and Elizabeth Jenkins, who lived just a
half block south of the Lincoln Home. They had been neighbors for years.
While the Lincoln family probably gave little, if any, thought to their living
in an integrated neighborhood, present-day demographers would quickly
conclude that they did.

Lincoln's African American Neighbors

In 1850, Springfield's 5,106 residents included 146 African Americans.[2] At least 20 of those African Americans lived as four families within a three-block radius of Mary and Abraham Lincoln's home at the northeast corner of Eighth and Jackson Streets. The frontispiece map shows the location of the Lincoln Home and those of the four families.[3]

Ten years later, in 1860, the Springfield African American population had grown to 290, an increase of 144, or 99 percent, from the 1850 population. At least 21 of those 290, about 10 percent of Springfield's African American population, lived within a three-block radius of the Lincoln Home. Of those 21, 18 lived as three African American families, and 3 worked as live-in domestic servants in white households.[4]

Two of the African American families, the John Jackson and the David King families, lived two blocks to the southeast of the Lincoln Home in both the 1850 and 1860 censuses.

John Jackson Family

In 1850, John Jackson, a forty-five-year-old cook and Virginia native, lived at 85 South Ninth Street on the east side of Ninth between Edwards and Cook. Living with John was his forty-year-old wife, Matilda, a Kentucky native. John and Matilda's four children wat the ere also living with them: Henrietta, age nine; Edward, age five; Georgeanna, age three; and Josephine, age two, all born in Illinois. John was listed as having real estate worth $1,000.[5]

Ten years later, in 1860, John was still living at this location. He was listed in the census as a fifty-year-old whitewasher. Also living with the Jackson family was Diana Tyler, an eighty-year-old Virginia native.[6]

John Jackson next obtained the job of cleaning the chamber pots in the basement of the State House. He also whitewashed the latrine walls. His services had begun by 1859.[7]

David King Family

In 1850, David King, a twenty-two-year-old mulatto barber and Virginia native, lived at 91 South Ninth Street, at the northeast corner of Cook and Ninth Streets. David lived with his twenty-five-year-old wife, Mary, who was born in Tennessee, and their son, Benjamin, age two, and daughter, Mary E., age two months, both listed as mulatto and born in Illinois.[8]

Ten years later, in 1860, David was still living at this location. He was listed in the census as residing with his wife, Mary, and their children: Elizabeth A., age ten; James, age nine; Virginia, age five; and seven-month-old John, all born in Illinois. David was listed as having real estate valued at $2,000.[9]

The Jenkins and Blanks Families

The other two African American families lived a half block south of the Lincoln Home. One was the Jameson Jenkins family and the other was the James Blanks family.

In the 1830s, Jameson and James migrated to Indiana from the South—Jenkins from North Carolina and Blanks from Virginia. Even though they were "free persons of color," their travel in the South would have been fraught with risk and terror were it not for the assistance of a religious group called the Society of Friends or Quakers. Most North Carolina Quakers opposed slavery. Some actively assisted African Americans in escaping that condition by providing room and board to runaway slaves and free people of color. African Americans would gather and wait in friendly North Carolina Quaker communities for the right time to migrate north to freedom. Some Quakers moved from North Carolina to southern Ohio and Indiana, where they established Quaker communities and assisted newly arrived slaves and free people of color. This Quaker assistance was the beginning of what came to be called the Underground Railroad, and Jameson and James were beneficiaries of that assistance on their travels north from Southern homes to a new life in Indiana.

In Indiana, Jenkins and Blanks lived for a short time in Beech Settlement, a self-sufficient African American farming community in east-central Indiana. There they married sisters, Elizabeth and Nancy Pellum, the daughters of African American Jane Pellum,[10] who would later become a servant at the Lincoln Home. Beech Settlement was important in the mid-nineteenth-century

history of midwestern African Americans—a part of the development of a number of African American agricultural settlements in Ohio, Indiana and Illinois. Later, in the 1840s, both Jameson and James and their families moved to Springfield, Illinois, where they became close neighbors of the Lincoln family.

In 1850, the Jenkins and Blanks families were living at the same location, a half block south of the Lincoln Home. They may have been living in two separate residences located on the same lot.[11] The presence of these two African American families as close neighbors of Abraham Lincoln gives us a sharp personal glimpse into Springfield and Abraham Lincoln's African American neighbors that might otherwise be abstract and remote. The Jenkins and Blanks families are the best examples of the diverse and interesting Springfield African Americans who knew and lived near Abraham Lincoln.

Tom Wood, in his unpublished paper (2014) on his relatives, includes this little story that must be referring to Jameson Jenkins:

> *During Mrs. Wood's residence in Springfield, she lived in the same block with Abraham Lincoln and she was acquainted with the martyr president...Mrs. Wood frequently told of an incident in the life of the president that is interesting. A relative was ill and the physician prescribed oak bark as the remedy. Mrs. Wood visited the neighbors in the hope of securing some oak bark but was unsuccessful and finally went to the home of the Lincolns. Mr. Lincoln accompanied her to the home of an old Negro across the street where with an axe he peeled off more than enough bark.*[12]

Jameson Jenkins Family

In 1844, Jameson Jenkins and his family arrived in Springfield, and in 1848, they moved to a house on the east side of Eighth Street, between Jackson and Edwards, just half a block south of the Lincoln Home. The 1850 Springfield census listed "Jimison" Jenkins as a forty-year-old mulatto who was born in North Carolina. He was residing with his wife, Elizabeth A., a forty-three-year-old mulatto who was born in Virginia, and their daughter, Nancy H., a six-year-old mulatto who was born in Indiana. Jameson's occupation was listed as drayman, one with a heavy cart or wagon used for hauling for hire. This would be the modern equivalent of a delivery truck driver. Jameson owned real estate having a value of $300.[13]

Also living in the Jenkins household were Elizabeth's two mulatto daughters by her first marriage, seventeen-year-old Jane Watkins, who

was born in Virginia, and twelve-year-old Aquilla (Quilly) Ann Watkins, who was born in Indiana.[14]

The 1860 census for Springfield listed Jameson "Jarkins," as a fifty-year-old mulatto drayman who was born in North Carolina. Residing with Jameson were his wife, Elizabeth, a forty-five-year-old mulatto who was born in Virginia, and their daughter, Nancy H., a sixteen-year old mulatto who was born in Indiana in 1844 and whose occupation was "washerwoman." Elizabeth Jenkins owned real estate having a value of $800[15] and personal property having a value of $45. Jameson had no assets.[16] Also living in the Jenkins household was "Quintian" (Aquilla Ann) Watkins, a twenty-year-old mulatto who was born in Indiana.[17] The Jenkins family had lived as the Lincolns' neighbor on the east side of Eighth Street, between Jackson and Edwards, since about 1848, a total of twelve years.

In the 1860 census, Elizabeth Jenkins's mother, Jane Pellum, was listed as a separate "head of household," immediately above the listing for Jameson Jenkins. Perhaps there was a small second house on the Jenkins lot where Jane Pellum lived. Jane was a seventy-five-year-old mulatto who was born in Virginia. Aunt Jane, as she was called, was a washerwoman. She owned no real estate and had a personal estate valued at thirty dollars.[18] (For additional information about Jane Pellum, see the entry under her name.)

Jameson Jenkins was one of the few brave souls in Lincoln's Springfield who took enormous personal risks to help runaway slaves move north from Springfield on the Underground Railroad. On the evening of January 16, 1850, Jameson assisted seven runaway slaves move sixty miles north along the Underground Railroad from Springfield to Bloomington. During the week that followed, Springfield's *Journal* and *Register* newspapers printed five confusing and sometimes contradictory reports on the presence of the runaway slaves and called the events that transpired a "slave stampede." It was initially and incorrectly rumored around Springfield that Jameson Jenkins had betrayed the slaves, resulting in their capture.

On January 23, 1850, the *Journal* printed a letter of response from "A Friend to Justice," which stated that the rumor that the runaway slaves had been betrayed by a local African American [Jameson Jenkins] was false, and in fact, the rumor was a ruse "to prevent, and maybe, to save the underground car from being upset or overtaken." Jenkins had in fact gone north by stage to Bloomington with some of the runaway slaves. The affidavit of J.C. Goodhue, stagecoach agent, stated, "This is to certify that Mr. Jenkins left for Bloomington on the 16th day of January, 1850 in the stage." The letter reads as follows:

Messrs, Editors:—In your paper of the 22d inst., there is a communication signed "Justice" which refers to the slave stampede in this neighborhood on the 16ᵗʰ, saying "that it was rumored that a colored person had betrayed the slaves, but, unfortunately, the one they accuse of having done so, started north with a part of the same gang the night before the capture; and this rumor was only to prevent, and maybe, to save the underground car from being upset or overtaken." Now, in order to correct public sentiment in regard to that man's conduct in this matter, I would refer them to the following certificate of the agent of the northern line of stages:

Springfield, January 22, 1850 This is to certify that Mr. Jenkins left for Bloomington on the 16ᵗʰ day of January, 1850, in the stage.

<div align="right">

J.C. Goodhue, agent.

A Friend to "Justice"[19]

</div>

On February 11, 1861, Jameson Jenkins, Underground Railroad conductor, drove president-elect Abraham Lincoln on his last Springfield carriage ride from the Chenery Hotel at the northeast corner of Fourth and Washington Streets to the Great Western Railroad Depot. There Lincoln gave his "Farewell Address," a touching goodbye to his Springfield friends, and began his train trip to Washington and the presidency.[20] Lincoln must have known that his driver and neighbor was also an Underground Railroad conductor.

James Blanks Family

Sometime in 1842, African Americans James and Martha Ann Pellum Blanks moved from the small Indiana African American agricultural community of Beech Settlement to Springfield, Illinois. Just five years earlier, Abraham Lincoln had made a similar move from New Salem to Springfield.

On October 13, 1842, James and Martha Blanks purchased lots at the southwest corner of Ninth and Jackson Streets in Springfield, Illinois.[21] The lots, part of the same subdivision where the Lincoln Home was located, were probably still vacant. Perhaps the Blanks family used them for a garden or as pasture for cows or horses. In 1838, Lincoln had also purchased a vacant lot within a block of the Blanks's property.

In 1844, when Abraham Lincoln purchased his home at Eighth and Jackson, it is most probable that he knew that James and Martha were

the African American owners of these lots that were across the street from his house. James and Martha owned these lots for twelve years, from 1842 until 1854.

On November 13, 1847, James Blanks, age thirty-nine, bought a lot on the east side of South Eighth Street, a half block south of where the Lincoln family had lived for three years.[22] On February 18, 1848, James and Martha Blanks sold the lot to Jameson and Elizabeth Jenkins's daughter, Nancy, for $200.[23] The price would indicate that the lot was not improved.

The 1850 census for Springfield listed James Blanks, a thirty-eight-year-old laborer, and his wife, Martha Ann, who was thirty-five years old. Both were listed as mulattos who were born in Virginia.[24] Also living with James and Martha was Jane Pellum, the mother of Elizabeth Ann Jenkins and Martha Ann Blanks.[25] Bellfield Jenkins (Watkins), a fourteen-year-old mulatto who was born in Indiana, and Lydiann Mason, a thirteen-year-old mulatto born in Indiana, were also living in the Blanks household. Bellfield was the son of Martha Ann Blanks's sister Elizabeth by her first marriage to an unknown Watkins.

On June 14, 1850, James Blanks was one of eight Springfield African American men, the trustees of the "Colored School," who signed a *Journal* newspaper announcement of a public supper to raise money for the "Colored School."

> *Whereas the people of color in this place desirous of educating their children, and finding themselves too weak in point of numbers to sustain a school permanently amongst them, therefore we, the Trustees of this the Colored School, in view of our weakness, propose giving a PUBLIC SUPPER, in aid of this School, on Thursday, the 20th of this month, at the Colored Baptist Church, in this city. We have appointed a committee of females to solicit donations among our white friends towards making the Supper, and we hope that their claims will not be disregarded.[26]*

On Monday, November 8, 1852, Springfield African Americans met and adopted a resolution saying, "We must speak in bold terms." The resolution opposed the Wood River Colored Baptist Association's proposal for separate, state-funded colored schools and stated that they would not ask for state-funded support for separate, colored schools. They asserted:

> *That we, as a portion of the colored population, representing its claims, feel a deep, very deep interest, in our schools, and think it the only sure way to*

redeem ourselves from the bondage we are now in, sympathize with our race, and will do everything that is in our power to educate our children by our exertions, and without the boldness to ask aid from the people of the State.[27]

The resolution was signed by twenty Springfield African American men, one of whom was James Blanks.

African American Servants Living in the Lincoln Neighborhood

In 1860, three female African American domestic servants lived in the homes of their white employers within a three-block radius of the Lincoln Home.

Lucy Butcher, a twenty-six-year-old Virginia native, was a servant at the residence of Isaac A. Hawley at the northwest corner of Ninth and Market (Capitol) Streets.[28]

Rebecca Smith, an eighteen-year-old mulatto, was a servant at the Jacob Bunn residence at the southwest corner of Sixth and Jackson Streets.[29]

Charlotte Sims was a servant at the John A. McClernand residence at the northwest corner of Edwards and Seventh Streets.[30]

African American Servants in the Lincoln Household

Over the years, at least six African American women—Eliza Early, Jane Pellum, Hepsy (Epsy) Arnsby Smith, Ruth Burns Stanton, Ellen Dalton Lyons Tibbs and Mariah Vance—worked in the Lincoln Home.

Eliza Early

Eliza Early claims that she was Robert Lincoln's childhood nurse. Eliza was born in slavery in North Carolina. She was purchased by a brother of Mary Lincoln and acted as Mary's maid at her marriage to Abraham Lincoln. She said that she left the Lincolns after the assassination and came west in a wagon, a claim that is most doubtful. On August 27, 1912, poor Eliza was judged insane by the Will County, Illinois medical commission.[31]

Jane Pellum

Jane Pellum was born in Virginia on August 8, 1787. She was the mother of James Blanks's future wife, Martha Ann, and Jameson Jenkins's future wife, Elizabeth Ann. Jane was most probably a free person of color at birth. In the 1850 census, Jane Pellum was listed as a sixty-two-year-old mulatto who was living with her daughter, Martha, and son-in-law, James Blanks.[32] The *Springfield City Directory (Sangamon County, Illinois) and Sangamon County Advertiser for 1855–1856* listed Jane Pellum as residing at Eighth Street near Edwards. Her occupation was "washing."[33]

In Springfield, Jane was a neighbor and friend of Abraham Lincoln and his family and was fondly known to them as "Aunt Pellum" or "Aunt Jane" or "Aunty Pellum."

In 1886, Margaret Ryan, an Irish live-in servant in the Lincoln household, recollected that "Jane Jenkins [Pellum] colored woman did not live there [at Lincoln's home]—in next block…"[34]

In 1856, Jane Pellum was a member of Springfield's First Methodist Church, where she was assigned the back seat on the north side of the church. The church also provided a load of wood for her. Two histories of the First Methodist Church give the following accounts of Aunt Pellum:

> *The back seat on the north side was given to Aunt Pelham. Shortly thereafter the preacher was directed to purchase a load of wood for her, or else pay her $3.00 from the Poor Fund so that she might buy her own.*[35]

> *There were several sisters who were a great help in the church…efficient workers for the Savior, and always ready for every good word and work. There was a colored sister too who was a very devote [sic] Christian, Aunty Pelham. She was a woman of strong faith, always in her place in the sanctuary when her infirmities would permit, and though very poor and a great suffering, bearing all without a murmur.*[36]

In the 1860 census, Jane Pellum was listed as a seventy-five-year-old mulatto washerwoman boarding with her daughter, Elizabeth, and son-in-law, Jameson Jenkins, a half block south of the Lincoln Home.[37]

I have heard a story, perhaps apocryphal, that a family living on Second Street was in the parlor one evening when they heard very loud conversation in front of their house. The lady of the house opened the front door and went out onto the porch, where she could see Abraham

Lincoln and Aunt Jane Pellum walking down the street together engaged in very loud conversation. She came back inside and told her family what she saw and added, "Why of course it makes sense that they would talk so loudly. Aunt Jane is almost deaf!"

Ruth Burns Stanton

"Aunt" Ruth Burns Stanton, an African American woman, worked and lived in the Lincoln household in the year after Abraham Lincoln returned from his term in Congress—1848–49. Ruth was born in about 1835 and would have been about thirteen or fourteen during the year she worked for the Lincolns.[38] In an 1894 reminiscence published in a St. Louis newspaper, Ruth remembered the following about the Lincolns:

The Lincolns were poor then and lived in a frame house with six rooms. Mrs. Lincoln belonged to the Episcopal church and so did the [John] Bradfords. I used to take the Bradford children to Sunday School, and on the way we would sometimes see Mr. Robert Lincoln, who was only five years old [1848]. He was going to Sunday School too, and the Bradford children would say, "Oh, Ruth, there's that Bobby Lincoln with his patched pants. Let's go the other way, so we won't meet him." Then we would go by a roundabout way to church to get away from Bobby Lincoln because he used to wear blue jean pants which his mother made for him and patched when he wore a hole in them.

After awhile, Mrs. Bradford sent me over to help Mrs. Lincoln every Saturday, for she had no servant and had to do her own housework. Then Mrs. Bradford sent me to live with the Lincolns.

I scrubbed the floors and waited on the table and helped Mrs. Lincoln to clean the dishes and do the washing. She did all the up stairs work, made clothes for the boys, Robert and Willie,[39] and cooked the meals. Mr. Lincoln was a very good and kind man, but I don't remember anything particular about him, for I was very young. He was a very tall man. That's all I can remember of him. He used to be at his office all the day long, and I did not see much of him, but I never expected to see him president of the United States.

Mrs. Lincoln was a very nice lady. She worked hard and was a good church member. Every Thursday the sewing society of the Episcopal church would meet at Mrs. Lincoln's house and make clothes for the very poor people. She was

very plain in her ways, and I remember that she used to go to church wearing a cheap calico dress and a sunbonnet. She didn't have silk or satin dresses. The children, Robert, 5 years old (1848), and Willie, a few years younger, were very good boys. I used to take care of them, for they were too small to go to school. We would play around the streets of Springfield, and the white children would throw stones at the colored children.

I was as bad as any of the white children at throwing, because I lived so much with white people I thought I was white. Sometimes Mrs. Lincoln would catch me and the boys throwing at colored children, then she would call "Ruth!" "Mam," I would say. "What are you throwing at those children for, aren't you colored?" "Yes, mam, but I am not black like them!"

After I left, Mrs. Lincoln had to do all of her own housework, for she could not afford to get another servant. I have never seen any of the family since, but of course I have heard a great deal about them. I guess that Mr. Robert Lincoln does not remember when he used to wear patched jeans pants since he has become a big man.[40]

Hepsy (Epsy) Arnsby Smith

Hepsy (Epsy) Arnsby Smith was a domestic servant in the Lincoln Home. Her association with the Lincoln family undoubtedly accounts for this lengthy obituary that appeared in Springfield's *Illinois State Journal* on Tuesday, May 10, 1892:[41]

SHE WORKED FOR LINCOLN
Death of a Negress Who Knew Much About Father Abraham. Aunt Epsy Smith Passes Away in a Ricketty Tenement House in Chicago—Her Eventful History.

It was in one of the dilapidated old frame tenement houses on Dearborn St. near Sixteenth, Chicago, where the rattle and roar of constantly passing trains never cease, and where such a thing as a garbage cart or street sweeper is unknown, that "Aunt" Epsy Smith died. It was near 1 o'clock Sunday morning that she breathed her last. She was of African descent and unknown, so to speak, in the great metropolis, but she had an eventful life—one of almost historic interest.

Away back in 1827 she was a protege of Ninian Edwards, at the time governor of Illinois. She was present at the wedding of Abraham and Mary

Todd, and after the wedding was a servant in Lincoln's home. She nursed Robert T. Lincoln, the present minister to the court of St. James, when he was a baby. Her death was caused by the grip, from which she had been suffering since last March. Her exact age is not known, for she was born a slave and no record of birth was made. But as near as could be told she was about 72 years old.

Epsy Arnsby Smith was her name in full and she was born on the plantation of Arnold Spear, near Shelbyville, Ky. The Spears were old friends of Ninian Edwards and shortly after his election as governor Mrs. Spears visited the family and brought Epsy, who was at that time 7 or 8 years old, along as a waiting maid. She was bright and active and the governor took a liking to her, and when Mrs. Spears was getting ready to return home, she gave the child to him.

...Mary Todd, Mrs. Edwards' sister, came from Kentucky to live with the governor's family. About this time Abraham Lincoln became a frequent visitor at the governor's mansion and he generally asked for Miss Todd. It was Epsy's duty to answer the call and in after years she used to tell her children and grandchildren how she used to usher "Massa Linkum" into the house when he was "a 'cortin' Mistus Mary."

She witnessed the wedding ceremony when Lincoln was married, and during the first few years of his married life she was his house servant. Then she became engaged to Robert Smith, a colored man living in Vandalia.

Shortly before her wedding she came back to live with the family of Governor Edwards and was married at his house by the minister who performed the ceremony for Lincoln. And the dress she wore on that occasion, a black brocaded silk, was a present from Mr. and Mrs. Lincoln.

Years rolled by: Lincoln was elected president; the war came and the slaves of the south were freed. Among the first negroes to come north was "Aunt" Epsy's father, and the proudest day of his life was when his daughter told him that she had worked for the man who had set him free.

In 1861 her husband died and then she sold her little home and moved to Greenville, where she lived with her daughter Mrs. Julia Barbee, until last March, when she went to Chicago to live with another daughter, Mrs. Catherine Jackson. 1630 Dearborn street. Mrs. Jakie Smith, also her daughter, went with her. She had been there but a few days when she became ill with the grip. Enfeebled by old age she lingered along until Sunday morning, when she was taken with a spasm and died. As there was no physician in attendance at the time of her death the matter was reported to Lieutenant Gallagher of the armory, who notified the coroner.

After relating the story of her mother's life Sunday night Mrs. Smith spoke of the anxiety the poor old "mammie" felt lest she should not be buried by the side of her dead husband in the old graveyard at Vandalia. "But we are too poor to send the body there," she continued, "and I am afraid her dying request cannot be granted. I know if Massa Robert Lincoln were here he would help us. But then he is so far away we can't let him know.

The funeral will be held today from the dingy tenement house where the old woman died.[42]

Ellen Dalton Lyons Tibbs

The tombstone of Ellen Dalton Lyons Tibbs asserts that she was Abraham Lincoln's family nurse. She claims that she accompanied Lincoln's body from the White House to Springfield on the funeral train, a claim that is highly unlikely. A Columbus, Ohio newspaper article describing the dedication of her tombstone on Sunday, April 17, 2011, makes the following statement:

LINCOLN NANNY HONORED
Until yesterday, the grave of the African-American woman who cared for Abraham Lincoln's children was unmarked. Civil War re-enactors and others unveiled a gravestone to honor the Cincinnati native, who first worked for Mary Todd's family in Kentucky. When Todd and Lincoln wed, she signed on as nanny, nurse and housekeeper, moving with them to Springfield, Ill., and then the White House. She later moved to Circleville.[43]

Mariah Vance

Mariah Vance—"Aunt Mariah," as she was called by the Lincolns—was an African American woman who served as cook, laundress, maid and, later, as a general helpmate for the Lincolns from 1850 to 1860. This ten-year period was the longest period that any servant is known to have been employed by the Lincolns in either Springfield or Washington. During her Lincoln service, Mariah would have been thirty-two to forty-one years of age, yet she was called "Aunt Mariah."[44]

Mariah Vance was born Mariah Bartlett, the daughter of Phoebe and George Bartlett. She said that she was born on Round Prairie, four miles east of

A photograph of Mariah Vance (right) with one of her daughters. *From Lincoln's Unknown Private Life: An Oral History by His Black Housekeeper Mariah Vance, 1850–60, Lloyd Ostendorf and Walter Oleksky, editors.*

Springfield, Illinois, on the "second Sunday in October" of the year 1819. Mariah's mother, Phoebe, was the slave of George Chilton, sometimes spelled Shelton.[45] On January 20, 1842, Mariah Bartlett married Henry Vance.

After the death of Eddie Lincoln, Lincoln realized that Mary was not well enough to take care of their house and son Robert. In early April 1850, he visited the Vance home on the north side of west Washington Street, between College and Pasfield, where Mariah lived with her husband, an

escaped slave, and twelve children. Lincoln asked Mariah if she would come to work for the family.[46] Mariah's reminiscences state:

> *I was spec'lating on getting most something to do, after the rainbow promised no more floods, and was about to tell my Henry, when I hear Mistah Abe say after greetings, "I'll come right to the point, Mrs. Vance. I believe you are the lady who did cleaning in my law office a while back. Anyone who could clean those windows so you could see through, really clean scrub that floor, and straighten up and make that office smell fresh, is the kind of woman we would like to do our washing and other household chores.*
>
> *"I's like most for you to come in the morning. I'm going out of town on the circuit for a spell. Mrs. Lincoln will be alone with our son, Robert."*

In her ten years with the family, she grew to understand Mary and have compassion for her:

> *Ma sewed, cooked, sometime wash, nursed them, kept a nice home for them, kept them clean. Took them to shows and church, waited on them when sick and welcome their friends. Even if her wasn't much fun, her never abuse them and did the best in the world for them, as well as herself, as her see it.[47]*
>
> *One day the girl threatened to leave unless she could get $1.50 per week. Mrs. L. Could [—] rather would [—] not give the extra 25 cents; the girl said she would leave. Mrs. L. Said leave. Mr. L. heard the conversation—didn't want the girl to leave—told his wife so—asked—begged her to pay the $1.50. Mrs. L. Remained incorrigible. Mr. L. Slipped around to the back door and said, ["]Don't leave. Tell Mrs. Lincoln you have concluded to stay at $1.25 and I'll pay the odd 25 cents to you["] Mrs. Lincoln overheard the conversation and said to the girl and Mr. L.: ["]What are you doing? I hear some conversation—couldn't understand it—I'm not going to be deceived. Miss[,] you can leave[,] and as for you, Mr. L.[,] I'd be ashamed of myself."[48]*
>
> *And from Springfield's black community she [Mary Lincoln] employed Mariah Vance twice a week for many years, but after two weeks of undercooked potatoes and watery gravy, she fired another black woman in the shrew's voice that resounded across Jackson and up Eighth Streets.[49]*

According to Mariah Vance, she "helped pack the household goods and was given numerous articles as keepsakes, which are scattered now." A porridge set, bowl, saucer and pitcher of "delicate design" were mentioned,

as was a cupboard, which family tradition claimed was given to Mariah as a wedding present.

Mariah moved to Danville, Illinois, after the Lincolns left Springfield. In the late nineteenth century, Robert Lincoln, who was then president of the Pullman Railroad, traveled from Chicago to Danville to speak to a large gathering of Republicans. He was met at the train by local leaders and quickly excused himself and made his way to the two-room cottage of Mariah Vance. There they exchanged stories of the days in Springfield and made arrangements for Robert to come back for supper. When it came time for Robert to speak to the Republican rally, he was nowhere to be found. Someone remembered that he had said something about Aunt Mariah Vance.

Someone quickly went to Mariah's house and brought Robert to the rally. He spoke and thanked everyone for coming. He then returned to Mariah's home and enjoyed the supper that she had prepared for him. It consisted of all of his favorite foods as a young man that had been cooked for him by Mariah. Robert returned to Chicago, and on the following workday, he called in the treasurer of the Pullman Company and instructed him to send a pension check to Maria Vance every month thereafter. He had not forgotten the importance of Mariah in the Lincoln household and made her the only Lincoln maid on the pension rolls of the Pullman Railroad.[50]

One of the most interesting stories revealing the reluctance with which Robert Lincoln accepted public acclaim yet displayed some of the humanitarian traits of his illustrious father is told by "Uncle Joe" Cannon. Mr. Cannon states that Lincoln was prevailed upon to make some speeches in the presidential campaign of 1900, and his last speech of the series—and as far as is known, the last political speech of his life—was made at Danville, Illinois. Robert Lincoln arrived at Danville early in the morning on the day of the speech and registered at the hotel. Soon, a reception was being arranged, but Lincoln objected. Later on, those who visited his room discovered that he was not in the hotel. They found him in the home of an aged Negress, Mrs. Mariah Vance and, according to Congressman Cannon, "enjoying one of the finest meals of corn pone and bacon you ever tasted."

However, it is best to let Mr. Cannon tell the story in his own words:

Mrs. Vance had been cook before the war in the Lincoln household at Springfield and nurse part of the time for young Robert Todd. Lincoln had heard that the

woman was still living there and hunted her up. They had spent several hours together. We hustled him away and to the park, where a great and impatient crowd awaited him. No sooner was his task over than Lincoln returned to the Vance home, humble as it was, and enjoyed more hours of talk with the aged woman, until it was near departure time of his train. That was the last political speech he ever delivered. From that day until her death "Mammy" Vance received a substantial check each month from Chicago.[51]

Mariah's reminiscences have met with many critics who attack them on a variety of issues. None has a thing to do with Mariah; rather, they target those who recorded the oral history of this illiterate woman and eventually transcribed and published her "reminiscences." Mariah suffers, as did Herndon, from being a subject of some skepticism. But it cannot be denied that Mariah was a significant participant in the Lincoln household during an important period of childhood development of the Lincoln boys and the ascendancy of Abraham Lincoln. She was more than a neighbor; she was an important part of the Lincoln family household.

Over the years, at least four African American men—Reverend Henry Brown, Jameson Jenkin, William Johnson and Allison Demery—worked in the Lincoln Home.

Reverend Henry Brown

African American Henry Brown was born in Raleigh, North Carolina, on April 17, 1823. In 1835, he moved to Ohio and, one year later, to Rush County, Indiana, where from 1837 to 1843 he was a farm laborer for a Quaker family. Henry was of immense physical stature, standing six feet, three inches and weighing 250 pounds.

Brown was a great admirer of Abraham Lincoln and served him in various capacities until he went to Washington as president. When Lincoln's body was brought back to Springfield in May 1865, Reverend Henry Brown was sent a telegram requesting that he come from Quincy to Springfield for the Lincoln funeral. He and another local minister, Reverend W.C. Trevan, led Lincoln's old family horse, Bob, in the funeral procession.[52]

Brown studied to become an African Methodist Episcopal Church preacher and was licensed to preach about 1846. He then began an itinerant ministry, walking from town to town. He was often refused meals and lodging because of his race. In 1847, he met his wife to be

in Paris, Illinois. They were married and shortly thereafter moved to Springfield. Except for four years' residence in Galena and Quincy, he lived in Springfield. In 1860, he lived at the northeast corner of Tenth and Madison Streets and later at 1530 East Mason Street.[53]

In both Quincy and Springfield, 'Brown helped runaway slaves move north on the Underground Railroad. On one occasion, he reportedly gave his own coat and vest to a poor black man:

> *Many a poor slave escaping by means of the underground railway during the civil war, was upheld on his way by Mr. Brown, who acted as a "conductor" at Quincy and Springfield stations. His idea of the golden rule was illustrated by one instance when he gave his own coat and vest to a poor fellow who was without one.*[54]

Lincoln did not know that Reverend Brown would lead his horse in his final journey to Oak Ridge Cemetery, but he had to know that his friend Brown was among a group of brave souls—African American conductors on the Underground Railroad at Springfield.

Reverend Henry Brown died at his Springfield residence on September 3, 1906, at age eighty-three. The headline of his obituary read, "NEGRO EMPLOYED BY LINCOLN DEAD...Was of Massive Build and With Rev. W.C. Trevan Led Lincoln's Horses in Martyred President's Funeral Cortege."[55]

William Johnson

William Johnson was an African American barber and bootblack who worked for Abraham Lincoln for a year before accompanying him to Washington in February 1861. There was antagonism toward Johnson from the existing African American White House servants. Only days after his inauguration, President Lincoln sought other employment for Johnson attesting that he was "honest, faithful, sober, industrious and handy as a servant." In a subsequent letter to Salmon Chase in November 1861, he successfully sought a position for Johnson in the Treasury Department, where he was employed as a laborer and messenger. Johnson, however, continued to spend mornings in service to the president—shaving him and acting as his valet.

On November 18, 1863, William Johnson traveled by train with President Lincoln to Gettysburg, Pennsylvania. Lincoln was present for the dedication of the Soldiers' National Cemetery and delivered the Gettysburg Address.

On the return trip to Washington, Lincoln became ill with what turned out to be smallpox. Johnson tended to him, and the president recovered. By January 12, 1864, Johnson was himself sick with the disease, and by January 28, he was dead. He is thought to be buried in Arlington National Cemetery. Johnson's funeral expenses were paid by President Lincoln.[56]

Allison Demery

Allison Demery, an African American man, was born in Illinois in 1843. He lived in Springfield at the time of Abraham Lincoln's election to the presidency, and his obituary, appearing in the April 30, 1912 edition of the *Register*, states that he had been a servant of Abraham Lincoln. It further states that Demery declined Lincoln's offer to accompany him to Washington, as he had a sweetheart in Springfield whom he did not wish to leave. Demery did leave Springfield, however, when, on March 18, 1865, he enlisted as a private in Company A of the Thirty-eighth Regiment of United States Colored Troops and served the Union for at least one year.

Conclusion

By early twenty-first-century standards, the Lincoln family lived in an integrated Springfield neighborhood. In 1860, the Lincolns certainly knew of the day-to-day life of Springfield's 290 African Americans. In their seventeen years at Eighth and Jackson, they employed at least seven as servants or helpers at their residence. Lincoln must have known that two of those helpers, Jameson Jenkins and Reverend Henry Brown, were active conductors on the Underground Railroad. He also knew that in early August it was the custom of many African American Springfield citizens to parade through the streets of Springfield and gather at what is now Douglas Park to celebrate the freeing of the Haitian slaves in 1804.

Lincoln's experiences and knowledge of Springfield African Americans were substantial and unfettered. At no other time or place did Lincoln have such close personal encounters with African Americans. In Lincoln's Springfield, there were no automobiles. The distances between residences and work and shopping were short. One could easily walk to town, and as Lincoln did so, he passed friends and neighbors on the street and at the market. He looked them in the eye and said, "Hello." They were real people

and could not be ignored by traveling in a car or living far from the center of the community in a disconnected and isolated suburb.

People of various races, ethnicities and wealth lived next door or down the street. There was a deep sense of community and the common good among the people of Lincoln's neighborhood and of Springfield. This sense of community and common purpose of neighbors and neighborhood had much to do with Lincoln's personal attitudes about slavery, tolerance, acceptance and individual freedom. They were his neighbors.

6

THE SCHOOLS IN AND NEAR THE LINCOLN NEIGHBORHOOD

Who can pass a district school
Without the hope that there may wait
Some baby-heart the books shall flame
With zeal to make his playmates great,
To make the whole wide village gleam.[1]
— *"The Illinois Village" by Vachel Lindsay*

Early pioneers did what they could to educate their children at home, in rented rooms or log cabins where, if they were fortunate, a regular teacher stoked the fires; taught reading, mathematics and penmanship; and tended to the often unruly youngsters. Many children of settlers received no formal education. Boys helped their fathers hunt in the woods, chop wood, plough, cultivate crops and build homes and fences on the prairie. Girls helped their mothers plant gardens, cook, bake, wash, weave, sew and mend garments. Life demanded that all adults and children, neighbors and relatives pull together for the basic survival of the group.

Lincoln's education as a boy in pioneering America was not unusual. His father, Thomas, needed him to clear the land, put up fences and plant the crops. To Thomas, time spent in books was time wasted. Despite this lack of encouragement, with his passionate desire to learn, Lincoln found books and sought out guidance from teachers such as Mentor Graham in New Salem. Education was hard earned but highly valued by Lincoln.

Before 1856, there was no public school system in Springfield. Children's education either took place in the home or in one of the twenty modest private schools that came and went, many established by men of the cloth. Teachers were both men and women; children were segregated by race and sex. Parents like the Lincolns who enjoyed a bit more affluence paid for private schools in homes or churches, offering studies in the basics of reading, writing, grammar and history. Some provided a more classical education with Greek and Latin.[2] Several of these were in the Lincoln neighborhood.

Reverend Francis Springer and His School at Eighth and Jackson

One such school was started by Reverend Francis Springer in what is now known at the Lincoln Home National Historic Site as the Arnold House.

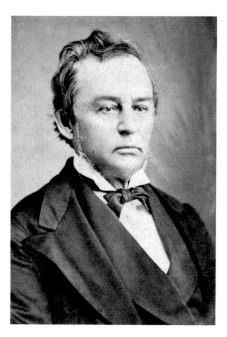

A photograph of Reverend Francis Springer, an early neighbor of the Lincolns and their lifelong friend, by J.H. McManus of Litchfield, Illinois. *Courtesy of the Abraham Lincoln Presidential Library & Museum.*

Among the many men and women who devoted their lives to the education of the young and to the spreading of the gospel in Springfield during the time of the Lincolns, no name is more prominent than that of Reverend Francis Springer, who became a Lincoln neighbor and friend. Until the Civil War, when he left Springfield to join the Union army as a chaplain with the Tenth Illinois Cavalry, Reverend Springer helped to establish and grow both private and public schools, as well as Lutheran churches and a university, in his adopted home of Springfield. He was a kind of Johnny Appleseed of education.

Reverend Francis Springer was born in 1810, a year after Lincoln, in Roxbury, Pennsylvania, the son of poor German immigrants. Orphaned at five years of age and raised by foster

parents, Springer learned early to fend for himself. He became an ornamental sign painter, and then, determined to educate himself, he enrolled in Pennsylvania State College at Gettysburg and later at Hartwick Seminary in New York State to prepare for a career in the Lutheran ministry. In 1836, he taught and preached in Maryland, where he was licensed and ordained as a pastor by the governing body of the Lutheran Synod.[3]

In May 1839, Reverend Francis Springer; his wife, Mary; and one child relocated to Springfield, where he opened the English and Classical School. Springer advertised his school in the *Journal* and stated that it would be held in the schoolroom recently occupied by Mrs. Lee. Tuition ranged from four to seven dollars per quarter depending on the course of study.[4]

However, Reverend Springer wanted his own space for his school. In 1840, he found what he was looking for: a lot at the southeast corner of Eighth and Jackson Streets across from Reverend Dresser's home prior to the Lincolns' purchasing of it. Here Reverend Springer built his home and continued to instruct pupils. And it was here that Reverend Springer also organized the Lutheran Congregation of Springfield and conducted the community's first Lutheran services with seven charter members of the congregation in attendance. Together they celebrated

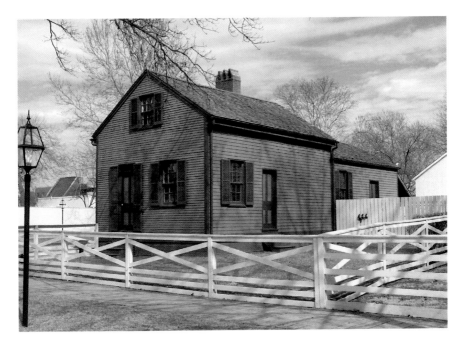

A contemporary photograph of Reverend Francis Springer's residence, now known as the Arnold House, at Eighth and Jackson Streets. *Courtesy of the National Park Service.*

Holy Communion on January 1, 1842, with Reverend Daniel Scherer, the "Father of Illinois Lutheranism," assisting with the service.[5]

Two Springfield churches descended directly from this humble beginning. These are known today as the Grace Lutheran, now located near the Lincolns' home at Seventh and Market (Capitol), and Trinity Lutheran Evangelical Lutheran Church (also known as the German Church) at Second and Monroe.[6]

During the time Reverend Springer lived in the neighborhood, he and Lincoln became good friends. Reverend Springer's affection for Lincoln is touchingly expressed in the message he sent to Lincoln shortly after his departure for Washington:

> *I cannot repress my desire to say to you, Good-bye! I did not call in person, for this purpose, for I know you were pressed with enough company.*
>
> *When the train bearing you passed my residence this morning, my heart said, "God Bless Lincoln and make him second to none but Washington."*
>
> *Be assured, (I speak what I know)—that thousands of earnest prayers daily ascend to Heaven for you and our beloved country.*
>
> *Yours, with very great respect,*
> *Francis Springer[7]*

And this love and respect was obviously shared, for on April 13, 1863, President Lincoln wrote to Secretary of War Edwin M. Stanton that Francis Springer was one of his best friends, adding, "There is no more reliable man."[8]

Reverend Springer continued to teach and preach in this location until 1844, when he became director of Springfield Academy. It appears from scanty data that a Ms. G. Olin opened a school for young ladies in the schoolroom owned and formerly occupied by Reverend Springer in the Lincoln neighborhood.[9] The Springers remained residents in the home.

Reverend Springer Becomes Director of Springfield Academy

Springfield Academy existed prior to 1834, but in 1839, it was officially incorporated, with Elijah Iles's son Washington Iles as one of the members of the board of trustees. They purchased two lots at Fifth between Monroe and Market Streets (Capitol), four and a half blocks from the Lincoln

neighborhood, and proceeded to erect a two-story building that would accommodate one hundred students. Even before its completion, the academy began accepting boys for the high school program.

By 1840, it had been completed with separate classrooms for boys and girls. Reverend John Brooks retired as school director in 1843 and was succeeded by Reverend Springer. He remained with Springfield Academy until 1847, when he moved to Hillsboro, Illinois, to establish yet another school, a Lutheran theological seminary known as Hillsboro College. Abel W. Estabrook took his place as teacher and director.[10]

Robert Todd Lincoln Studies with Abel W. Estabrook

Robert Todd Lincoln, age seven, began three years of study under Abel W. Estabrook at Springfield Academy in the fall of 1850, walking the four and a half blocks from home to school with his friend, George Latham, from Seventh and Market. Over the years, the story has been told that Robert and his father practiced reciting together the various forms of Latin verbs. Before enrolling in Springfield Academy, Robert attended what was referred to as a "Slipper School." Robert said, "I have a dim recollection of being under the slipper-guardianship of a schoolmistress until 1850." Apparently, the "slipper" referred to here was the mode of punishment used by the schoolmistress to enforce discipline.[11]

Estabrook was a fascinating young man. He migrated in

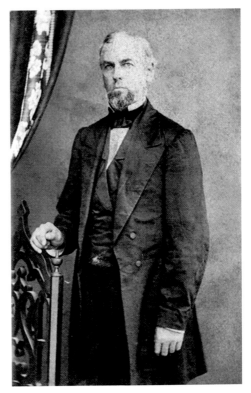

Abel W. Estabrook, Robert Lincoln's abolitionist teacher, photographed in the 1860s by Christopher Smith German of Springfield, Illinois. *Courtesy of Richard E. Hart, Springfield, Illinois.*

1834 with his parents and a group of New Englanders to central Illinois, where they founded the Lyman Colony settlement near Farmington, close to Springfield. Among the shared beliefs of this group was a hatred of slavery and a commitment to abolish it from American soil.

Estabrook attended Illinois College, the first of its kind in the state. William Herndon, who later became Lincoln's legal partner, also attended this college for a short time. It was founded in 1829 in Jacksonville, Illinois, twenty miles from his home in Farmington, by a group called "The Yale Band" from Yale College. Its mission was "to promote collegiate and theological education in the West."[12]

Edwin Beecher, also from Yale and a brother of Harriet Beecher Stowe, who wrote *Uncle Tom's Cabin*, headed the college. He became a passionate abolitionist, and his college became an institution committed to abolishing slavery. So it was that one of Robert Lincoln's earliest teachers was born into and educated in an antislavery milieu and, like Beecher, became a dedicated and outspoken abolitionist. How this may have affected Estabrook's teaching and the learning of his students we can only surmise.

In 1853, Reverend Estabrook purchased Springfield Academy, where he opened the Sangamon Female Academy. In 1855–56, the Springfield City Directory lists Estabrook as residing with George Wood on Eighth near Market, four doors north of the Lincoln Home. He sold the academy in 1857, when he left the field of education to become a local merchant.[13]

The Lincolns' Neighborhood Welcomes a Second School

Central Academy, the second school to open its doors in the Lincoln neighborhood, was the result of a land sale by Charles and Louisa Arnold on July 22, 1850. Having purchased Reverend Springer's home at Eighth and Jackson, they decided to sell their lot at the northeast corner of Seventh and Edwards to the trustees of the Second Charge Methodist Episcopal Church for $200.00. The deed required the trustees to build a "house or Place of Worship for the use of the members of the Second Charge Methodist Episcopal Church." This was done, but then the property was sold in 1853 for $426.48 to trustees of the Central Academy, a school for boys and girls, headed by Reverend Reuben Andrus:[14]

The Trustees of the Central Academy published a notice in the Journal *dated August 11, 1853, announcing that the second school year would*

APPENDIX. 63

CENTRAL ACADEMY,

Edwards, corner 7th Street.

The third year of this Institution commenced on Monday, Sept. 18th, 1854.

It is under the control of a board of Trustees appointed by the Methodist Church, who, at the beginning of the present year, elected Miletus Green, A. B., Principal.— He has associated with him, Alexander Pollock, and employed Mrs. Sarah Pollock, as Teacher of the Primary Department. The number of Pupils now in attendance is 100, and the school is in a very prosperous condition.

It will be open for the education of youth of both sexes, in all the branches usually taught in such Institutions of learning.

The year will be divided into four terms of ten weeks each.

The different departments and prices of tuition in each will be as follows:

Primary Department, - - -	$4,00
Academic, - - - -	- 5,00
Classic, - - -	6,00

For further information, enquire of the undersigned,

M. GREEN, A. B., *Principal.*

A. POLLOCK, *Associate.*

Advertisement for the third year of the Central Academy, a school in the Lincoln neighborhood. *From* Springfield City Directory and Sangamon County Advisor, for 1855–56, *compiled by E.H. Hall (Springfield, Illinois, 1855).*

begin on September 5, 1853. Rev. R. Andrus's term as principal had been a short summer one, as the superintendent was now Rev. J.S. Barwick, assisted by competent teachers. There were two departments, the Primary and the "Academical." The school year was divided into four quarters of ten weeks each.[15]

Springfield Central Academy, as it came to be known, continued to educate as many as one hundred students a term until 1858, when the last owner, Thomas Clarke, an educator from England, sold the property, thus ending the presence of private schools in the immediate Lincoln neighborhood.[16]

Reverend Springer Assists Hillsboro College to Become Illinois State University

Reverend Springer continued his involvement in the expansion of educational institutions in central Illinois. In 1852, he returned to Springfield as president of the relocated Lutheran Hillsboro College, now

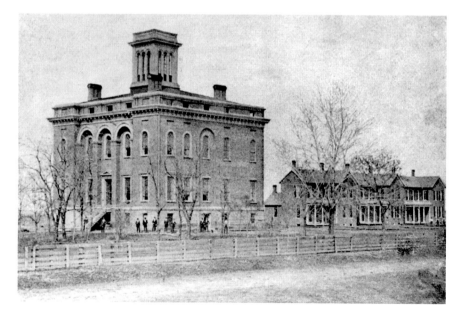

Photograph of Illinois State University in Springfield, Illinois, where Robert Lincoln attended and Abraham Lincoln acted as one of the trustees. *Courtesy of the Sangamon Valley Collection, Lincoln Library, Springfield, Illinois.*

named Illinois State University. The new school included in its student body in its first year John Hay, around thirteen years of age, and in 1854 Robert Todd Lincoln and his friend George Latham. Hay later became Lincoln's presidential private secretary, along with John Nicolay. The college was first located in the Mechanics' Union Building just south of Third and Washington.

Abraham Lincoln contributed financially to the school, allowing him to enroll Robert there in the college preparatory program in 1852. Lincoln also became a trustee of the school, a position he gave up when he became president.[17]

Springfield Establishes Its First Public School System

In April 1854, William Herndon, Lincoln's law partner, was elected mayor of Springfield. His political agenda included "laying the ground work for a public school system."[18] He supervised the expenditure of thousands of dollars to buy suitable lots in each of the city's four wards. The schools did not come into being until later, but credit is due to Herndon for his fierce advocacy of public education for all, regardless of race, creed or color.

Once the funds were appropriated, the first two free public schools opened. In 1856, the Palmer School, as it became known, opened in the First Ward on Mason between Twelfth and Thirteenth Streets. Again, Reverend Springer appears, this time as the principal of the Palmer School and later, because of his distinguished career as a local educator, as the first superintendent of Springfield's new public school system.

The school in the Third Ward, Edwards School at Edwards and Spring Street, opened, and those in the Second and Fourth Wards were up and running by 1858. Abel W. Estabrook again enters the educational scene as the principal of the Edwards School.

Several years later, in 1859, a separate public school for colored children began at Fifteenth and Madison Streets in the "Cottage District." As a result of the establishment and expansion of the public school system, the privately supported schools began to disappear in Springfield.[19] (For information about an earlier attempt by local African Americans to establish a colored school in 1852, see Chapter 5.)

From the records available, it does not appear that the younger Lincoln boys, Willie and Tad, spent much time in either private or public classrooms. They may have been pupils for a short time with

A photograph of the Third Ward School, also known as the Edwards School. *Courtesy of the Sangamon Valley Collection, Lincoln Library, Springfield, Illinois.*

Ms. Corcoran, a local schoolmarm who taught privately. According to Reverend Springer's great-great-grandson David, Reverend Springer taught the Lincoln boys for a while in a back room of his home when he lived nearby at Eighth and Jackson.[20]

Once Robert's years in Springfield private schools were over, he decided to continue his studies at Harvard, the best of the eastern colleges.

Robert Todd Lincoln Leaves for Harvard, and His Father Writes a Letter

As the exciting decade of the 1850s drew to a close, Robert Todd Lincoln, sixteen years of age, and his friend George Latham packed their bags and left Springfield for Cambridge, Massachusetts, and Harvard University. They were among the very few sons of the West who crossed the prairie to study in an eastern state. However, based on their entrance exams, both failed to qualify for Harvard and studied at Phillips Exeter Academy for a

year. They were determined to prepare themselves to retake and pass the Harvard exams in the next year.

In addition to failing his Harvard entrance exam, George Latham suffered the death of his father. Abraham Lincoln knew both father and son very well as friends and neighbors. Out of his "severe experience" as the son of a pioneer who had lost his mother at a young age and who struggled to educate himself, Lincoln was well qualified to encourage a discouraged young man. His words provide an inspiring conclusion to this chapter on education:

Springfield, Ills. July 22, 1860

My dear George

I have scarcely felt greater pain in my life than on learning yesterday from Bob's letter, that you failed to enter Harvard University. And yet there is very little in it, if you will allow no feeling of discouragement to seize, and prey upon you. It is a certain truth, that you can enter, and graduate in, Harvard University; and having made the attempt, you must succeed in it. "Must" is the word.

I know not how to aid you, save in the assurance of one of mature age, and much severe experience, that you can not fail, if you resolutely determine, that you will not.

The President of the institution can scarcely be other than a kind man; and doubtless he would grant you an interview, and point out the readiest way to remove, or overcome, the obstacles which have thwarted you.

In your temporary failure there is no evidence that you may not yet be a better scholar, and a more successful man in the great struggle of life, than many others, who have entered college more easily.

Again I say let no feeling of discouragement prey upon you, and in the end you are sure to succeed.

With more than a common interest I subscribe myself

Very truly your friend,

A. Lincoln.[21]

POLITICAL ALLIES AND OPPONENTS IN THE NEIGHBORHOOD

We gave the vote to Lincoln because we liked him, because we wanted to oblige our friend and because we recognized him as our leader.[1]
—*Jesse K. Dubois*

Among Lincoln's many outstanding qualities was his ability to accept the viewpoint of others, whether he agreed with it or not. There were neighbors who supported him politically and those who did not. Lincoln valued their friendships equally.

Jesse K. Dubois (1811-1876), State Auditor

My acquaintance first began with him in 1836. He was a member from Lawrence and Coles [legislative counties in southern Illinois]. *Our friendship has continued and strengthened. When I first saw him he was a slim handsome young man, with auburn hair and sky-blue eyes, with the elegant manners of a Frenchman, from which nation he had his descent.*[2]
—*Abraham Lincoln*

Here Lincoln describes his early memory of Jesse Kilgore Dubois, his neighbor at Eighth and Jackson who knew him the longest and the best. Dubois even named his second son "Lincoln Dubois" in honor of his good

friend. "Uncle Jesse," as he came to be known, was there with "Uncle Abe" at the beginning of his political career in the Illinois legislature; he was there with him during the heady days of the nominating convention in Chicago and his election as president, and he was there with him at the end as one of his grieving pallbearers.

Like Lincoln, Jesse Dubois was the son of a pioneer. Toussaint Dubois, an adventurous Frenchman, traveled from his home in Montreal, Canada, to join his brothers in the French settlement of Vincennes, Indiana, around 1780. The settlement was a French fur-trading post and the oldest town in Indiana, then a part of the Northwest Territory. Here, too, in 1830, the Lincoln family passed into Illinois, where the Buffalo Trace crosses the Wabash River. (Today, a large memorial designates this event on the Lincoln Trail.)

Did the Dubois and Lincoln families meet at that time? According to local tradition, the Lincolns camped for a night at the foot of Dubois Hill. In keeping with the settlers' hospitable tradition toward migrants, Mrs. Dubois sent her son Jesse, home from college, to greet the Lincolns and their twenty-one-year-old son, Abraham.[3]

Unlike Thomas Lincoln, who struggled to provide adequately for his family, Toussaint Dubois became a wealthy man with an estate on Dubois Hill on the Illinois side of the Wabash River. His success in the new territory grew from his skills as a businessman coupled with exceptional understanding of and sympathy for Native Americans in his region. His ability to resolve disputes with diplomacy among natives, settlers and traders became legendary and contributed to his rise as a leader in his community. William Henry Harrison, governor of the Indiana Territory and later ninth president of the United States, trusted him sufficiently to appoint him as a confidential messenger to Tecumseh, the famous Shawnee chief.

In 1816, returning home from a business trip, Toussaint drowned crossing the flood-swollen waters of the Little Wabash River in Illinois. At the peak of his career, he left a thriving business; his second wife, Jane; and eight children from two marriages. Jesse, the youngest, found himself fatherless at the age of five.[4]

True to his father's tradition of service to the community, Dubois, at twenty-two, became the youngest member of the Illinois state legislature, where he again met young Abe Lincoln. Two years apart in age, the young men forged an instant bond. This lasted throughout their four terms together as fervent Whig legislators, from 1834 to 1844, and continued until Lincoln's death in 1865.

Photograph of Jesse Kilgore Dubois, Illinois state auditor, Lincoln neighbor and close friend. *Courtesy of the Abraham Lincoln Presidential Library & Museum.*

It is hard to believe that Lincoln's description of Dubois as a young man refers to the same serious, clean-shaven, middle-aged gentleman scowling at us in the picture. Yet it was this same Dubois who, inspired by Lincoln, swore his enthusiastic allegiance with the words, "I am for you against the world."[5] He kept his promise and was there for Lincoln at pivotal moments in his career, as documented by his passionate utterances.

Lincoln and "the Long Nine" (humorously labeled because all these Sangamon County legislators were over six feet tall) began their agitation to move the capital from Vandalia to Springfield in 1836:

> *He made Webb and me [Jesse] vote for the removal though we belonged to the southern end of the State. We defended our vote before our constituents by saying that necessity would ultimately force the seat of government to a central position. But, in reality, we gave the vote to Lincoln because we liked him, because we wanted to oblige our friend and because we recognized him as our leader.*[6]

Some years later, the passing of the Kansas-Nebraska Act in 1854 opened the door to the spread of slavery in the territories.[7] It brought Lincoln out of retirement as a politician to spearhead its repeal and the defeat of Stephen A. Douglas, the bill's author and Lincoln's rival, in his bid for the Senate and, later, the presidency.

Based on both his own antislavery beliefs and his loyalty to Lincoln, Dubois again followed his friend, abandoning his Whig affiliations and becoming an Illinois Republican at the 1856 anti–Nebraska law convention in Bloomington. It was here that Lincoln gave his famous fiery "lost speech," so moving and powerful that the audience, including all the journalists, dropped their pens and left no coherent record of it.

History did record convention delegate Dubois' response, however: "That is the greatest speech ever made in Illinois and it puts Lincoln on the track for the President."[8]

In July 1858, Lincoln was in his office preparing another speech to be delivered at the Republican State Convention in Springfield. No doubt, to Dubois' surprise, Lincoln refused to share it with him. He revealed his reason after the convention: "This passage in the Speech about the house divided against itself I would not read it to you because I Knew you would make me Change it—modify & molify [mollify] & I was determined to read it."[9]

The Springfield Years

Dubois was elected state auditor in 1857 and continued on at this post until 1864. To assume his office, he relocated to Springfield, and in 1858, he contracted with the firm of Graham and Dallman to build a home on Eighth Street, one block from the Lincolns. From then until the Lincolns left for Washington, the two families shared many occasions together—dinners, teas and horse races at the county fair. And the Dubois and Lincoln boys became fast friends.

Dubois' son Fred tells us:

> *Lincoln and my father and some other friends would get into the family carriage, accompanied always by some of us boys and drive out to the fair grounds. Mr. Lincoln was a good judge of horses and he and his companion would often place a small wager on the result of the race.*[10]

Adelia Dubois, Jesse's second wife, became a close friend of Mary Todd Lincoln. The ladies often took tea together while their boys romped in the neighborhood. Mary continued to write to Adelia as first lady and, later, as widow of the martyred president.

Dubois' Candidate Wins

As part of a powerful team led by Judge David Davis, Lincoln's old friend from his days on the legal circuit, Dubois participated actively in the heated campaign to nominate Lincoln as the Republican presidential candidate in 1860. Especially constructed by the City of Chicago as a temporary home

for the convention, "the wigwam," as it was dubbed, housed ten thousand excited and sometimes hysterical delegates and spectators.

Lincoln remained at home in Springfield and did not participate directly in the political drama. The protocol of the time did not allow participation by the candidate himself, so Lincoln relied on Davis and Dubois for daily reports.

It was from the wigwam that Dubois telegraphed Lincoln back home in Springfield on Monday, May 13, 1860: "We have a great confusion. Things this evening look as favorable as we had any right to expect." And then on Tuesday, with Davis, he insisted, "Don't come unless we send for you.[11]

John Nicolay, who became one of Lincoln's loyal secretaries in the White House, relates those suspenseful and exhilarating moments of the convention delegates' third roll call. Lincoln emerged the victor over such powerful candidates as William Seward of New York and Salmon Chase of Ohio. Dubois helped create one of the most memorable moments in American political history:

> *A profound silence suddenly fell upon the wigwam; the men ceased to talk and the ladies to flutter their fans; one could distinctly hear the scratching of pencils and the ticking of telegraph instruments on the reporters' tables...*
> *While every one was leaning forward in intense expectancy, David K. Carter sprang upon his chair and reported a change of four Ohio votes from Chase to Lincoln. There was a moment's pause—a teller waved his tally-sheet towards the skylight and shouted a name—and then the boom of a cannon on the roof of the wigwam announced the nomination to the crowds in the streets, where shouts and salutes took up and spread the news. In the convention the Lincoln river now became an inundation. Amid the wildest hurrahs, delegation after delegation changed its vote to the victor.*[12]

Fast-forward to Springfield on November 6, 1860, 7:30 p.m. of election night. Springfield was in a state of wild excitement. Wherever Lincoln appeared that day, enthusiastic crowds trailed him; Democrats and Republicans alike jockeyed for a chance to say a word or shake his hand. People danced and sang in the streets and even rolled on the ground as if possessed. At the Illinois & Mississippi Telegraph Company headquarters on the second story of a brick building on the north side of Springfield's public square, Dubois, John G. Nicolay, Ozias Hatch and a young reporter tensely awaited election results. Although Lincoln maintained his usual outward calm, the group sat listening nervously for the clicking of the telegraph and news from New England, most particularly the pivotal state of New York.

As the evening wore on, good news began arriving. Dubois turned to Lincoln, who remained cool and collected, and asked, "Well, Uncle Abe, are you satisfied now?" With his usual restraint, Lincoln replied, "Well, the agony is most over, and you will soon be able to go to bed."[13]

Midnight approached and with it a telegram bearing hopeful news from the chairman of the Republican State Committee. Lincoln cautioned, "Not too fast, my friends. Not too fast, it may not be over yet." Then, when a second private dispatch from Simeon Draper arrived for Lincoln, now uncharacteristically nervous, Dubois and the others watched as he knelt down, adjusted his spectacles and then

> *read and reread several times the mustard-colored telegraph message bearing the final news of success. Dubois, Nikolay and Hatch burst into cheers. Even the telegraph operators left their posts to join in this historical moment. The telegram was read aloud from the window of the telegraph office to the ecstatic crowd below: "We tender you our congratulations upon this magnificent victory."*

Great shouts rose up, a church bell rang and Springfield residents sprang from their beds to join in the midnight singing and celebration. Lincoln left his friends to celebrate together. Acknowledging Mary's importance in his campaign, Lincoln's parting words were, "Well Gentlemen, there is a little woman at our house who is probably more interested in this dispatch than I am."[14]

Lincoln's Departure

When Lincoln boarded the train at the Great Western Station to begin his Washington journey, Adelia and Jesse Dubois accompanied him. Their son Lincoln, fourteen years of age, was among the throng of well-wishers. He recalled standing in the middle of the train track near the platform where Lincoln was facing the crowd, seeing his sorrowful face and hearing his moving words of farewell to his friends and neighbors.[15]

Indianapolis was one of the many stops on the journey where locals fêted the newly elected president. A reporter present described a touching moment:

> *On February 12, in the president's room a reception mean time took place. His old Illinois friends, J.K. Dubois and E.K. Peck, took hold of him in*

a melodramatic manner. They hugged him and told him to behave himself like a good boy in the White House and lastly even cut a lock of hair off his head with which they rushed triumphantly out of his room.[16]

Once Lincoln became president, he and Dubois had disagreements over patronage. Despite this, Dubois remained loyal, campaigning vigorously for Lincoln's reelection in 1864 and visiting and corresponding with him in Washington.

In 1865, Dubois made his last appearance at Lincoln's side as a passenger on the funeral train from Washington to Springfield. On May 4, 1865, Dubois was a pallbearer, accompanying Lincoln's body through the streets of Springfield, past their black-draped houses in the old neighborhood to his final resting place at Oak Ridge Cemetery, the quiet spot where Lincoln had once requested to be buried.

Dubois became an important member of the Lincoln National Monument Association that was established to plan and raise funds for the Lincoln tomb. He remained a friend and helpmate to Mary Lincoln in her distressed widowhood. Ten years after Lincoln's death, he dedicated a statue of Lincoln at the tomb with these moving words:

Every member of this Association was a neighbor of President Lincoln, and most of them had known him intimately since his early manhood.

It is their unanimous opinion that this statue is a truthful likeness, and will serve to give to future generations a perfectly accurate conception of Abraham Lincoln.

Here ends what has been to the members of the Association for almost ten years, a labor of love and duty.

By the liberal contributions of a grateful nation we have been enabled to provide a suitable place for the remains of one of the wisest, purest men known to our national history.

There may they rest in peace.[17]

Jesse Kilgore Dubois passed away in 1876, eleven years after Lincoln, and was buried in Oak Ridge Cemetery near his friend. His son Fred T. Dubois continued his grandfather's and his father's commitment to public service. He became United States marshal of the Idaho Territory in 1882 and then the state's first full-term senator from the newly formed state of Idaho.

Other Allies in the Neighborhood

Among Lincoln's other political allies in the neighborhood were Charles Arnold, Jared P. Irwin, Charles S. Corneau and Amos H. Worthen.

Charles Arnold (1809-1888), Springfield Sheriff

Charles Arnold was born in 1809, the same year as Abraham Lincoln. A miller by trade, he preferred public service. Like many New Englanders who relocated to Springfield, Arnold was a member of the Whig Party. He was elected treasurer for Sangamon County and later held the position of sheriff in 1848 and again in 1852, elected on the Whig ticket.

In 1849, Charles and Louisa Arnold and their three children moved into one of the oldest properties in the Lincoln neighborhood. For $800, they purchased their home from Reverend Francis Springer, who had established there the English and Classical School, one of Springfield's earliest educational institutions. The original house was built in 1840 on this site and was a small two-room cottage with a sleeping loft above. The following year, a one-story addition was made to the back of the house, doubling the size of the first floor. Eleven-year-old Robert Lincoln may have studied here with Reverend Springer for a short while.

This structure, now referred to as the Arnold House at the Lincoln Home National Historic Site, still stands at 500 South Eighth Street, on the same side of the street as the Lincoln Home, at the southeast corner of Eighth and Jackson Streets. Arnold's active involvement as a Whig leader in the temperance movement—and later, as a Republican—often brought the men together as friends and political colleagues.

Arnold supported Lincoln, but as local sheriff, Mary's recurring fear of robbers when home alone tried his patience. Mariah Vance quoted Mary as saying that "the sheriff, who lives only a stone's throw, came. He told me I had a nightmare, and that the neighbors were complaining about my continual disturbances in the night. I swore to him that the intruder ran out as he came in. He said, 'Poppycock.'"[18] In the 1850s, Arnold and Lincoln worked together to upgrade the neighborhood with planked sidewalks:

> *It was not until 1853 that Lincoln, Charles Arnold, sheriff and others petitioned the city council "praying that certain sidewalks on the East side*

of Eighth street between Cook and Adams streets be graded and paved or planked as in said petition specified."[19]

Arnold also served on the Committee of Vigilance with other neighbors Charles Corneau and James Gourley in 1848. This committee monitored elections to prevent unethical or illegal voting practices.

Reverend Francis Springer (see Chapter 6 for more on him), the first owner of Arnold's home, should also be mentioned here as a former neighbor and political ally of Lincoln. Although by the time of Lincoln's election as president, Springer had long since moved from the neighborhood, he remained a friend of Lincoln and, like him, was a dedicated Whig and later a Republican. He stood behind Lincoln as his neighbor ascended to the highest-ranking position in the nation and supported his friend in the Civil War to preserve the nation and to end slavery. He became a chaplain in the Union army at the age of fifty-one. For more information on this period of Reverend Springer's life, see *The Preacher's Tale: The Civil War Journal of Rev. Francis Spring, Chaplain, U.S. Army of the Frontier*, edited by William Furry.

Jared P. Irwin (1810-1870), Springfield Mason

No sooner had the Illinois legislature passed the bill to move Illinois' capital from Vandalia to Springfield than plans were underway for the construction of the State House. After learning of these plans, Jared P. Irwin, a brick mason in Philadelphia, packed up and headed west. In the diary he kept of his daily life, Irwin noted: "June 22, 1837. I this day commenced laying the foundation of the Capitol, or State House, at $2.50 pr. day."[20]

Irwin must have paused at his work on the square to observe important historical events because his journal records them:

September 15, 1838. Today a caravan or company of "Mormons" with 67 waggons numbering about 800 Souls passed through this place on their way (as they say) to the "Promised Land" west of the Mississippi. The sight was quite imposing.

September 30. Today a remnant of the Tribe of Pottawatonie Indians passed through town on their journey to their new homes west of the Mississippi...The number was about 800 souls, each one having a horse (save the sick, they being in wagons).[21]

When Irwin finished working on the State House, he left for Philadelphia and was married there.

In the 1850s, he returned to Springfield with his wife. They became neighbors of the Lincolns in 1857, when, for $1,400, they purchased Henry Oswald's home next door to Charles and Louisa Arnold. The house was later demolished.

Irwin shared Lincoln's commitment to the temperance movement and to the Republican Party. In 1860, he was elected vice-president of the Springfield Lincoln Club.

Prior to the family's departure for Washington, Irwin caught sight of Mary burning trash in the backyard of her home. When he approached more closely, he saw that these were letters that could be of future value. Irwin asked if he could have some as mementos, and Mary acquiesced, thus preserving for posterity letters exchanged by the couple in 1848.[22]

After Lincoln's assassination, Irwin offered to build his burial vault gratis in the downtown site originally chosen by the city fathers. Although built, the vault was never used. Mary Lincoln's insistence on Lincoln's burial in Oak Ridge was honored.

Amos Henry Worthen (1813-1888), State Geologist

Between 1859 and 1862, Amos H. Worthen lived four houses north of the Lincolns on Eighth Street between Market (Capitol) and Jackson, in a single-story frame cottage with a shingle roof originally constructed by George Wood in 1842. (The house no longer stands, and historic photos of this home have not been located.) Worthen was the state geologist from 1858 to 1887 and also the first curator of the Illinois State Historical Library and Natural History Museum, founded in 1877.

Worthen was one of thirteen children born in Bradford, Vermont, to Thomas and Susannah Worthen, who farmed the land. Through his contact with local fields and forests and his work on his father's farm, he developed a passion for nature. This led to his future career in geology in the state of Illinois.

In 1834, he and his young wife, Sarah, moved to Cincinnati, where he taught school. After two years there, they joined members of his wife's family in Warsaw, Illinois. He established and ran a dry goods business, but fossils, not fabrics, and rocks, not rugs, occupied his interest. The area around Warsaw fascinated him. His nephew observed that his home and shop were more stone collections than home and store.[23]

Worthen was still running his dry goods store when he first met Lincoln in 1841. Perhaps as part of his travels as a circuit lawyer, Lincoln represented Worthen in a debt collection suit.

By mid-century, Illinois had exceeded one million in population. Writer Harlow B. Mills described this period of expansion as one of "ferment, excitement and great ideas."[24] More people meant more homes, factories and public buildings; it meant the laying of more tracks for the railroad and the improvement of roads for increased travel. These required survey data on the soil, rocks and natural resources. Worthen's participation in the first state-sponsored Illinois Geological Survey provided vital information for this expansion.

The famous collection of fossil specimens in the Illinois State Geological Survey is known as the Worthen Collection, as most of the objects were collected and described by him.

In the mid-nineteenth century, the natural sciences such as botany, geology and archaeology became subjects for serious study. More and more books and papers were published on these sciences, culminating in Darwin's controversial *Origin of the Species* in 1859. (Darwin was born on the same day and year as Lincoln.) His theory of evolution raised questions of the relationship of God to the natural world and resulted in heated debates that would have interested Lincoln very much. John Todd Stuart said of his former legal partner, "I consider [Lincoln] a man of very general and varied knowledge—Has made Geology and other Sciences especial Study."[25]

Lincoln may very well have walked north four doors on Eighth Street to chat with his neighbor, state geologist Worthen, about these subjects. Worthen was a free thinker, an abolitionist and a Republican, like Lincoln. These neighbors would have had much in common and much to talk about. There is also some evidence that the Worthen and Lincoln boys played together in the neighborhood:

> *During the reconstruction of the Lincoln home in the late 1980s while tearing out the inside walls, workers discovered geodes from the Keokuk and Warsaw area. The mystery of how these geodes (round rocks with crystals inside) ended up in the walls of the Lincoln home might be explained as follows: Amos Worthen had a residence nearby the Lincolns'. As the Lincoln children would often play along the street it is believed Worthen gave the shiny quartz objects to the Lincoln boys who probably dropped the rocks into the walls, only to be discovered many years later.*[26]

After Lincoln's death, the Worthens left the neighborhood and moved back to Warsaw.

Charles Corneau (1826-1860), Springfield Pharmacist, and John E. Roll (1814-1901), Builder

Charles S. Corneau, like Jared Irwin, relocated to Springfield from his home in Philadelphia, Pennsylvania. In 1855, he was already well acquainted with the Lincolns when he and his wife, Elizabeth, bought the property at the southeast corner of Eighth and Jackson from Abner Wilkinson for $1,500. In 1850, Corneau, at age twenty-four, replaced Dr. William Wallace, husband of Mary's sister Frances, as Diller's partner in the Diller family pharmacy dating back to 1837. He also married Diller's wife's sister, so the business partners became brothers-in-law as well. The Lincolns purchased cough syrup, castor oil and most of their medicines there, as well as soaps and lotions. Lincoln often stopped by the store to talk and tell stories to a receptive clutch of cronies.[27]

Isaac Diller, Roland Diller's son, lived nearby and spent much time in the neighborhood with his playmates Willie and Tad Lincoln. Sometimes, he stayed over with his aunt and uncle, the Corneaus, to be closer to his friends.

In 1848, Corneau joined with Charles Arnold and other Whigs to form the Illinois State Taylor for President Club. (Lincoln also supported Zachary Taylor.)[28]

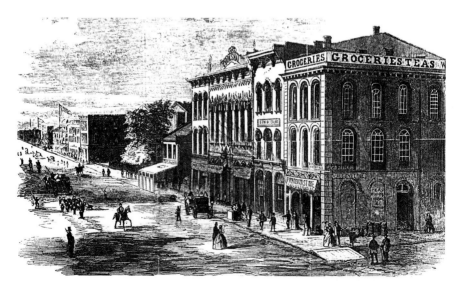

A drawing of the east side of the public square, circa 1859, the location of Corneau & Diller's Drugstore, from a photograph by Preston Butler of Springfield, Illinois, as it appeared in *Frank Leslie's Illustrated Newspaper* on December 22, 1860. *Courtesy of Richard E. Hart, Springfield, Illinois.*

With the collapse of the Whig Party, Corneau, like Lincoln, became a Republican. Had he not contracted "brain fever" and died in June 1860, twenty-one days after Lincoln's nomination, he most certainly would have been among the crowd of celebrants at the great August gathering in Lincoln's honor on his street. And he would have cast his vote for Lincoln as president in November 1860. He was only thirty-four. The funeral was held in their home. Elizabeth Corneau sold the property in 1865. With her three young children, she returned to her home and Quaker family in Buffalo, New York.[29]

One other Lincoln ally worth mentioning is John E. Roll. Only briefly a resident of the neighborhood, he built several homes there and many others in and around Springfield. With his skills as a plasterer and mason, he also helped in the refurbishing of other homes, including the Lincolns' after their first trip to Washington, D.C. Sarah Cook rented one of his former houses, next to the Arnolds. A lifelong friend and political ally of Lincoln, Roll first met twenty-two-year-old Lincoln during his stay in New Salem, where he helped Lincoln construct the famous flatboat he took down the Mississippi to New Orleans.

Before the Lincolns left Springfield in 1861, the Roll family adopted their beloved dog Fido. In a letter to President Lincoln in 1863, Lincoln's former barber William Florville, "Billie the Barber," mentioned Fido:

Tell Taddy that his (and Willie's) dog is alive and kicking doing well and he stays mostly at John E. Rolls with his boys who are about the size now that Tad and Willie were when they left for Washington.[30]

Lincoln's Political Opponents in the Neighborhood

Mason Brayman (1813-1895), Springfield Attorney and Civil War General

Mason Brayman was an interesting and versatile young man by the time he arrived in Springfield from his home in Buffalo, New York, where he was born on May 23, 1813. His strong religious commitment and sympathy for the temperance movement started with his strict religious upbringing. Liquor was abhorred as an elixir of the devil. He shared this enthusiasm for the temperance movement with Lincoln, but politically, he was a Democrat. The two men were destined to cross paths frequently in business, law and real estate.

Major General Mason Brayman, neighbor and friend of the Lincolns.
Courtesy of the Abraham Lincoln Presidential Library & Museum.

At seventeen, he was apprenticed to a printer and later became the editor of a local newspaper. Then he studied law and was admitted to the New York Bar in 1836. His interest in journalism and the law continued throughout his life.

With his wife, Mary, Brayman began a series of moves westward, finally settling in Springfield, where he joined Jesse B. Thomas Jr. in a law practice, wrote editorials for the local newspapers and oversaw the American Baptist Publishing Society. In 1845, Illinois governor Thomas Ford commissioned him to investigate the community's hostility toward the Mormon settlement in Nauvoo, Illinois.

The Braymans' first connection to the Eighth and Jackson neighborhood was as renters of the Lincoln Home during most of Lincoln's term in the Thirtieth Congress. When Cornelius Ludlum was unable to meet his financial obligations as leaseholder of the Lincoln Home, Brayman stepped in and took over the obligation in February 1848. Brayman described his happiness with his wife, daughters and the rented home in a letter to his sister Sarah: "We have an excellent house and garden—with plenty of cherries and currants, and peaches growing—with vegetable of my own raising."[31]

The Lincolns returned to Springfield on October 10, 1848. Brayman, like Ludlum, had fallen behind in his rent, and his lease was due to expire in November. Rather than evict the Braymans, the Lincolns checked into the now upgraded Globe Tavern, where they were once newlyweds. Brayman managed to pay his past-due rent and arranged to stay on in the home until February 1849, when Lincoln's obligation ended as a member of the House of Representatives. Meanwhile, during the cold winter months, Mary and the boys remained at the friendly and comfortable Globe.

While still leasing the Lincoln Home, Brayman became a solicitor for the Illinois Central Railroad. This enabled him to handle the debt to Lincoln, pay for another three months' rent and purchase a home nearby.

Mary and Mason Brayman's friendship with the Lincolns and their obvious fondness for the neighborhood must have influenced their decision to purchase a home there. Once their lease was up in 1850, they bought what is now designated as the Shutt House at the corner of Eighth and Edwards. Originally, Ninian Edwards, Lincoln's brother-in-law, owned this lot. Edwards sold the unimproved property to John Larrimore, who later sold it to Mason Brayman.

The Braymans enjoyed a comfortable social relationship with the Lincolns during these years in the neighborhood and were often guests in their home. Through Brayman's contacts, the Illinois Central retained Lincoln as a lawyer, which brought in good money to Lincoln.

By chance, on February 27, 1860, Brayman and Lincoln found themselves together in New York at the Astor House. Lincoln was preparing to deliver his Cooper Union speech, which would introduce him to eastern Republicans. The success of this speech led to Lincoln being chosen later as the party's candidate for president, winning over formidable competitors, and his subsequent rise to the presidency.[32] Although a Democrat, Brayman planned to attend the talk, so Lincoln asked him to help by raising his hat high on a cane if he could not be easily heard.[33] Thus, Brayman was the only neighbor to attend this historic event.

During the Civil War, Mason Brayman became a major general in the Twenty-ninth Illinois Volunteer Infantry Regiment. After the war, he was the editor of the *Illinois State Journal* until President Grant appointed him governor of the Idaho Territory.

John McClernand (1812-1900), Attorney, Politician and Civil War General

Like Mason Brayman, John McClernand lived close to the Lincolns. He was a general in the Civil War and a Democrat dedicated to supporting Stephen A. Douglas. McClernand resigned his seat in the U.S. Congress to join the Union army and led troops in the Battles of Shiloh and Vicksburg. He often bypassed the military chain of command and used his political connections, the news media and his friendship with President Lincoln to gain favors and give advice. This pattern antagonized General Grant and other high-ranking officials, and in June 1863, General Grant relieved him of his command. Lincoln reinstated him in 1864.[34]

George Shutt (1832-1881), Springfield Attorney

Lincoln's most outspoken political opponent in the neighborhood was George W. Shutt, who rented Mason Brayman's home in 1860 at the corner of Eighth and Edwards Streets.

George Shutt came from a long line of Virginia Democrats. He continued this political affiliation throughout his life. He took up the study of law under Judge James Matheny, with whom he later became a partner.

In the 1860 presidential election, he supported Stephen Douglas against his neighbor Lincoln. The pro-Republican *Illinois State Journal* of Springfield described a political gathering that Shutt addressed in August: "A Douglas meeting was held in the afternoon, which was attended by Messers George Shutt and Judge Wick of this city." According to the article, the judge made himself so ridiculous that his friends took him away, and "the ambitious young man who accompanied the judge, was also most effectively Shutt down."[35]

Once the Civil War commenced, political differences resolved, and Shutt became a strong Union supporter. Shutt's affection for and appreciation of Lincoln were also reflected in his volunteering to be one of a three-man committee in Springfield that arranged for Lincoln's burial and in his helping to raise the appropriations for the Lincoln Monument.

A contemporary photograph of the George Shutt House at Eighth and Edwards Streets (rented from Mason Brayman) showing its Greek Revival architectural style with some Italianate influence. *Courtesy of the National Park Service.*

Other Political Opponents

Henry Carrigan, a neighbor living next door to the Lincolns, and Abner Wilkinson, renting the Lushbaugh House across the street, did not agree with Lincoln politically. Similar to most Irish immigrants, Carrigan was a Catholic and a Democrat. (For more information on the family, see Chapter 4 on diversity.)

Abner Wilkinson was born in Philadelphia. In 1847, he met and married Elizabeth Ann Brown, a local girl from the Springfield area, so he must have relocated from the East sometime before that. Together they had six children. The family lived in the neighborhood in the mid-1850s, in the home that stood on the lot now designated in the National Historic Site as that of the William Burch family.

For a year, he operated Dickey's Bakery with John Billington and then moved on to become a tailor on the south side of the square. By 1852, he had terminated his partnership in tailoring and put his attention on

public affairs. The Democrats chose him to run for the office of Springfield marshal, but in the 1860 election, he was soundly defeated. Some years after Lincoln's death, he did become the local chief of police.[36]

Conclusion

Although Mary Lincoln was prone to bear grudges—she never forgave her once close friend Julia Trumbull when her husband, Lyman, walked off with the senate seat she had intended for her spouse—Lincoln accepted the differences in people. This included those who openly opposed him. He could be adversarial when circumstances required, but he rarely nursed a grievance and remained friends with allies and opponents alike. He practiced what the Bible had taught him: "Thou shalt love thy neighbor as thyself (Matthew 22:39)."

Ida Tarbell, an American journalist, in her *Life of Abraham Lincoln*, captures something of Lincoln's power to attract and inspire others, regardless of political ties, both in his time and throughout the years:

> *While Lincoln's speeches awakened respect for and confidence in his ability, the story of his life stirred something deeper in men. Here was a man who had become a leader of the nation by the labor of is his hands, the honesty of his intellect, the uprightness of his heart. Plain people were touched by the hardships of this life so like their own, inspired by the thought that a man who had struggled as they had done, who had remained poor, who had lived simply, could be eligible to the highest place in the nation. They had believed that it could be done. Here was a proof of it. They told the story to their boys. This, they said, is what American institutions make possible; not glitter or wealth, trickery or demagogy is necessary, only honesty, hard thinking, and a fixed purpose. Affection and sympathy for Lincoln grew with respect. It was the beginning of that peculiar sympathetic relation between him and the common people, which was to become one of the controlling influences in the great drama of the Civil War.*[37]

8

Parties and Parades in the Neighborhood

This little neighborhood was witness to some of the most historic events in our national journey.

—*Richard E. Hart*

Mary Todd Lincoln may have known little about being a homemaker when she married and moved into her new home on Eighth and Jackson, but she did know how to be a hostess. Her parents and her sister Elizabeth were excellent models for creating successful parties with elegance and grace.

As Lincoln's political ambitions accelerated, so did the need for entertaining. Although Lincoln had removed himself from the political scene in the early 1850s, by 1854, he was back with all sails unfurled once the Kansas-Nebraska Act became law. It was sponsored by Lincoln's old rival Senator Stephen A. Douglas, and its passage replaced the time-honored Missouri Compromise, limiting the spread of slavery in the West. With the passage of this new act, the territories could become more welcoming to the slave-owning population, threatening the balance of power between the North and the South and spreading further the institution of slavery. Lincoln was not about to sit quietly by on the sidelines and watch this occur, for he believed, "as I would not be a slave, so I would not be a master."[1]

Lincoln's acceptance of the Republican presidential nomination, followed by his election in 1860, led to a snowballing of household gatherings. Eighth and Jackson Street became an extension of the Lincoln parlor, with the entire town of Springfield celebrating together these momentous events.

By 1856, the Lincoln lifestyle had outgrown the confines of the original cottage purchased twelve years before. Springfield was expanding, with large, beautiful new homes dotting the once barren landscape. Mary, being very status-conscious, yearned for something more elegant and befitting of a family of prominence in the community.

Lincoln's practice now afforded a more comfortable income. Mary also received money from the sale of an eighty-acre land tract deeded to her by her father. While Lincoln was away on his spring circuit tour, Mary engaged the services of the firm of Hannan and Ragsdate to enlarge the home by replacing the old roof with a new one. By doing so, they created space for a second story with four bedrooms, a maid's room and storage. The downstairs bedroom could now become a back parlor, allowing more room for guests.

Many biographers have reported Lincoln's reaction when he returned home from his circuit riding and glimpsed his newly renovated home. Seeing his neighbor from around the corner, the shoemaker James Gourley, Lincoln approached him with mock seriousness and inquired, "Stranger, do you know where Lincoln lives? He used to live here." Missing the humor in this statement, some historians have wrongly concluded that Mary renovated the home without her husband's knowledge. This was very unlikely.[2]

Mary Becomes Recognized as a Hostess

With Eighth Street now a more elegant two-story home, refurbished within and without, Mary was ready to host the legislature on Thursday, February 5, 1857, for "a very handsome & agreeable entertainment." She reported to her half-sister Emilie Todd Helm that "about 500 were invited, yet owing to an *unlucky* rain, only 300 favored us by their presence." This she attributed to competition from a bridal party given by Colonel William B. Warren for his son in Jacksonville.[3]

Harry G. Little, a legislator and guest at the party, observed people enjoying themselves more at the Lincolns' than at the governor's mansion:

A long table was stretched nearly the whole length of the room, while above the table was a succession of shelves growing narrower upward. On those shelves the edibles were placed, and the guests…were left to help themselves, the waiters serving only coffee. Mr. Lincoln passed around among his guests

in his genial way, with a friendly word for each. I remember that he said to me, "Do they give you anything to eat here?"[4]

Although Mary may have pinched pennies when it came to feeding her family, she made up for her frugality with lavish, inviting spreads for the many guests who graced her home. From her very small kitchen with its cast-iron stove, Mary and a servant or two produced delectable dishes. Isaac Arnold, an attorney, politician and strong opponent of slavery, visited from Chicago and praised her hospitality:

Mrs. Lincoln often entertained small numbers of friends at dinner and somewhat larger numbers at evening parties. Her table was famed for the excellence of its rare Kentucky dishes and in season was loaded with venison, wild turkeys, prairie chicken and quail and other game.[5]

Mary did not rely on her husband's presence as a reason to invite guests to their home. She had confidence in herself as a hostess. With her excellent cuisine, lively conversation and warmth, she sometimes entertained alone when he was away on the circuit or on speaking tours.

One such guest was prominent Republican, local bachelor and Illinois secretary of state Ozias Hatch. On October 3, 1859, Mary wrote:

By way of impressing upon your mind, that friends must not be entirely forgotten, I would be pleased to have you wander up our way to see us this evening altho' I have not the inducements of meeting company to offer you, or Mr. Lincoln to welcome you, yet if you are disengaged, I should like to see you.[6]

Orville H. Browning, a lawyer from Quincy, Illinois, frequently visited Springfield, particularly when the legislature was in session. His diaries recorded the weather, along with frequent social visits with both the Lincolns or just with Mary over a six-year period:

Monday Jan 19 1852 Delivered a lecture at 3rd Presbyterian Church for the benefit of the poor. After went to Mr. Lincoln's to supper. Thermometers ranged 19 to 23 below zero.

Thurs. July 22 1852 The warmest days of season. Mrs. B and self spent evening at Lincolns.

Feb 5 1857 Thurs At night attended large and pleasant party at L[incoln].

Thurs. Feb 4, 1858 Called at Lincoln's.

Wed., Feb 2 1859 At large party at L[incoln]'s. cloudy, foggy. Muddy, dismal day.

Thurs. June 9, 1859 Went to party at night at L[incoln].

Wed, Feb 1, 1860 After tea went to L[incoln] for an hour or two.

Thurs. Aug 9, 1860 In forenoon called at L[incoln] and spent an hour with him, Mrs. Lincoln and Mrs. Judd.[7]

When it came to parties, Mrs. Lincoln did not ignore the younger generation. Her sons' birthdays provided another opportunity to welcome friends and show off her home. Their birthdays were carefully planned and properly celebrated with special favors for each child and games led by Mary. An invitation in her elegant handwriting addressed to her sons' friend "Little Isaac Diller" still exists in the Abraham Lincoln Presidential Library.

The event was a somewhat late celebration of Willie's birthday. Mary wrote to her friend Hannah Shearer, who had left the neighborhood and moved to Pennsylvania for her husband's health:

Speaking of boys, Willie's [ninth] birthday came off on the 21st of Dec. and as I had long promised him a celebration, it duly came off. Some 50 Or 60 boys & girls attended the gala, you may believe I have come to the conclusion, that they are nonsensical affairs. However, I wish your boys, had been in their midst.[8]

Lincoln's Reputation Grows

In 1858, the Lincoln family was excited. "Father" was the Republican candidate for the United States Senate, opposing Stephen A. Douglas. Once again, there was talk of Lincoln's returning to Washington.

When Lincoln challenged Douglas to debate the burning issues of the Kansas-Nebraska Act, Douglas agreed. Thus, the election campaign included

A photograph by Ron Schramm of sculptor Lorado Taft's *A Lincoln-Douglas Debate Memorial Relief* in Washington Park, Quincy, Illinois. *Courtesy of Ron Schramm, Chicago, Illinois.*

what became seven very famous debates across the state of Illinois, beginning in Ottawa and ending in Alton, where Mary was in the audience. Arriving on foot, on horseback, in wagons, in boats or by train, crowds ranging from three thousand to twenty thousand attended the debates. Regardless of the weather—sometimes hot, sometimes freezing—parades with marching bands and colorful banners welcomed the debaters. Liquor flowed freely. It was like the Super Bowl and New Year's Eve rolled into one. There was no debate in Springfield, but when Lincoln arrived home on September 25, a great crowd came to his house that evening to serenade him and welcome him back.

Lincoln lost the Senate election to Douglas, but his reputation spread as a powerfully effective spokesman for the Republican Party in its stand

against the expansion of slavery. Although the door to the Senate closed for Lincoln, another opened: the door to the Republican presidential nomination and, ultimately, to his election as the sixteenth president of the United States.

In 1856, the cottage at Eighth and Jackson had been enlarged and improved at a cost equal to its original purchase price. By June 1859, the carriage (once new when bought from Obed Lewis in 1852) now, at Mary's urging, received refurbishing with a coat of paint on the outside and lovely silk curtains within. The bill came to $19.50.[9]

Also with June came the annual round of strawberry parties, a Springfield custom borrowed from Europe's mid-century "strawberry fever." One week, the Lincolns attended such a gathering every night of the week and reciprocated with their own celebration. Fortunately for Mary, Aunt Mariah Vance was there to help, and the market selling fresh strawberries was only one block away.

Mary wrote to Hannah Shearer:

> *For the last two weeks, we have had a continual round of* strawberry *parties, this last week, I have spent five evenings out—and you may suppose, that this day of rest, I am happy to enjoy. You need not suppose with our pleasures, you are forgotten. I shall never cease to long for your dear presence, a cloud always hangs over me, when I think of you. This last week, we gave a strawberry company of about seventy, and I need not assure you, that your absence was sadly remembered.*[10]

Springfield enthusiastically welcomed the holiday season with shopping on the square in the day and elegant dinners and social gatherings in the evening. Calling on friends, family and neighbors on New Year's Day became another Springfield social custom. Most likely, the Lincolns welcomed their guests at a table piled high with popular foods for this occasion—chicken salad, oysters, bonbons, macaroon pyramids drizzled with sugar, coffee and ice cream. This hospitality would have been reciprocated by friends and neighbors such as the Duboises, the Corneaus and the Braymans and family members such as Ninian Edwards and Clark Smith, only a block away on Seventh Street.

The Excitement of 1860

The year 1860 was electric for the Lincolns, promising a continual widening of their sphere of influence. By February, there was much talk of Lincoln becoming a presidential candidate. The influential *Chicago Tribune* supported his nomination. Then, his speaking tour in the East, starting with his Cooper Union speech on February 27, 1860, in New York, introduced him for the first time to those eastern Republicans who barely knew of him before. In his home state, crowds continued to turn out in the thousands to hear more from this eloquent, charismatic speaker.

In early May 1860, the Illinois Republican convention at Decatur officially endorsed Lincoln as its nominee for president. In the midst of the convention excitement, John Hanks, Lincoln's cousin, appeared with a banner of flags and streamers attached to two split rails, proclaiming Lincoln as the candidate who split rails in his youth. The image captured the public's imagination and followed Lincoln throughout his campaign. Lincoln was dubbed the "rail splitter" and his son the "Prince of Rails," probably a humorous take on Edward, Prince of Wales, heir to the British throne, who was touring North America in 1860. The newly formed Illinois Republican Party now had a candidate it believed could win.

Later, in mid-May, at the Republican National Convention, the Lincoln team, headed by his friends David Davis and Jesse Dubois, fought a vigorous battle on his behalf in the tension-filled environment of the Chicago wigwam (the name given to the temporary structure that housed the convention). Lincoln remained in Springfield, a custom at the time for presidential hopefuls, occupying himself with his law practice and playing handball for relaxation near his office. Mary, intensely interested in the convention's outcome, busied herself at home, cooking, cleaning and helping her husband and sons.

On May 18, 1860, as tension mounted, Lincoln dropped by the *Illinois State Journal* and then the telegraph office seeking the latest news from Chicago. An excited messenger boy burst into the room waving a telegram announcing Lincoln's victory on the third ballot—354 votes over such formidable opposition as William Seward of New York and Salmon Chase of Pennsylvania. To the tolling of church bells and the firing of one hundred cannons punctuating the air, eager to share his victory with Mary, Lincoln excused himself to "take the dispatch up and let her see it." He returned home with a quick step, hurrying past the flags flying on the State House and Republican headquarters, to tell Mary the good news.[11]

That evening, in the rotunda of the State House, hundreds of devoted Republicans assembled by candlelight. Following the young American Band, they marched to the Lincoln Home at Eighth and Jackson, attracting thousands of others to their ranks. John Hay, who became a trusted secretary to Lincoln in Washington, witnessed the occasion and described Lincoln as "the tall, gaunt form of the future anchor of the republic appear[ing] in his doorway, and in a few good-humored and dignified words he thanked them for their kind manifestations of regard."[12] One can only imagine the pushing and jostling of so many friends and strangers eager to be part of this momentous occasion in their history.

Suddenly, the home at Eighth and Jackson Street had become a magnet attracting neighbors on the street, as well as friends and well-wishers from all over the Springfield area and beyond. The plain-spoken, humorous, down-to-earth man so familiar to his neighbors—with top hat, umbrella, battered case in hand, gray shawl over his shoulders and little boys hanging on his coattails—had become someone to be reckoned with.

"I'm a Lincoln, Too!"

On Saturday, May 19, Springfield residents welcomed the train from Chicago carrying the official Republican Presidential Nomination Notification Committee. Among the dignitaries were convention president the Honorable George Ashmun, former Massachusetts congressman; the governor of New York, Edwin D. Morgan; and Francis P. Blair, the great abolitionist and Republican Party founder, with his sons Frank and Montgomery of Maryland. In addition were Henry J. Raymond, editor of the *New York Times*, and other editors to record this significant gathering.

Against a background of blaring bands, an ecstatic crowd greeted the esteemed gentlemen at the depot and escorted them to the Chenery House, where they unpacked and dined. Then, with top hats and canes, they proceeded to the Lincoln Home for their 8:00 p.m. meeting. Carefully scrubbed and smartly dressed in white pantaloons, Willie and Tad waited at the gate to greet the dignitaries. Mr. Evarts of New York leaned over and asked Willie if he was Lincoln's son and shook his hand as Willie smiled and nodded in assent. Tad, not to be ignored, pushed forward and, in a loud voice, proclaimed, "I'm a Lincoln, too!"[13]

Accompanied by two lively boys, the amused dignitaries proceeded to the front door. Here Mary had stationed William Johnson (later Lincoln's valet in Washington) to announce them and direct them to the parlor, where the Lincolns waited to shake their hands.

Lincoln was known only by reputation to most of these gentlemen. Once over the shock of their first impression—a lanky, somber and uncomfortable Lincoln—his warmth, kindness and articulateness convinced them of the rightness of their choice. Lincoln acknowledged the honor with the words, "I tender to you...my profoundest thanks for the high honor done me...Deeply, and even painfully sensible of the great responsibility which is inseparable from this high honor."[14]

An amusing conversation occurred between the tallest member of the delegation, Judge William Kelly of Pennsylvania, and his host. Lincoln asked him his height, to which Kelly responded that he was six feet, three inches tall. Lincoln, chuckling, responded that he was six-foot-four without his high-heeled boots.

"Then Pennsylvania bows to Illinois," retorted Kelly. "My dear man, for years my heart has been aching for a President that I could *look up to*, and I've found him at last in the land where we thought there were none but *little* giants." (Stephen A. Douglas was known as "the little giant" because of his short stature.)[15]

Mary, of course, was at her best, gracing the occasion with her social charms and providing a lovely table of edibles without signs of spirits, thus avoiding any criticism from advocates of temperance.

Reports of her hospitality and sprightliness reached the papers and pleased Mary immensely:

> *This amiable and accomplished lady...she adorns a drawing-room, presides over a table, does the honors on an occasion like the present, or will do the honors at the White House with appropriate grace...She is one of three sisters known for their beauty and accomplishments. Mrs. Lincoln is now apparently about 35 years of age* [she was forty-two]; *is a very handsome woman with a vivacious and graceful manner; is an interesting and often sparkling talker.*[16]

The Largest Demonstration

With the "rail splitter's" nomination for Republican presidential candidate now official, Springfield became a destination site for tourists, old friends and acquaintances, news seekers and journalists from all over the state and country. No longer was Lincoln able to carry on business as usual. He had become a celebrity and Springfield's main tourist attraction.

On August 8, 1860, the Republicans mounted their largest demonstration in Springfield. It was preceded by a bad storm that caused the burning of Crowder's stable and the toppling of the chimney at Corneau and Diller's Drugstore.

In mid-century America, besides the excitement of natural disasters, the most popular entertainments were circuses, religious revivals and political debates and rallies. The rally to end all rallies in Illinois occurred on this day in August. An estimated crowd of eighty thousand locals joined by participants from all over the Midwest and East converged on Eighth and Jackson. People lined up for blocks to shake Lincoln's hand. "I came all the way from Chicago to shake hands with the next president and I'm not going away without doing so," asserted one ardent fan. Lincoln extended his hand and replied, "God bless you."[17]

On its way to the fairgrounds for an immense rally, a parade of from eight to twelve miles long (reports vary) passed down the usually quiet, tree-lined street before the Lincoln Home. It included twenty-two Wide Awake clubs[18] made up of pro-Lincoln young men, ten decorated caravans of ladies, one full-rigged schooner with sails, one huge wagon pulled by six horses with a power loom manufacturing cloth, an immense wagon bearing the sign "Vote for Lincoln the rail splitter" drawn by twenty-six yoke of oxen on which every department of mechanical labor was represented and a wagon carrying thirty-three ladies dressed in white representing the states in the Union.

There were floats representing the flatboat that took Lincoln on his trip to New Orleans and a log cabin covered with coonskins and deer hides. A lone lady, also in white, followed them in a small buggy representing Kansas with the sign "Won't you let me in." The crowd belted out songs such as "Old Abe Lincoln Came Out of the Wilderness" and "Ain't You Glad You Joined the Republicans" to the tune of "The Old Gray Mare."[19]

William A. Shaw, a professional photographer from Chicago, managed to climb to the second floor of either Harriet Dean's or Ira Brown's house across the street and snap some photos for posterity. Lincoln is dressed in a

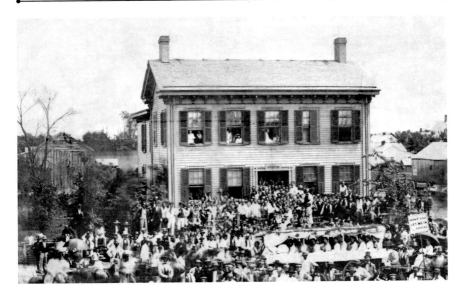

The "Rally Photograph," a photograph of Abraham Lincoln's Home on August 8, 1860, by William A. Shaw of Chicago, Illinois. The photograph shows Abraham Lincoln viewing a parade float carrying thirty-three young women dressed in white passing his home. These women represent the thirty-three states of the Union in 1860. *Courtesy of the Abraham Lincoln Presidential Library & Museum.*

white suit and is standing near the front door. Mary observes from the left first-floor window, and Willie Lincoln leans out of the second window from the left on the second floor.[20]

Elizabeth Lushbaugh Capps, former neighbor and Thomas Lushbaugh's daughter, who had grown up across the street from the Lincolns, describes this historical event in her "Early Recollections of Abraham Lincoln":

> *There never was such a time before nor has there ever been anything to compare with it since. No one having attended can ever forget it. Some traveled three and four days to get there. There was a daytime celebration and a torchlight procession at night...Those waiting to shake hands with Mr. Lincoln stood in a line blocks long waiting their turn...In the evening was the torchlight procession. It was said to be 12 miles long with illuminated floats...It was the most wonderful gathering ever in Illinois. The city couldn't furnish sleeping quarters for all these people so, as it was August and very warm weather, they lay along the curbing and inside on the lawns of private residences. My party didn't find sleeping places until after 12 o'clock. This surely was a time never to be forgotten.[21]*

Illinois congressman Elihu B. Washburne, who was in Springfield with the Lincolns that day, said, "I know of no demonstration of a similar character that can compare with it except the review by Napoleon of his army for the invasion of Russia, about the same season of the year, in 1812."[22]

Joshua Zeitz summed up this period full of tension and release: "From the moment that it began, the presidential race of 1860 emerged as one of the most dramatic moments then or since in American political life."[23]

"Mary, Mary, We Are Elected!"

Three months later, in November 1860, Lincoln won the prized presidential election. As he hurried home at 1:30 a.m. to share the news of their joint victory with his biggest supporter, he was heard calling out, "Mary, Mary, we are elected!"[24] Her childhood dream of becoming the wife of the president of the United States had come true!

Immediately, Mary began preparations for Lincoln's second tour of duty in the country's capital. As for her husband, once the initial excitement of election success had passed, Lincoln faced the daunting task of holding together a country coming apart at the seams. Behind his smiles and handshakes lay the dark cloud of anxiety for the future of his beloved country.

With Lincoln now the president-elect, the house at Eighth and Jackson witnessed a constant stream of people—friends and strangers alike, particularly those seeking patronage for themselves or others, along with journalists, photographers and politicians, some well mannered and well dressed, others, scruffy and ill behaved. The campaign had touted Lincoln as the rail-splitter, a man of the people. And "the people" consequently felt no shyness about showing up and paying their respects. Most came uninvited and parked themselves on a rocker or on a lovely Lincoln settee, awaiting an audience with Lincoln or a glimpse of the missus. One reporter saw strangers pointing in Mary Lincoln's direction and rudely asking, "Is this the old woman?"[25] At one event, possibly New Year's, Lincoln had to direct some young men to forcibly eject a stubborn guest who refused to leave.[26]

This continual invasion of their privacy forced Lincoln to divert the crowds elsewhere. He readily accepted an offer to make use of the governor's office in the state building for conducting business and meeting with throngs of visitors during this four-month interim period before leaving for Washington. Despite all this pressure for his attention, Lincoln showed

the same friendliness and infinite patience that would characterize him as president, one who sometimes shook the hands of so many that his hand became bruised and swollen.

Among the many visitors to Springfield, a select few came as invited guests of the president-elect. During this forced period of waiting, dubbed "the Great Secession Winter" by writer and historian Henry Adams, Lincoln monitored threats from the South. He also endured the positive and negative assessments of himself by the press while pondering his choices for the best men to serve in his cabinet. He felt it imperative that they represented different parts of the country and included some of his very able opponents for the Republican nomination. Thus, Salmon P. Chase of Ohio; Edward Bates of Missouri; Thurlow Weed, William H. Seward's representative from New York; and Simon Cameron of Pennsylvania came to confer at Lincoln's Springfield office and home.[27]

With most of the visitors gone now from Eighth and Jackson, Mary could make preparations for the family's departure. She saw to it that some furniture was packed, some stored at the Burches across the street and some sold to neighbor Samuel Melvin and others. The beloved family dog, Fido, found a new home with John Roll and his family nearby, and the drayman John Flynn became the owner of the horse Old Bob. The house itself was leased to Mr. and Mrs. Lucian Tilton, president of the Great Western Railroad, which would carry Lincoln and his family and friends on the first leg of their journey to Washington.

A neighbor, Jared P. Irwin, found Mary Lincoln preparing to toss a pile of family correspondence into the rubbish fire behind the home. He asked if he might have a few for remembrance, and she gave him sixty of these. Aunt Mariah rescued the remains of a photograph album that otherwise would have been lost.[28]

The house at Eighth and Jackson saw its last official event or "levee"—as Mary preferred to call such an occasion—on February 6, 1861, a pleasant day bringing hope of spring. Again, the street was filled with over seven hundred people jostling to give their last farewells to the Lincolns. It took nearly twenty minutes to reach the front entrance, where they could enter the home to be greeted by their future president and first lady. Mary's sisters, Anne, Frances and Elizabeth, and half sisters from Lexington were present to assist Mary at this time.

The *Missouri Democrat*, in February 1861, enthusiastically reported the event:

The first levee given by the President-elect took place last evening at his own residence in this city and there was a grand outpouring of citizens

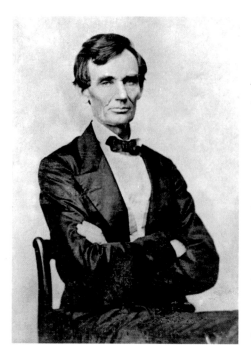

and strangers together with the members of the legislature. Mr. Lincoln threw open his house for a general reception of all the people who felt disposed to give him and his lady a parting call. The levee lasted from seven to Twelve o'clock in the evening and the house was thronged by thousands up to the latest hour. Mr. Lincoln received the guests as they entered and were made known. They then passed on and were introduced to Mrs. Lincoln, who stood near the center of the parlor, and who, I must say acquitted herself most gracefully and admirably.[29]

An ambrotype (photograph) of Abraham Lincoln, fifty-one-year-old presidential candidate, taken on August 11, 1860, by Preston Butler of Springfield, Illinois. *Courtesy of the Abraham Lincoln Presidential Library & Museum. The original is in the Library of Congress.*

The End of an Era

Closing the door on their home for the last time, Abraham, Mary, Willie and Tad Lincoln relocated to a second-floor suite in the Chenery House at Fourth and Washington Streets, where they spent the weekend before their Washington departure. By this time, Robert had entered Harvard but returned home to accompany his family on their journey east.

In an interview years later, Mariah Vance described her last service to the family:

> *Mrs. Vance says that she packed up all the belongings of Abraham Lincoln and his wife when they left for Washington after Mr. Lincoln's election to the presidency. After this was done she cleaned the house, carefully closing the windows and locking the doors when her work was finished. She took the keys to the old Chenery hotel, where Mr. Lincoln was staying, and delivered them to the proprietor, who turned them over to the owner.*[30]

On the gloomy and rainy Monday morning of February 11, 1861, Lincoln and his family traveled in a carriage, driven by their neighbor Jameson Jenkins, to the Great Western Station. There, close to one thousand people gathered to bid them farewell and Godspeed. Lincoln responded with a brief, emotional tribute to this town—to his friends and neighbors who had nurtured him. Visibly moved, he began with the memorable words, "My friends, no one, not in my situation, can appreciate my feeling of sadness at this parting. To this place, and the kindness of these people, I owe everything."

Thus came to an end the happiest period in the life of the Lincolns, a period in which Mary had enjoyed her role as confidante to Lincoln and hostess without parallel. She had achieved the goal of her youth to become the wife of a president. Washington was a turbulent city, preparing for war, with many Southern sympathizers and Southern legislators leaving to join the Confederacy and outspoken critics of the "bumpkins" from the rough-and-tumble West. Neither Lincoln nor Mary would again enjoy such love and support and the close association with friends and neighbors.

The Last Farewell

The last major Lincoln-related event in the neighborhood was neither party nor parade but a funeral procession on May 4, 1865. A hearse decorated with black plumes and drawn by six horses bore the casket with the body of the slain sixteenth president of the United States.

The funeral procession from the State Capitol to Oak Ridge Cemetery took a circuitous route in order to pass by the Lincoln Home at Eighth and Jackson. One can imagine that most impressive of processions led by Old Bob and Reverend Brown coming down Eighth Street past all of the familiar homes of Lincoln's neighbors decorated in black funeral mourning. The neighbors who played such an important part in his life would have stood in quiet reverence as the funeral hearse passed with his body, now dead for twenty-one days. They would be the last of millions to bid him farewell. It would have been quiet except for the sound of footsteps and horse-drawn carriages and the painful sound of funeral dirges played by military regiments.

There is no description of the hearse as it passed Lincoln's home. Did it pause for a moment to acknowledge his life lived there, so full of both

A photograph of the funeral-decorated Lincoln Home with Reverend Henry Brown to the left, or rear, of Old Bob and the Reverend William Trevan on the right, or front, of the horse on the day of the Lincoln funeral, May 4, 1865, by Frederick W. Ingmire of Springfield, Illinois. *Courtesy of the Abraham Lincoln Library & Museum.*

happiness and sadness? Were the neighbors remembering his presence among them, his many acts of neighborly kindness and generosity, his love of the children and animals, his playful nature, his simple dignity without pretense or vanity, his patience, his acceptance of diversity and ability to quickly forgive? He had been president of the United States, but to the residents of Eighth and Jackson Streets, Abraham Lincoln would always be remembered as a trusted friend and beloved neighbor.

Appendix A

Irish Families Living in the Lincoln Neighborhood

JANE ALSOP, a twenty-nine-year-old milliner born in Ireland, lived on the east side of Eighth, between Market (Capitol) and Jackson Streets. Her husband Thomas was a miller born in England.

HENRY CARRIGAN, age fifty, and Susan, his fifty-year-old wife, were both born in Ireland. They lived on Eighth Street, between Market (Capitol) and Jackson, next door to the north of the Lincoln Home. Their twelve-year-old son, Henry, was born in Illinois.[1]

HUGH CARRIGAN, a twenty-four-year-old Irish-born son and livery stable operator (Moran & Carrigan Boarding), also lived with the Carrigan family.[2]

CHARLES CONNE(O)R, a fifty-three-year-old Irish man, was a laborer who lived at the southeast corner of Eighth and Adams Streets. Living with him were his fifty-year-old wife, Bridget, and their two children, eighteen-year-old Patrick and twelve-year-old Mike. The parents and children were all born in Ireland.[3]

JOHN CUNNINGHAM, a forty-five-year-old Irish man, was a painter who lived on the east side of Seventh Street, between Jackson and Edwards Streets. Living with him were his forty-five-year-old wife, Mary, and their two children, seventeen-year-old Margaret and twelve-year-old Patrick. All were born in Ireland.[4]

ANDREW L. FAWCETT, a twenty-four-year-old Irish-born moulder at J.C. Lamb's, came to Springfield in 1856. He lived on the west side of Ninth Street, between Jackson and Edwards Streets.[5]

WILLIAM FAWCETT was a fifty-year-old Irish-born porter on the Great Western Railroad. Also born in Ireland were his forty-nine-year-old wife, Eliza, and their three daughters: Jane, age twenty-five; Eliza, age twenty-two; and Mary, age nineteen. William and his family came to Springfield in 1856 and lived on the west side of Ninth Street, between Jackson and Edwards Streets.[6]

WILLIAM FAWCETT JR., a thirty-year-old Irish-born moulder at J.C. Lamb's, came to Springfield in 1856. He lived on the west side of Ninth Street, between Jackson and Edwards Streets.[7]

PHILIP FOGARTY, a fifty-year-old Irish-born drayman, and Margaret, his thirty-two-year-old Irish-born wife, lived at the southeast corner of Eleventh and Adams Streets. Living with them was a fifty-year-old Irish-born washerwoman, Mrs. Sexton.[8]

THOMAS MURPHEY, a fifteen-year-old Irish boy, lived in the home of Caleb Birchall at the southwest corner of Sixth and Cook Streets.[9]

MARY SCHONSTEIN was the twenty-six-year-old Irish-born wife of Michael, who was born in Baden, Germany. The family lived at the northeast corner of Edwards and Ninth Streets.[10]

THOMAS SHAUGHNAHAM, a fifty-one-year-old Irish-born laborer, came to Springfield in about 1855 and lived on the west side of Seventh Street, between Edwards and Cook Streets. Living with him were his fifty-year-old Irish-born wife, Margaret, and their two children, seventeen-year-old Margaret and twelve-year-old Patrick.[11]

Appendix B

IRISH SERVANTS LIVING IN THE LINCOLN NEIGHBORHOOD

MARY BINCE, a twenty-five-year-old native of Ireland, was a servant at the Asa Eastman residence at the southwest corner of Sixth and Edwards Streets.[1]

JOHANA BROMON, a twenty-year-old native of Ireland, was a servant at the Richard Latham residence at the southwest corner of Sixth and Monroe Streets.[2] Lincoln would stop here and sit on the porch on his way to and from home.[3]

MARY E. CLAU, a twenty-eight-year-old Irish woman, was a servant in the home of Mason Brayman, who lived on the east side of Sixth Street between Jackson and Edwards Streets.[4]

JOHN DALEY, a twenty-six-year-old Irish man, was a farmer/servant in the home of Jacob G. Loose, who lived at the southeast corner of Seventh and Cook Streets.[5]

PATRICK DAILY, a twenty-four-year-old native of Ireland, was a servant at the John D. Keedy residence at the northwest corner of Market (Capitol) and Sixth Streets.[6]

CATHERINE DANA, a twenty-one-year-old Irish woman, was a servant in the home of Obed Lewis. Lewis lived at the southwest corner of Seventh and Jackson Streets.[7]

E. EADE, a twenty-one-year-old Irish woman, was a servant in the home of Jacob Bunn on the west side of Sixth Street, at the dead-end of Jackson Street.[8]

MARTIN EDWARD, an eighteen-year-old native of Ireland, was a servant at the Asa Eastman residence at the southwest corner of Sixth and Edwards Streets.[9]

JOANA FEEZER, a twenty-five-year-old Irish girl, was a servant in the home of John G. Schermerhorn, who lived on Sixth Street between Monroe and Market (Capitol) Streets.[10]

E.E. FITZGERALD, a sixteen-year-old Irish girl, was a servant in the home of George W. Chatterton, who lived on the west side of Sixth Street between Market (Capitol) and Edwards Streets.[11]

ANN FLOOD, a seventeen-year-old Irish girl, was a servant in the home of Robert Irwin, who lived at the southeast corner of Sixth and Cook Streets.

JOHN FOGARTY, a fifteen-year-old native of Ireland, was a servant at the Reuben Francis Ruth residence at the southeast corner of Eleventh and Adams Streets.[12]

JULIE FOGARTY, a forty-year-old native of Ireland, was a servant at the Reuben Francis Ruth residence at the south corner of Eleventh and Adams Streets.[13]

ANN GRADY, a twenty-four-year-old Irish woman, was a servant in the home of Joshua F. Amos. Amos lived at the northeast corner of Market (Capitol) and Eighth Streets.[14]

ALICE GUATHMEY, a forty-five-year-old Irish woman, was a servant in the home of Robert Irwin, who lived at the southeast corner of Sixth and Cook Streets.[15]

MARY LAMB, a twenty-four-year-old Irish woman, was a servant in the home of George R. Teasdale. Teasdale lived at the northwest corner of Market (Capitol) and Eighth Streets.[16]

JAMES LAWLESS, a thirty-year-old Irish man, was a coachman in the home of John Alexander McClernand. McClernand lived at the northwest corner of Edwards and Seventh Streets.[17]

J. MAHON, a twenty-year-old Irish woman, was a servant in the home of Dr. William S. Wallace, Lincoln's brother-in-law. Wallace lived at the southeast corner of Market (Capitol) and Seventh Streets.[18]

BRIDGET MALONEY, a nineteen-year-old Irish girl, was a servant in the home of Jesse Kilgore Dubois. Dubois lived on the west side of Eighth Street, between Jackson and Edwards Streets.[19]

MARY McCUE, a thirteen-year-old Irish girl, was a nurse in the home of George R. Teasdale. Teasdale lived at the northwest corner of Market (Capitol) and Eighth Streets.[20]

ELIZABETH McGRAIN (McGEOUD), a twenty-year-old native of Ireland, was a servant at the John F. Hutchi(n)son residence at the southwest corner of Market (Capitol) and Fifth Streets.[21]

ANN MEDENA, an eighteen-year-old Irish girl, was a servant in the home of Henry P. Cone (Cane). Cone lived on the west side of Seventh Street, between Market and Jackson Streets.[22]

MARY MORLEY, a nineteen-year-old Irish girl, was a servant in the home of Dr. C.G. French, Lincoln's dentist. French lived on Seventh Street, between Market and Jackson Streets.[23]

KATE ROONEY, a nineteen-year-old Irish girl, was a servant in the home of Caleb Birchall, who lived at the southwest corner of Sixth and Cook Streets.[24]

MARY ROONEY, an eighteen-year-old Irish girl, was a servant in the home of Dr. John Todd, who lived on the east side of Sixth Street, between Monroe and Market (Capitol) Streets.[25]

JOHN RYAN, a nineteen-year-old Irish girl, was a servant in the home of Jacob Bunn on the west side of Sixth Street at the dead-end of Jackson Street.[26]

NANCY SALMON, an eighteen-year-old Irish girl, was a servant in the home of Isaac Keys. Keys lived on the west side of Seventh Street, between Market and Jackson Streets.[27]

HARRIET SMITH, a twenty-year-old Irish woman, was a servant in the home of Elijah Iles.[28]

MARY SMITH, a twenty-year-old Irish woman, was a servant in the home of Elijah Iles.[29]

MARGARET STEVENSON, a sixteen-year-old Irish girl, was a servant in the home of Mason Brayman, who lived on the east side of Sixth Street, between Jackson and Edwards Streets.[30]

B.M. TIERNEY, a thirty-six-year-old Irish woman, was a servant in the home of William L. Van Harlingen (Harlinger). Van Harlingen lived at 85 South Sixth Street.[31]

KATE TIERNEY, a sixteen-year-old Irish girl, was a servant in the home of William H. Beedle. Beedle lived on the west side of Eighth Street, across the street from the Lincolns, between Market (Capitol) and Jackson Streets.[32]

Appendix C

GERMAN FAMILIES LIVING IN THE LINCOLN NEIGHBORHOOD

JOHN BRESSMER was born on June 8, 1833, in Wurtenburg, Germany. In 1860, he was a clerk at Hurst and Matheny and lived at 77 South Ninth Street, between Jackson and Edwards Streets.[1] In 1848, his father embarked with his wife and seven children and landed at New Orleans sixty days after leaving Havre. He came up the river to St. Louis, thence to Pekin, Illinois, which he reached on July 4, 1848, and thence traveled in a wagon to Mt. Pulaski, Logan County.[2]

ELLEN DEALING, a native of Prussia, was a boarder at the residence of Martin Van B. Hickox at the northwest corner of Seventh and Cook Streets.

JACOB J. DECKER boarded at the boardinghouse of Peter Sperry at 89 South Seventh Street between Market (Capitol) and Jackson. Decker was a twenty-seven-year-old pressman at the *Journal* who was born in Baden.[3]

ADAM DENNES (DENNIS), a twenty-nine-year-old German weaver who was born in Hesse Cassel, Germany, and his twenty-two-year-old wife, Betty, who was born in Holland, lived at 115 South Seventh, between Edwards and Cook Streets, with their three Illinois-born children: Mary, age six; Herman, age three; and Caroline, age one.[4]

BARBARA DINGLE (Dinker, Dinkel, Dinckel), a thirty-five-year-old widow and native of Wurtemburg, Germany, lived on the south side of Edwards

between Eighth and Ninth Streets.[5] Living with her were eighty-year-old John M. and sixty-two-year-old Margaret Mergenthaler (Merguthole), also natives of Wurtemberg, Germany.[6]

HENRY DOENES (DENNIS), a thirty-two-year-old laborer and native of Hesse Cassel, Germany, and his wife, Mary, a forty-seven-year-old native of Saxi Heinnour, Germany, along with a thirteen-year-old boy, Augustus Featsher, who was born in New York, lived at the southeast corner of Seventh and Edwards Streets.[7]

JACOB FETZER, a forty-two-year-old laborer and native of Germany (Prussia), lived at the southeast corner of Seventh and Edwards Streets.[8]

CHARLES F. HERMAN, a thirty-one-year-old native of Prussia, was a freight agent on the Great Western Railroad. He lived with his twenty-four-year-old wife, Theresa, who was also born in Prussia.[9]

RICHARD JACOB, a twenty-seven-year-old Prussian-born teamster, was a boarder at Henry C. Myers's residence at 73 South Ninth, between Jackson and Edwards.[10]

PHILIP MISCHLER (MESCHLER), a thirty-nine-year-old cooper, and his wife, Elizabeth Hoechster, age thirty-seven years, were both born in Germany, Philip in Heppenheim, Hesse Darmstadt, Germany, and Elizabeth in Hemsbach, Baden, Germany. He came to New York City on September 17, 1839, and traveled to St. Louis, then to Springfield, arriving on September 7, 1840. He learned the business of coopering in Springfield and carried it on quite extensively from 1844 to 1868. They lived at the southeast corner of Eighth and Edwards. They had two sons: Phillip, age thirteen, and Henry, age one month.[11]

JACOB NONNEMAN (NORRIARD), a twenty-nine-year-old engineer and native of Wurtemburg, Germany; his thirty-one-year-old wife, Catherine, a native of Prussia; and their two-year-old child, August,[12] lived at the southeast corner of Seventh and Edwards Streets.[13]

JOHN PIERICK, a thirty-nine-year-old Holland-born blacksmith (firm of Pierick & Brothers), and his thirty-eight-year-old wife, Mary, who was born in Hesse Cassel (Germany), lived at 115 South Seventh, between Edwards and Cook Streets, with their six-month-old daughter, Mary.[14]

HENRY REMANN, a German immigrant, and his wife, Mary Black Remann, lived in a home at the southeast corner of Market (Capitol) and Eighth. Lincoln knew Henry from his Vandalia days. The families became close friends, sharing birthdays and holidays together. Henry even encouraged Abraham to study German. In 1849, thirty-two-year-old Henry Remann Sr. died of tuberculosis (then called consumption), the number one cause of death in children and adults in mid-century America.[15] He left his widow, Mary, pregnant with his child.

FRANK RICHARD, a twenty-nine-year-old native of Germany, operated the Washington House hotel at the southwest corner of Ninth and Adams Streets. He lived there with his twenty-six-year-old wife, Catherine, a native of Baden, Germany, and three children: Mary, a five-year-old Hessian; Jacob Kloffer, a seventeen- year-old Hessian; and August Hineman, a four-year-old native of Wuirtemburg.[16]

HEXTER SCHNODY, an eighty-year-old farmer who was born in Baden, Germany, was also Lincoln's neighbor. He lived at Philip Mischler's (Meschler) at the southeast corner of Eighth and Edwards.[17]

MICHAEL SCHONSTEIN, a thirty-year-old cooper born in Baden, Germany, and his twenty-six-year-old wife, Betty, who was born in Ireland, lived at the northeast corner of Edwards and Ninth Streets with their three Illinois-born children.[18]

JOHN HENRY (J.W.) SCHUCK, a thirty-year-old native of Heidleburg, Baden, Germany, was a clerk at G.L. Huntington's, living with his wife, Kate, who was a twenty-nine-year-old native of Wurtemburg, Germany. They lived on the south side of Adams, between Ninth and Tenth.[19]

JULIA ANN SPRIGG, the widow of John Sprigg and sister of Henry Remann, was forty-four years old and born in Baden, Germany. She lived on the west side of Eighth Street between Jackson and Edwards.[20] In 1853, shortly after her husband's death, Julia Ann Sprigg purchased 507 Eighth Street. With her seven children, she became an active member of the neighborhood and one of Mary's closest friends. Her daughter Julia often babysat for the Lincoln boys. The bond of friendship between these women remained throughout Mary's life, as verified by their ongoing correspondence when Mary became the first lady and then the widow of the martyred president.

EMILY B. WHITNEY, a twenty-two-year-old Prussian native, lived at the Reverend N.W. Miner residence on the south side of Edwards, between Sixth and Seventh Streets.

JOHN ZELLER(S), a seventy-four-year-old native of Prussia, was a teamster living with his wife, Margaret, a forty-seven-year-old native of Prussia. They lived on the south side of Edwards between Seventh and Eighth Streets.[21]

Appendix D

GERMAN SERVANTS LIVING IN THE LINCOLN NEIGHBORHOOD

The 1860 census showed nine German-born persons working as servants and living in the houses where they served.

MARY BAKER, a twenty-one-year-old German servant, lived at the Jacob Ruckel residence at the southwest corner of Seventh and Edwards Streets.[1]

GEORGE BOWER, a twenty-four-year-old German servant, lived at the home of Lincoln's brother-in-law, Dr. William S. Wallace, at the southeast corner of Ninth and Market Streets.[2]

ELLEN DUNSHA, an eighteen-year-old Prussian native, was a servant living at the Reverend N.W. Miner residence on the south side of Edwards, between Sixth and Seventh Streets.[3]

THEODORE FENEMAN, a nineteen-year-old native of Prussia, was a servant at the Martin Van B. Hickox residence at the northwest corner of Seventh and Cook Streets.[4]

E. FONDERGREEN, an eighteen-year-old native of Bavaria, Germany, was a servant at the Edward B. Pease residence at the southeast corner of Sixth and Jackson Streets.[5]

ELIZABETH HOCTMAN, a twenty-year-old native of Hanover, Germany, was a servant at the John D. Keedy residence at the northwest corner of Market (Capitol) and Sixth Streets.[6]

LEONARD LAWLESS, a fourteen-year-old Prussian native, was a servant at the John A. McClernand residence at the northwest corner of Edwards and Seventh.[7]

EMMA RIPTIEN, a native of Wurtemburg, was a servant at the Dr. Charles Ryan residence at the northeast corner of Sixth and Jackson Streets.[8]

MARY SELICK, a thirteen-year-old German servant, lived in the home of Stephen A. Corneau at 91 South Sixth, between Market and Jackson.[9]

Appendix E

ENGLISH AND SCOTTISH FAMILIES LIVING IN THE LINCOLN NEIGHBORHOOD

THOMAS ALSOP lived on the east side of Eighth, between Market (Capitol) and Jackson Streets. Thomas was a miller born in England, and his twenty-nine-year-old wife, Jane, was a milliner born in Ireland.

PETER BERRIMAN, a thirty-five-year-old foundry man with the company of Berriman and Rippon, was born in Yorkshire, England, on September 24, 1825. He came to Springfield from England. He and his thirty-six-year-old wife, Adeline, a native of Canada, lived on the east side of Ninth between Jackson and Edwards Streets.[1] They had six children, including Peter; Adeline, the wife of William McConnell, a broker; and Celia, the wife of Henry Shore of Marshalltown, Iowa.[2]

EDWARD JOSEPH BUGG, a forty-eight-year-old teamster and native of England; his wife, Nancy, a native of Virginia; and their fifteen-year old son, Hampton, who was an apprentice carpenter, lived in a one-and-a-half-story frame house at 418 South Eighth, between Market and Jackson Streets, two doors north of the Lincoln Home.[3]

ROBERT B. CAMPBELL, a forty-one-year-old tailor and native of Scotland, lived on the east side of Fifth Street.[4]

CHARLES DALLMAN, local builder, from Staffordshire, England, and his wife, Harriet, from Kent lived on the north side of Jackson Street, a few doors west of Eighth.

DAVID DOE, a thirty-five-year-old laborer/stone mason and native of England,[5] lived on the west side of Eighth Street, between Edwards and Cook Streets.

ELEANOR DOYLE, a seventy-four-year-old native of Wales, was living with William B. Corneau on the east side of Seventh Street, between Jackson and Edwards Streets.[6]

ALEXANDER GRAHAM, a thrity-five-year-old carpenter with Dallman & Graham; his thirty-two-year-old wife, Rebecca; and their ten-year-old daughter, Elizabeth, all of whom were natives of Scotland,[7] lived on the west side of Eighth Street, between Jackson and Market (Capitol) Streets.[8] Boarding with them was Mary Brown, a thirty-four-year-old native of Scotland.

WILLIAM KING, a forty-two-year-old merchant and native of England, and his twenty-five-year-old wife, Josephine, a native of Pennsylvania, lived with William's eighteen-year-old daughter, Kate, who was a native of England; his fifteen-year-old daughter, Louisa; his fourteen-year-old son, Charles; and his thirteen-year-old daughter, Jennie, all of whom were born in England, as well as his three-year-old daughter, Clara, born in New York, and his one-year-old son, David H., born in Illinois. They lived at the northeast corner of Ninth and Cook Streets.[9]

CHARLES McKEEHNIL, a fifty-eight-year-old blacksmith and native of Scotland, lived on the east side of Fifth Street, between Edwards and Cook Streets (129 South Fifth).[10]

ROBERT SNAPE, a thirty-seven-year-old silver plater/bell hanger and native of England, lived on the east side of Fifth Street, between Market and Jackson Streets.[11]

ROBERT UNDERWOOD, a thirty-eight-year-old carpenter, and his wife, Jessie, were both natives of Scotland.[12] They lived on the east side of Eighth Street, between Edwards and Cook Streets.

Notes

Chapter 1

The facts and figures in this chapter were taken from many sources; however, special acknowledgment goes to *"Here I Have Lived": A History of Lincoln's Springfield, 1821–1865* by Paul M. Angle and *By Square and Compass: Saga of the Lincoln Home* by Dr. Wayne C. Temple.

1. Iles, *Sketches of Early Life and Times*, 30. Lincoln's and Iles's histories intertwined frequently; they first knew each other as volunteers fighting the Sauk Indians in the Black Hawk War of 1832. The Lincolns purchased their home on land in the Elijah Iles subdivision, and Elijah Iles was a pallbearer at Lincoln's funeral in Springfield in May 1865.
2. Ibid., 31.
3. Angle, *"Here I Have Lived,"* 9–13.
4. Ibid., 88.
5. Abraham Lincoln to Mary Owens, Springfield, May 7, 1837, in Basler, *Collected Works of Abraham Lincoln*, 78–79.
6. William Cullen Bryant, as quoted in Angle, *"Here I Have Lived,"* 44.
7. Angle, *"Here I Have Lived,"* 57–58.
8. Ibid., 115.
9. Ibid., 108.
10. Temple, *By Square and Compass*, 26–27.
11. Randall, *Lincoln's Sons*, 13.
12. Temple, *By Square and Compass*, 31–34.
13. Turner and Turner, *Mary Todd Lincoln*, 506.
14. Ostendorf and Oleksky, *Oral History*, 136.
15. Temple, *By Square and Compass*, 32.

16. Wood, "George and Eliza Wood."
17. Capps, "My Early Recollections," 2.
18. Lawrence, "Some Memories," 11.
19. Angle, *"Here I Have Lived,"* 144.
20. Ibid., 162–63.
21. Ibid., 166.
22. Ibid., 176.
23. Howarth, "Mr. and Mrs. Lincoln's Neighbors."

Chapter 2

1. James C. Conkling to Mercy Ann Levering, September 21, 1840.
2. Helm, *True Story of Mary*, 81.
3. Elizabeth Edwards to W.H. Herndon (WHH), January 10, 1866, in Wilson and Davis, *Herndon's Informants*, 443–45.
4. The Whig Party was formed in opposition to the Democratic Party and was active in early nineteenth-century America. The word *Whig* was associated with the opposition to tyranny and the struggle for American independence. Eventually, the controversy over the expansion of slavery into the territories destroyed the party, and it was replaced by the Republican Party. Abraham Lincoln was a Whig who became a Republican and the first president to be elected by the new party.
5. In the late 1840s and early 1850s, small rural communities depended on traveling circuit riders to hold court and try criminal and civil cases. Lincoln was a popular member of a traveling troupe of lawyers and a judge who covered the Eighth Circuit twice a year for three months in the fall and spring. Lincoln thoroughly enjoyed his years riding the circuit with men who became lifelong friends like Judge David Davis, Ward Hill Lamon and Leonard Swett.
6. Lincoln to Joshua Speed, as quoted in Epstein, *The Lincolns*, 76.
7. Temple, *Abraham Lincoln*, 27.
8. Greek Revival was a style of architecture popular in the United States prior to the Civil War and during the Lincoln era in Springfield from 1837 to 1860. "Inspired by the architecture of ancient Greece, buildings in this style are patterned after Greek temples." Hart, *Greek Revival Architecture*, inside cover.
9. Baker, *Mary Todd Lincoln*, 103.
10. Margaret Ryan to Jesse W. Weik, October 27, 1886, Wilson and Davis, *Herndon's Informants*, 596–97.
11. Mary Todd Lincoln to Josiah Holland, December 4, 1865, in Turner and Turner, *Mary Todd Lincoln*, 292–94.
12. James Gourley to WHH, February 9, 1866, in Wilson and Davis, *Herndon's Informants*, 451–53.
13. Baker, *Mary Todd Lincoln,* 17.
14. Mary Lincoln to Hannah Shearer, October 2, 1859, Turner and Turner, *Mary Todd Lincoln*, 59–60.
15. "Noyes W. Miner Papers Collection," October 15, 1881, 8.

16. Browne, *Every-Day Life of Abraham Lincoln.*
17. *Illinois Register,* quoted in Sandburg, *Abraham Lincoln,* 407.
18. *Illinois Daily Journal,* March 27, 1849.
19. Ibid., February 2, 1850, 3.
20. Holzer, *Lincoln As I Knew Him,* 28.
21. Kunhardt, "Lincoln's Neighbors," 57.
22. "Took Tea at Mrs. Lincoln's: The Diary of Mrs. William M. Black," 59–64.
23. Ibid.
24. Ibid.
25. Mary Lincoln to Elizabeth Dale Black, September 17, 1853, in Turner and Turner, *Mary Todd Lincoln,* 42.
26. Mary Lincoln to Julia Ann Sprigg, in Turner and Turner, *Mary Todd Lincoln,* 127–28.
27. Chenery, "Mary Todd Lincoln."
28. Mary Lincoln to Mary Brayman, c. 1857, in Turner and Turner, *Mary Todd Lincoln,* 51.
29. Randall, *Lincoln's Sons,* 58–59.
30. Mary Lincoln to Hannah Shearer, October 2, 1859, in Turner and Turner, *Mary Todd Lincoln,* 59–60.
31. "Noyes W. Miner Papers Collection," 9.
32. After the Shearers left, the Lushbaughs sold the property to William Burch, who stored some of the Lincolns' furniture when they departed for Washington.
33. Mary Lincoln to Hannah Shearer, April 24, 1859, in Turner and Turner, *Mary Todd Lincoln,* 54–56.
34. Ibid., June 26, 1859, 56–57.
35. Randall, *Lincoln's Sons,* 44–45.
36. Mary Lincoln to Mrs. Samuel H. Melvin, April 27, 1861, in Turner and Turner, *Mary Todd Lincoln,* 85–86.

Chapter 3

1. Gassner, *Best Plays,* 749.
2. Holzer, *Lincoln As I Knew Him,* 35; Tarbell, *Life of Lincoln,* 24.
3. Sandburg, *Abraham Lincoln,* v. 1, vii.
4. Ibid., 47.
5. Brooks, *Washington in Lincoln's Time,* 31.
6. Randall, *Lincoln's Sons,* 45.
7. Philip Wheelock Ayres interview, *Review of Reviews,* February 1918, in Wilson, *Lincoln Among His Friends,* 85
8. Ibid.
9. Mary Lincoln to WHH, September 1866, in Wilson and Davis, *Herndon's Informants,* 357–58.
10. Capps, "Recollections," 2.
11. Randall, *Lincoln's Boys,* 40–41.
12. Tarbell, *Life of Abraham Lincoln,* 30.

13. Gary, *Following in Lincoln's Footsteps*, 136.

14. Browne, *Every-Day Life of Abraham Lincoln*, 78.

15. Helm, *True Story of Mary*, 115.

16. Randall, *Mary Lincoln*, 138–39.

17. Frank P. Blair to J. McCan Davis, December 9, 1898, in Burlingame, *Inner World*, 59.

18. Weik, *Real Lincoln*, 124, as quoted in Burlingame, *Inner World*, 57–58.

19. Wilson, *Intimate Memories*, 136, originally printed as "A Neighbor Boy's Recollections" in the *Illinois State Journal*, January 28, 1909.

20. Ibid., 136.

21. Dubois, "I Knew Lincoln," 20, as quoted in Burlingame, *Inner World*, 58.

22. Wilson, *Intimate Memories*, 138.

23. Ibid., 137.

24. Randall, *Lincoln's Animal Friends*.

25. *New York Times*, February 6, 1938, 2:6, as quoted in Burlingame, *Inner World*, 59.

26. Browne, *Every-Day Life of Abraham Lincoln*, 202.

27. Wilson, *Lincoln Among His Friends*, 87.

28. Hart, *Circuses in Lincoln's Springfield*, 55.

29. Olivia Leidig, *Decatur Herald and Review*, February 10, 1929, as quoted in Ostendorf and Oleksky, *Oral History*, 212.

30. "Noyes W. Miner Papers Collection," 10.

Chapter 4

1. *Springfield City Directory*, 1857–58.

2. Lincoln paid Elijah Iles and his wife $300 for Lots 12 and 13 in Block 7, Elijah Iles's Addition to the Town of Springfield. Elijah Iles was one of the founders of Springfield and captain of a company in which Lincoln served in the Black Hawk War. Lincoln retained both of these lots for a number of years. On March 30, 1850, he sold the south half of Lot 12 to Frederick S. and Harriet W. Dean for $125, and on March 2, 1853, he sold Lot 13 and the north half of Lot 12 to Alexander Graham for $375. Both Dean and Graham built houses on their lots, thus becoming neighbors of Lincoln. Pratt, *Personal Finances*, 63–66.

3. The statistical information contained in this chapter was prepared by Richard E. Hart and is from his research, collection and collation of information taken from the 1850 and 1860 United States census records for Springfield, Illinois.

4. Baker, *Mary Todd Lincoln*, 105–08.

5. www.nps.gov/liho/planyourvisit/upload/Hired-Girl-Site-Bulletin.pdf.

6. Baker, "Mary Todd Lincoln: Managing Home…"

7. Doyle, *Social Order*, 137.

8. *Journal*, Friday, March 17, 1854, 3.

9. *Register*, Saturday, March 17, 1860, 3.

10. 1860 census, 126.

11. Ibid., (Ireland)(24).

12. Krupka, *Frances Affonsa DeFreitas*, 1.

13. Efford, "Abraham Lincoln."

14. www.germanheritage./1848/civil_war_part1.

15. *Williams' Springfield Directory, 1860–61*, 64 (hereafter referred to as *1860–61 City Directory*.) *Campbell & Richardson's Springfield City Directory and Business Mirror for 1863*, Johnson & Bradford, Booksellers and Printers, West Side of the Public Square, 1863, Preface dated February 17, 1863 (hereafter referred to as *1863 City Directory*).

16. *Past and Present of the City of Springfield*, 1519 (hereafter referred to as *1904 History*); *Portrait & Biographical Album of Sangamon County*, 201 (hereafter referred to as *1891 Portrait*).

17. www.horsesoldier.com/products/identifiedtems/photography/12439# sthash.zv9lE13O.dpuf. On August 15, 1862, at age eighteen, John G. Weilein enlisted as a private in Company E, 124th Illinois Regiment. He was among the first seventy-five thousand to volunteer for service in the Civil War and was wounded in action at Wilson Creek, Missouri, in 1861. He was mustered out at Camp Douglas, Illinois, on August 15, 1865. Weilein's obituary says that he was severely wounded, and the effects of the injuries were never entirely absent from his body. Weilein died on February 11, 1920, and was buried in Elmwood Cemetery in Waterloo, Iowa.

18. *Waterloo Evening Courier*, Wednesday, February 11, 1920. http://iagenweb.org/ boards/blackhawk/obituaries/index.cgi?read=467086.

19. Poage, "Coming of the Portuguese"; Angle, *"Here I Have Lived,"* 142–43.

20. Angle, *"Here I Have Lived,"* 142–43.

21. 1860 census, 129 (Portugal)(17).

22. Ibid., 120 (f)(Madeira)(18).

23. Baker, *Mary Todd Lincoln*, 107.

24. Letter written by M.A. Carleton L. Beal to Richard M. Decrastos with enclosures including three typewritten pages of the remembrances of Lizzie Decrastos. Sangamon Valley Collection, Lincoln Library, Springfield, Illinois. This letter is a part of a paper by Evan L. Kurrasch, "The De Crastos Cottage, 1407 East Dams Street, Springfield, Illinois, 1842–1983," October 14, 1983, for a class at Sangamon State University, Springfield, Illinois.

25. Krupka, "Frances De Freitas," 8–10.

26. Sandburg, *Abraham Lincoln*, vol. 2, 271. Krupka, "Frances De Freitas," 1–2.

27. Fiore, "Mr. Lincoln's Portuguese Neighbors," 150–55; *Illinois State Journal*. Undated clipping in the vertical files of the Lincoln Library, Springfield, Illinois.

28. Basler, *Collected Works*, vol. 1, 331,

29. 1860 census, 133. (England)(26).

30. Ibid., 122. (England)(22).

31. Ibid., 234. (France)(79).

32. Basler, *Collected Works*, vol. 6, 275.

Chapter 5

1. http://www.mrlincolnandfreedom.org/content_insideasp?ID=85&subjectID=4.

2. For a full account of African Americans in Lincoln's Springfield, see Hart, *Lincoln's Springfield*. The book may be found in the Abraham Lincoln Presidential Library

(ALPS-ZDE) F896 S76 H3267Li; Lincolniana L2 H326Li. Appendix J of the book contains a list of the African Americans living in Springfield in 1850.

3. The statistical information contained in this chapter was prepared by Richard E. Hart and is from his research, collection and collation of information taken from the 1850 and 1860 United States census records for Springfield, Illinois.

4. For a full account of African Americans in Lincoln's Springfield, see Hart, *Lincoln's Springfield*. Appendix L of the book contains a list of the African Americans living in Springfield in 1860. Sixty-six blacks were engaged in thirteen different occupations, as reported to the census taker or determined from newspaper advertisements. Those occupations and the number engaged in each were as follows:

Barber	12
Bill Poster	2
Cook	5
Domestic/Servant	12
Drayman	2
Farm Laborer	2
Hostler	1
Laborer	12
Laundress	8
Minister	2
Osler	1
Shoemaker	4
White-Washer	3

5. *1850 Population Census and 1850 Mortality Schedule*, 193 (hereafter referred to as *1850 Census*).

6. *1860 Census*, 112; *History of Sangamon County, Illinois*, 737 (hereafter referred to as *1881 History of Sangamon County of Sangamon County*).

7. Temple and Temple, *Abraham Lincoln*, 32.

8. *1850 Census*, 197.

9. *1860 Census*, 112 (Va.)(26), $2,000/$100; *1860* and *1863 City Directories*, 91 South Ninth, between Edwards and Cook.

10. The last name of "Pellum" is often spelled "Pelham." Jane Pellum's tombstone reads, "Jane Pellum." It is that spelling that we will use. Bonner, Mercer, and Pelham Family Papers, ca. 200 items, 1762–1888, correspondence, financial records, wills and genealogical data of the Pelham families of Virginia. Manuscripts Division, Special Collections Department, University of Virginia Library, Charlottesville, VA.

11. Bearss, *Historic Resource Study*, Base Map, 177, 133; *1850 Census*, 194.

12. *Decatur Herald*, March 5, 1901.

13. *1850 Census*, 122; *1860 Census*; *1857–58 Census*; Power, *Early Settlers*, 303; Bearss, *Base Map*, 84–86.

14. *1850 Census*, 122, 194; Winkle, *Young Eagle*, 263. Winkle states that Jenkins "also managed to harbor two free African American girls in his household of five." The two girls were Jameson's stepdaughters, the daughters of his wife by a prior marriage.

15. Even though title to their home was in the name of their daughter, Nancy, perhaps Elizabeth considered it hers for answering the census questioner.

16. *1860 Census*, 122; *1860–61 City Directory*; *1857–58 City Directory*; Power, *Early Settlers*, 303; Bearss, *Base Map*, 84–86.

17. *1860 Census*, 122.

18. Ibid.

19. *Journal*, January 23, 1850.

20. *Washington Star*, February 12, 1861; Jones, *Memories*, 16.

21. Lots 13 and 14, Block 11, E. Iles Addition to Springfield. Sangamon County Recorder of Deeds, Deed Record Book U, 11, 12. Jackson and Ninth Southwest Corner: present site of Lincoln Home National Park. *1857 Improvements*, 7: a frame dwelling on the corner of Jackson and Ninth Streets, built and owned by J. Wood. Cost $500.

22. Lot 5, Block 11, E. Iles Addition to Springfield. Sangamon County Recorder of Deeds, Deed Record Book AA, 20, 21.

23. Ibid., Book AA, p. 284. On June 2, 1838, Lincoln paid Elijah Iles and his wife $300 for Lots 12 and 13 in Block 7. The lots were in the center of the block across the street from the Lincoln Home. He retained both of these lots for a number of years.

24. *1850 Census*, 194.

25. Ibid., 122.

26. *Journal*, June 14, 1850, 3c.1.

27. *Journal*, November 11, 1852, 3c.1.

28. *1860 Census*, 134.

29. Ibid., 120.

30. Ibid., (f)(Mu.)(D.C.)(40).

31. Undated newspaper clipping in the vertical files of the Lincoln Library, Springfield, IL.

32. *1850 Census*, 122.

33. *1855–56 City Directory*, 152.

34. Wilson and Davis, *Herndon's Informants*, 597. Jesse W. Weik interview of Margaret Ryan, October 27, 1886, ISHL, Weik Papers, Box 2, Memorandum Book 1. http://lincoln. lib.niu.edu/cgi-bin/philologic/getobject.pl?c.6774:1.lincoln.

35. Piersel, *First Methodist Church, Springfield*, 16.

36. Learton, *Methodism in Illinois*, 3–4. See also, *First Methodist Church*, August 23, 1884, 24.

37. *1860 Census*, 122; *Williams' Springfield Directory, 1860–61*, 95, 118.

38. Under the Illinois law at the time, Ruth could have been an indentured servant, and if she was, the person holding the indenture could have "rented her out" to the Lincolns. Guelzo, "Did the Lincoln Family Employ a Slave?":

> *Ruth Burns (who did not, significantly, claim to have been born free) may have been born under provisions of Article 6, section 3, of the Illinois Public and General Statute Laws (1836) which bound her as an 'indentured servant' until age eighteen. Until that time, the Semples or Bradfords could hire her out to families such as the Lincolns...it*

underscores the uncertain fluidity of Illinois law concerning people of color. Although Illinois was technically a free state, it had nearly adopted a slave code with the proposed state constitution of 1821, and it continued to make generous provision for transient use of slaves by slave owners who happened to own land or businesses in Illinois. Not until 1848 did the Illinois Constitution abolish all forms of slavery outright; but even that did not touch the other forms of semi-slavery that persisted until the eve of the Civil War, including "apprenticeships."

39. Since William Wallace Lincoln was not born until December 1850, Stanton may have been remembering Edward Baker Lincoln, who died in 1850, as "Willie."
40. "She Nursed Bob Lincoln."
41. The question arises, was Epsy Smith the same person as an indentured mulatto girl named Hepsey? Indentures were contractual relationships in which minors were taught employable skills in return for having their basic needs provided. Ninian Wirt Edwards, who would become Abraham Lincoln's brother-in-law, signed an indenture of apprenticeship on October 29, 1835, for Hepsey, who was described as "a mulatto girl aged eleven years...having no parent or guardian." Edwards agreed to provide her

good holesome [sic] and sufficient meat drink washing lodging and apparel suitable and proper for such an apprentice and needful medical attention in care of sickness and will cause her to be instructed in the best way and most approved manner of domestic housewifery and will cause her to be taught to read and at the expiration of her term of service will give unto her a new bible and two new suits of clothes suitable and proper for summer and winter wear.

This arrangement lasted until Hepsey's eighteenth birthday.

Most leading families in Springfield used hired help. Indentures from the period of the 1830s and 1840s showed that blacks and "mulattos" were the source of this hired help. If Edwards were using a phonetic spelling for Hepsey, there is little difference between Hepsey and Epsy. That Epsy was clearly part of the Edwardses' household and witnessed the Lincoln marriage suggests that Elizabeth sent Hepsey to work for her sister Mary after her service ended with the Edwards family. In fact, Hepsey and Epsy were undoubtedly one and the same.
42. *Journal*, Tuesday, May 10, 1892, 1c.6.
43. *Columbus Dispatch*, April 2011.
44. Burlingame, *Inner World*, 275; Ostendorf, "Monument for One of the Lincolns Maids," 184–86.
45. She was born a slave about 1781 in Tennessee. Her master was Augustine Chilton. In 1808, Augustine was living in Overton County, Tennessee, and in late January of that year, he moved to Illinois and, at Cahokia, registered his slave, Phoebe, as an indentured servant. Augustine Chilton died in 1817 at Chilton's Fort in what is now Clinton County, Illinois. Phoebe and her children were assets

of his estate, and they were sold to Mathias Chilton, one of Augustine's children, for $62.49. Phoebe was twenty-six years old at the time. About 1819, Mathias moved to Sangamon County, Illinois, and brought with him Phoebe and her children. Maria was born a few years after the move. In the 1830 census, Mathias Chilton is listed as living at Round Prairie in Sangamon County, Illinois. Living with him are three female "slaves." Two are under ten years of age, probably Maria and her sister Elizabeth. The third is between the ages of thirty-six and fifty-five and is probably Maria's mother, Phoebe.

46. Ostendorf, "Monument for One of the Lincolns Maids," 185.

47. Ibid.

48. Burlingame, *Inner World*, 274; statement of Mrs. N.W. Edwards, H-W Mss, DLC.

49. Baker, *Mary Todd Lincoln*, 107.

50. *Danville Weekly News*, November 6, 1896; *Literary Digest*, August 14, 1926, 42.

51. *Lincoln Kinsman*, "Hon. Robert Todd Lincoln," April 10, 1839, 6–7.

52. *1881 History of Sangamon County*, 736. Unpublished manuscript of William Ray Wood, 800½ South Spring Street, Springfield, Illinois, undated, 1–2, Sangamon Valley Collection, Lincoln Library, Springfield, IL.

53. Brown was listed as living at the same address in 1873, 1874 and 1875. *1873–74 City Directory*; *1875 City Directory*.

54. *1881 History of Sangamon County*, 736.

55. *Journal*, September 4, 1906.

56. Basler, *Collected Works*, 156; Holzer, *Lincoln President-Elect*, 280; Lincoln wrote him a note of recommendation on March 7, 1861. It stated:

> *Whom it may concern. William Johnson, a colored boy, and bearer of this, has been with me about twelve months; and has been, so far, as I believe, honest, faithful, sober, industrious, and handy as a servant. A. LINCOLN. On November 29, 1861, Lincoln wrote Treasury Secretary Salmon P. Chase: You remember kindly asking me, some time ago whether I really desired you to find a place for William Johnson, a colored boy who came from Illinois with me. If you can find him the place shall really be obliged. Yours truly A. LINCOLN.*

He was then given a place as laborer (messenger) in the Treasury Department at $600 per year. On November 18, 1863, Lincoln wrote a note saying that William H. Johnson, his valet, would accompany him to Gettysburg. Mary Todd Lincoln did not travel with the president as Tad Lincoln was ill with smallpox. On the way back to Washington from Gettysburg, Lincoln began to feel ill. Johnson attended to the president as best he could, made sure the president was comfortable and began putting cold cloths across Lincoln's head. Although the president would survive, he gave the illness to Johnson, who died. The day of his death is not known, but it is known that on January 28, 1864, Lincoln had him buried on the Arlington Mansion grounds, now Arlington National Cemetery, and paid all the expenses for his funeral services. Lincoln even paid for his stone. That stone today doesn't exist,

so Johnson now rests under a government-issued stone that states, "WILLIAM H JOHNSON," and below his name is a word that would make both him and Lincoln proud: "CITIZEN."

Chapter 6

1. Lindsay, *Collected Poems*, 74.
2. Hart, *Springfield's Early Schools*, vi–vii.
3. Springer, *Preacher's Tale*, xii–xiii.
4. *Journal*, June 21, 1839, 3c.1.
5. "The Congregational Timeline," Trinity Evangelical Lutheran Church, Missouri Synod, http://www.trinity-lutheran.com/timeline.php5.
6. Sangamon County Historical Society, SagamonLlink, http://sangamoncountyhistory.org/wp/?p=1280.
7. Francis Springer to Lincoln, February 11, 1861, Abraham Lincoln Papers in the Library of Congress (ALPLC); Power, *History of the Early Settlers*, 675.
8. Lincoln to Edwin Stanton, April 13, 1863, APLPC.
9 Hart, *Springfield's Early Schools*, 33.
10. Ibid., 32.
11. Goff, *Robert Todd Lincoln*, 17.
12. Willis, *God's Frontiersmen*, 19, as quoted in Hart, *Abel W. Estabrook*, 8.
13. Hart, *Abel W. Estabrook*, 29–35.
14. *Journal*, April 20, 1853, 3c.2.
15. Hart, *Springfield's Early Schools*, 51–52.
16. *Illinois State Democrat*, August 11, 1858, 3.
17. Hart, *Springfield's Early Schools*, 76.
18. Miers, *Lincoln Day by Day*.
19. Hart, *Springfield's Early Schools*, 66–74.
20. Saul, "Museum Gets Rare Newspaper."
21. Basler, *Collected Works*, vol. 4, 87.

Chapter 7

1. Rothchild, *Lincoln, Master of Men*, 59.
2. Allen, "Sketch of the Dubois Family," 62–63 in Basler, *Collected Works*, vol. 8.
3. White, "Historical Notes on Lawrence County, Illinois," cited in Bearss, *Historic Resource Study*.
4. Graf, "Toussaint Dubois," 1–11.
5. Jesse K. Dubois to Abraham Lincoln, November 21, 1854, ALPLC, General Correspondence, 1833–1916.
6. Rothchild, *Lincoln, Master of Men*, 59.
7. Senator Stephen A. Douglas sponsored the controversial Kansas-Nebraska Act, passed in 1854. This bill allowed settlers in new territories to decide on whether to allow slavery in these areas. Prior to the passage of the act, the

Missouri Compromise of 1820 prohibited the expansion of slavery north of the 36´30° parallel. The passage of this act upset a delicate balance between the North and the South; split the Whig Party, leading to the formation of the new Republican Party; and brought an outraged Abraham Lincoln out of political retirement and into the forefront of the battle to stop the expansion of slavery.

8. Whitney, *Life on the Circuit*, 94.

9. Jesse K. Dubois to WHH, circa 1865–1866), in Wilson and Davis, *Herndon's Informants*, 441–42. (The opening words from this famous speech are: "A house divided against itself cannot stand. I believe this government cannot endure permanently half slave and half free—I do not expect the house to fall—but I do expect it will cease to be divided. It will become all one thing, or all the other.) Nicolay and Hay, *Abraham Lincoln*, 3:1–2.

10. *New York Tribune*, February 12, 1927, in Wilson, *Lincoln Among His Friends*, 97.

11. Jesse. K. Dubois to Lincoln, May 13, 1860, ALPLC; Jesse K. Dubois and David Davis to Lincoln, May 14, 12.

12 Nicolay and Hay, *Abraham Lincoln*, 2:273–77

13. Weed, "Hearing the Returns," *New York Times*, February 14, 1932, in Wilson, *Intimate Memories*, 323.

14. Charles S. Zane to WHH, 1865–66, in Wilson and Davis, *Herndon's Informants*, 490–91.

15. Wilson, *Lincoln Among His Friends*, 98.

16. Villard, *Lincoln on the Eve of '61*, 79.

17. Jesse K. Dubois, ALPLC, Dubois Papers.

18. Ostendorf and Oleksky, *Oral History*, 176.

19. Hagen, "What a Pleasant Home," 5–27.

20. Angle, *"Here I Have Lived,"* 75–76.

21. Ibid., 78.

22. Randall, *Mary Lincoln*, 172.

23. Kent, "Type and Figured Fossils."

24. Mills, *Illinois*, as quoted in McMillan, "The First Century."

25. John T. Stuart quoted in Howard, "Biographical Notes," Series 1, General Correspondence, ALPLC, 15.

26. Oakland Cemetery, Warsaw, Illinois, http://www.oaklandcemeterywarsaw. com/oakland-cemetery-history.php.

27. *Illinois State Journal*, August 22, 1849; October 23, 1854, as cited in Bearss, *Historic Resource Study*, 107–08.

28. *Illinois State Journal*, June 19, 1848, as cited in Bearss, *Historic Resource Study*, 107.

29. *Illinois State Journal*, June 11, 1860, as cited in Bearss, *Historic Resource Study*, 109; 1860 Mortality Schedule, 738.

30. "Mr. Lincoln's Neighborhood."

31. Temple, *By Square and Compass*, 70; *Lincolniana Notes*, quoted in Temple, 213–14.

32. Temple, *By Square and Compass*, 71–76.

33. Holzer, *Lincoln at Cooper Union*, 105.

34. Eicher and Eicher, *Civil War High Commands*.

35. *Illinois State Journal,* August 1860.

36. Temple, *By Square and Compass,* 280–83

37. Tarbell, *Life of Abraham Lincoln,* 4.

Chapter 8

1. Nicolay and Hay, *Abraham Lincoln,* 10:66.

2. Temple, *By Square and Compass,* 89–90.

3. Mary Lincoln to Emilie Todd Helm, February 16, 1857; Turner and Turner, *Mary Todd Lincoln,* 48–49. An invitation to this party in Mary Lincoln's hand to neighbor Mrs. Henry Remann is owned by the Illinois State Historical Library and reads: "Mr. and Mrs. Lincoln will be pleased to see you on Thursday evening Feb 5th at 8 o'clock." See also fn.48.

4. Little, "Recollections of Henry G. Little," as quoted in Randall, *Lincoln's Sons,* 60.

5. Arnold, *Life of Abraham Lincoln,* 82–83. For an interesting peek into the Lincoln kitchen, read Rae Katherine Eighmey's *Abraham Lincoln in the Kitchen: A Culinary View of Lincoln's Life and Times* (Washington, D.C.: Smithsonian Books, 2013).

6. Mary Lincoln to Ozias M. Hatch, October 3, 1859, Turner and Turner, *Mary Todd Lincoln,* 60.

7. Pease and Randall, *Diary of Orville Hickman Browning.*

8. Mary Lincoln to Hannah Shearer, October 3, 1859, in Turner and Turner, *Mary Todd Lincoln,* 61–62. See also fn.61.

9. Dyba, *Seventeen Years at Eighth and Jackson,* 41.

10. Mary Lincoln to Hannah Shearer, June 26, 1859, in Turner and Turner, *Mary Todd Lincoln,* 56–57.

11. Charles S. Zane to WHH, 1865–66, in Wilson and Davis, *Herndon's Informants,* 490–91. Once elected to the presidency, Lincoln appointed Seward and Chase to his new cabinet, Seward as secretary of state and Chase as secretary of the treasury.

12. Zeitz, *Lincoln's Boys,* 63.

13. *New York Tribune,* May 22, 1860, as quoted in Epstein, *The Lincolns,* 255.

14. Ibid.

15. Ibid., 256; Dyba, *Seventeen Years,* 51.

16. News reports referred to in Epstein, *The Lincolns,* 256.

17. Capps, "Early Recollections."

18. "The Republican campaign of 1860 had one-distinguishing feature—the Wide Awakes, bands of torch-bearers who in a simple uniform of glazed cap and cape, and carrying colored lanterns or blazing coal-oil torches, paraded the streets of almost every town of the North throughout the summer and fall, arousing everywhere the wildest enthusiasm." Tarbell, *Life of Abraham Lincoln,* 164. Robert Lincoln belonged to a Wide Awake club at Phillips Exeter, where he attended school, and in Springfield.

19. *Woodstock Sentinel,* Wednesday, August 15, 1860.

20. Lincoln Home Rally Photo, Chicago History Museum, 2007.

21. Capps, "Early Recollections," 3.

22. Tarbell, *Life of Abraham Lincoln*, 166.

23. Zeitz, *Lincoln's Boys*, 63.

24. Stevens, *A Reporter's Lincoln*, 46, as quoted in Baker, *Mary Todd Lincoln*, 162.

25. Villard, *Lincoln on the Eve of '61*, 19–20.

26. Holzer, *Lincoln President-Elect*, 190.

27. For more information on Lincoln and his struggle to form and to work with his cabinet, see Doris Kearns Goodwin, *Team of Rivals: The Political Genius of Abraham Lincoln* (New York: Simon & Schuster, 2005).

28. Dyba, *Seventeen Years*, 64.

29. *Missouri Democrat*, February 1861.

30. *Illinois State Journal*, July 13, 1903, 5c.3.

Appendix A

1. *1860 Census*, 126.

2. Ibid., 126 (Ireland)(24).

3. Ibid., 223. (Ireland)(53).

4. Ibid., 121.

5. Ibid., 124; *History of Sangamon County, Illinois*, 633 (hereafter referred to as *1881 History of Sangamon County*).

6. *1860 Census*, 124; *1881 History of Sangamon County*, 633.

7. *1860 Census*, 124; *1881 History of Sangamon County*, 633.

8. *1860 Census*, 148 (Ireland)(50), $400/$150.

9. Ibid., 109 (Ireland)(19).

10. Ibid., 123.

11. Ibid., 115.

Appendix B

1. *1860 Census*, 116 (Ireland)(25).

2. Ibid., 131 (Ireland)(20).

3. Power, *Early Settlers*, 445.

4. *1860 Census*, 135 (Ireland)(28).

5. Ibid., 128 (Ireland)(24).

6. Ibid., 111 (Ireland)(26).

7. Ibid., 121.

8. Ibid., 120. (Ireland)(21)(f).

9. Ibid., 116. (Ireland)(18).

10. Ibid., 133 (Ireland)(25).

11. Ibid., 120 (Ireland)(16)(f).

12. Ibid., 120 (Ireland)(15).

13. Ibid., 120 (Ireland)(40).

14. Ibid., 401.

15. Ibid., 110 (Ireland)(45).

16. Ibid., 134.
17. Ibid., 120 (Ireland)(30).
18. Ibid., 129.
19. Ibid., 122.
20. Ibid., 131 (Ireland)(20).
21. Ibid., 134.
22. Ibid., 129.
24. Ibid., 109. (Ireland)(19).
25. Ibid., 133. (Ireland)(18).
26. Ibid., 120. (Ireland)(19).
27. Ibid., 121.
28. Ibid., 133 (Ireland)(20).
29. Ibid., 133 (Ireland)(20).
30. Ibid., 135 (Ireland)(16).
31. Ibid., 130 (Ireland)(36)(f).
32. Ibid., 126.

Appendix C

1. *1860–61 City Directory*; *1863 City Directory*.
2. *1904 History*, 1519; *1891 Portrait*, 201.
3. *1860 Census*, 129 (Baden)(27).
4. Ibid., 115.
5. Ibid., 114 (Hesse Cassel)(32).
6. Ibid., 113 (Wurtemburg)(35), $1,000/$100.
7. Ibid., 113 (Wurtemberg)(80).
8. Ibid., 166 (Prussia)(42).
9. Ibid., 149 (31)(Prussia), $2,500/$1,000.
10. Ibid., 123.
11. Ibid., 113 (Hesse Darmstadt)(39), $4,000/$400; Power, *Early Settlers*, 525–26.
12. *1860 Census*, 121 (Scotland)(35), $7,000/$500; Bearss, *Base Map*, 41–42.
13. *1860 Census*, 114.
14. Ibid., 115 (Holland)(39), $10,000/$300.
15. It was not until 1882, when Robert Koch, a German physician and scientist, discovered the source of the disease, that a cure was possible.
16. *1860 Census*, 229 (Germany)(29).
17. Ibid., 113 (Baden)(80).
18. Ibid., 123 (Baden)(30) 0/$50.
19. Ibid., 229 (Heidleburg Baden)(30) $3,000/$200.
20. Ibid., 122 (Baden)(44). $1,200/$200.
21. Ibid., 114 (Prussia)(47). $4,000/$400.

Appendix D

1. *1860 Census*, 121 (Scotland)(35), $7,000/$500; Bearss, *Base Map*, 41–42.
2. Ibid.
3. *1860 Census*, 115 (Prussia)(18).
4. Ibid., 111 (Holland)(7).
5. Ibid., 120 (Bavaria)(18)(f).
6. Ibid., 128 (Hanover)(20).
7. Ibid., 120 (m)(Prussia)(14).
8. Ibid., 126 (Wurtemburg)(11).
9. Ibid., 234 (Germany)(13).

Appendix E

1. *1860 and 1863 Censuses*: 69 South Ninth, between Jackson and Edwards; *1860 Census*, 124 (England)(35), $5,500/$4,000.
2. *1904 History*, 478.
3. *1860 and 1863 Censuses*: 41 South Eighth Street; *1860 Census*, 126 (England)(48), $4,000/$300; *1860 Census*: Henry (carpenter) and Joseph (teamster); Bearss, *Base Map*, 25–27.
4. *1860 Census*, 105 (Scotland)(4l), 0/$75.
5. Ibid., 140 (England)(35), 0/$50.
6. Ibid., 121.
7. Ibid., 121 (Scotland)(35), $7,000/$500; Bearss, *Base Map*, 41–42.
8. *1860 Census*, 122 (Scotland)(34).
9. Ibid., 129 (England)(42), 0/$1,000; *1881 History of Sangamon County*, 392, 393, 859, 1054.
10. *1860 Census*, 16 (Scotland)(58), $20,000/$200.
11. Ibid., 119 (England)(37), $1,500/$20085.
12. Ibid., 114 (Scotland)(38), 0/$80.

BIBLIOGRAPHY

Allen, Helen L. "A Sketch of the Dubois Family, Pioneers of Indiana and Illinois." *Journal of the Illinois State Historical Society* 5 (April 1912): 62–63.

Angle, Paul M. *"Here I Have Lived": A History of Lincoln's Springfield, 1821–1865.* Chicago: Abraham Lincoln Book Shop, 1971.

Arnold, Isaac. *The Life of Abraham Lincoln.* Chicago: Jansen, McClurg and Company, 1884.

Baker, Jean H. *Mary Todd Lincoln: A Biography.* New York: W.W. Norton & Company, 2008.

———. "Mary Todd Lincoln: Managing Home, Husband, and Children." *Journal of the Abraham Lincoln Association* 11, no. 1 (1990).

Banton, Albert W., Ellen Carol Balm and Jill York O'Bright. *Historic Resource Study and Historic Structures Report: Blocks 7 & 10, Elijah Iles' Addition, Springfield, Illinois: Lincoln Home National Historic Site.* Denver, CO: United States Department of the Interior, National Park Service, 1987.

Basler, Roy, ed. *The Collected Works of Abraham Lincoln.* 9 vols. New Brunswick, NJ: Rutgers University Press, 1905, 1953–55.

Bearss, Edwin C. *Historic Resource Study and Historic Structure Report. Historical Data, Blocks 6 and 11.* Lincoln Home National Historic Site Illinois. Denver, CO: United States Department of the Interior, National Park Service, 1977.

Brooks, Noah. *Washington in Lincoln's Time.* Washington, D.C.: Century Co., 1895.

Browne, Francis F. *The Every-Day Life of Abraham Lincoln.* Chicago: Brown & Howell Co., 1913.

Burlingame, Michael. *The Inner World of Abraham Lincoln.* Urbana: University of Illinois Press, 1994.

Capps, Elizabeth Lushbaugh. "My Early Recollections of Abraham Lincoln." Vertical File, "Reminiscences." Lincoln Collection, Illinois State Historical Library Collection, Illinois State Historical Library.

Chenery, William Todd. "Mary Todd Lincoln Should Be Remembered for Many Kind Acts." *Illinois State Register*, February 27, 1938.

"City of Springfield, Sangamon Co., Ill." Surveyed & published by Hart & Mapother C.E., & Architects, 140 Pearl Street, New York, in connection with M. McManus, City Surveyor, 1854.

"The Congregational Timeline." Trinity Evangelical Lutheran Church, Missouri Synod. http://www.trinity-lutheran.com/timeline.php.

Conkling, James C., to Mercy Ann Levering, September 21, 1840. Manuscript in the Illinois State Historical Library, Springfield, IL.

Craig, Carol R. "An Exploration of the Social Relationships between the Abraham Lincoln Family and His Neighbors—Jameson Jenkins, William S. Burch, and Henry Carrigan Families: A Survey of Sources in Springfield, Illinois." Master's thesis, University of Illinois–Springfield, 2005.

Doyle, Don Harrison. *The Social Order of a Frontier Community: Jacksonville, Illinois, 1825–70.* Champaign: University of Illinois Press, 1983.

Dubois, Fred. "I Knew Lincoln When I Was a Boy." *National Republic* (October 1926): 20.

Dubois, Jesse. General Correspondence, 1833–1916. Abraham Lincoln Papers Library of Congress. [Further references will use ALPLC.]

Dyba, Thomas J. *Seventeen Years at Eighth and Jackson.* Lisle, IL: IBC Publications, 1982.

Efford, Alison Clark. "Abraham Lincoln, German-Born Republicans, and American Citizenship." *Marquette Law Review* 93, no. 1375 (2010).

Eicher, John H., and David J. Eicher. *Civil War High Commands.* Palo Alto, CA: Stanford University Press, 2001.

Eighmey, Rae Katherine. *Abraham Lincoln in the Kitchen: A Culinary View of Lincoln's Life and Times.* Washington, D.C.: Smithsonian Books, 2013.

Emerson, Jason. *Giant in the Shadows: The Life of Robert T. Lincoln.* Carbondale & Edwardsville: Southern Illinois University Press, 2012.

Epstein, Daniel Mark. *The Lincolns: Portrait of a Marriage.* New York: Ballantine Books, 2008.

Ferguson, Andrew. *Land of Lincoln: Adventures in Abe's America.* New York: Atlantic Monthly Press, 2007.

Gary, Ralph. *Following in Lincoln's Footsteps.* New York: Carroll & Graf Publishers, 2001.

Gassner, John, ed. *Best Plays of the Modern American Theatre, Second Series.* New York: Crown Publishers, 1947.

Goff, John S. *Robert Todd Lincoln: A Man in His Own Right.* Oklahoma City: University of Oklahoma Press, 1969.

Goodwin, Doris Kearns. *Team of Rivals: The Political Genius of Abraham Lincoln.* New York: Simon & Schuster, 2005.

Graff, Leo W., Jr. "Toussaint Dubois: Political Patriarch of Old Vincennes." Selected Papers from the 1987 and 1988 George Rogers Clark Trans-Appaclachian Frontier History Conferences, 1–11.

Guelzo, Allen. *Abraham Lincoln: Redeemer President.* Grand Rapids, MI: Wm. B. Eerdmans Publishing, 2003.

———. "Did the Lincoln Family Employ a Slave in 1849–1850?" *For the People* 3, no. 3 (Autumn 2001).

Hagen, Richard S. "What a Pleasant Home Abe Lincoln Has." *Journal of the Illinois State Historical Society* 48, no.1 (Spring 1955): 5–27.

Hart, Richard E. *Abel W. Estabrook: Robert Todd Lincoln's Abolitionist Teacher.* Springfield, IL: Spring Creek Series, 2009.

———. *Camp Butler: A Civil War Story.* Springfield, IL: Elijah Iles House Foundation, 2013.

———. *Circuses in Lincoln's Springfield (1833–1860).* Springfield, IL: Spring Creek Series, 2013.

———. *Greek Revival Architecture on the Prairie.* Springfield, IL: Spring Creek Series, 2011.

———. *Lincoln's Springfield: The Early African American Population.* Springfield, IL: Spring Creek Series, 2008.

———. *Springfield's Early Schools (1819–1860).* Springfield, IL: Spring Creek Series, 2008.

Helm, Katherine. *The True Story of Mary, Wife of Lincoln.* New York: Harper & Brothers Publishers, 1928.

History of Sangamon County, Illinois. Chicago: Inter-State Publishing Company, 1881.

Holzer, Harold. *Lincoln As I Knew Him.* Chapel Hill, NC: Algonquin Books of Chapel Hill, 1999.

———. *Lincoln at Cooper Union: The Speech that Made Abraham Lincoln President.* New York: Simon & Schuster, 2004.

———. *Lincoln President-Elect: Abraham Lincoln and the Great Secession Winter, 1860–1861.* New York: Simon & Schuster, 2008.

Hopkins, Donald R. *The Greatest Killer: Smallpox in History.* Chicago: University of Chicago Press, 2002.

Howarth, Nelson. "Mr. and Mrs. Lincoln's Neighbors on July 14, 1860." Radio talk, June 4, 1970, for WMAY, Springfield, IL.

Hunt, Eugenia Jones. "My Personal Recollections of Abraham and Mary Todd Lincoln." *Abraham Lincoln Quarterly* (March 1945): 235–52.

Iles, Elijah. *Sketches of Early Life and Time in Kentucky, Missouri and Illinois.* Springfield, IL: Sangamon County Historical Society, 1995.

"Illinois State Geological Survey Circular." Worthen Fossil Collection Catalogue.

Jones, Thomas D. *Memories of Lincoln.* New York: Press of the Pioneers, 1934.

Kent, Lois S. *Type and Figured Fossils in the Worthen Collection at the Illinois State Geological Survey.* Champaign: Illinois State Geological Survey, 1982.

Krupka, Francis. *Frances Affonsa DeFreitas.* Lincoln Home National Historic Site, Springfield, IL.

Kunhardt, Dorothy Meserve. "Lincoln's Neighbors: A Dramatic Find." Picture Essay with "An Old Lady's Lincoln Memories." *LIFE* (February 9, 1959): 48–60.

Lawrence, Elizabeth Capps. "Some Memories." *Abraham Lincoln Library* (1966): 11.

Learton, James. *History of Methodism in Illinois from 1793–1832.* Cincinnati, OH, 1883.

Leidig, Olivia. Interview in the *Decatur Herald and Review,* February 10, 1929.

"Lincoln's Neighborhood and the Civil War." National Historic Site Bulletin. Washington, D.C.: United States, Department of the Interior, National Park Service.

Lindsay, Vachel. *Collected Poems.* Rev. ed. New York: Macmillan Publishing Co., 1973.

McMillan, R. Bruce. "The First Century." *Living Museum* 64, nos. 2&3 (Summer and Fall 2002).

Miers, Earl Schenk, ed. *Lincoln Day by Day, A Chronology, 1809–1865.* 3 vols. Washington, D.C.: Lincoln Sesquicentennial Commission, 1960.

Miner, Noyes W. "Noyes W. Miner Papers Collection (SC1052)." October 15, 1881. ALPLM, Springfield, IL.

Mr. Lincoln's Neighborhood. Washington, D.C.: United States Department of the Interior, National Park Service, 1980.

Nicolay, John G., and John Hay. *Abraham Lincoln: A History.* 10 vols. New York: Century Co., 1890.

Oakland Cemetery, Warsaw, Illinois. http://www.oaklandcemeterywarsaw.com/about-oakland-cemetery.php.

Oak Ridge Cemetery Records. Springfield, IL.

Ostendorf, Lloyd. "A Monument for One of the Lincolns Maids." *Lincoln Herald* 66 (Winter 1964): 184–186.

Ostendorf, Lloyd, and Walter Oleksky, eds. *Lincoln's Unknown Private Life: An Oral History by His Black Housekeeper Mariah Vance, 1850–60.* Mamaroneck, NY: Hastings House Publishing, 1995.

Pease, Theodore C., and James G. Randall, eds. *Diary of Orville Hickman Browning.* Springfield, IL: Illinois State Historical Society, 1925.

Piersel, W.G. *First Methodist Church, Springfield, Illinois, 125 Years.* Springfield, IL: Official Board for the 125th Anniversary Celebration, First Methodist Church, January 1947.

Poage, George Rawlings. "The Coming of the Portuguese." *Journal of the Illinois State Historical Society (JISHS)* 18 (1925).

Portrait & Biographical Album Of Sangamon County, Illinois. Chicago: Chapman Brothers, 1891.

Power, John Carroll. *History of the Early Settlers of Sangamon County, Illinois.* Springfield, IL: Edwin A. Wilson & Co., 1876.

Pratt, Harry E. *The Personal Finances of Abraham Lincoln.* Springfield, IL: Abraham Lincoln Association, 1947.

Randall, Ruth Painter. *Lincoln's Animal Friends.* Boston: Little, Brown and Company, 1958.
———. *Lincoln's Sons.* Boston: Little, Brown and Company, 1955.
———. *Mary Lincoln: Biography of a Marriage.* Boston: Little, Brown and Company, 1953.

Rosenthal, Rob, and Sam Rosenthal, eds. *Pete Seeger: In His Own Words.* Boulder, CO: Paradigm Publishers, 2012.

Rothchild, Alonzo. *Lincoln, Master of Men: A Study in Character.* Boston: Houghton Mifflin, 1906.

Sandburg, Carl. *Abraham Lincoln: The Prairie Years.* 2 vols. New York: Harcourt, Brace & World, Inc., 1926.

Sangamon County Recorder of Deeds. Deed Record Book. Illinois Regional Archives.

Saul, Nancy Rollings. "Museum Gets Rare Newspaper." *Lincoln Courier,* April 15, 2009.

Springer, Francis. *The Preacher's Tale: The Civil War Journal of Rev. Francis Springer, Chaplain U.S. Army of the Frontier.* Edited by William Furry. Fayetteville: University of Arkansas Press, 2001.

St. Louis Post Dispatch. "She Nursed Bob Lincoln. Ann Ruth Stanton Took Him to School When He Was a Boy. She Is a Janitress Here Now." November 25, 1894.

Tarbell, Ida. *The Life of Abraham Lincoln.* 2 vols. New York: McClure, Phillips & Co., 1900.

Temple, Wayne C. *Abraham Lincoln: From Skeptic to Prophet.* 3rd ed. Mahomet, IL: Mayhaven Publishing, Inc., 2013.

———. *By Square and Compass: Saga of the Lincoln Home.* Mahomet, IL: Mayhaven Publishing, 2002.

———. "Lincolniana Notes." Journal of the Illinois State Historical Society 69, no. 2 (Summer 1956): 213–14.

Temple, Wayne C., and Sunderine Temple. *Abraham Lincoln and Illinois' Fifth Capitol.* Mahomet, IL: Mayhaven Publishing, Inc., 2006.

"'Took Tea at Mrs. Lincoln's,' The Diary of Mrs. William M. Black." *Journal of the Illinois State Historical Society* 48, no.1. (Spring 1955): 59–64.

Townsend, Timothy P. "Site Adrift in the City." Unpublished ms., 1995. [This document gives a very full and interesting history of how the Lincoln neighborhood became a National Historic Site. Copies may be obtained by contacting the National Park Service or Timothy P. Townsend, historian at the Lincoln Home National Historic Site.]

Trinity Evangelical Lutheran Church. Congregational Timeline. http:///www. trinity-lutheran.com/timeline.php.

Turner, Justin G., and Linda Levitt Turner. *Mary Todd Lincoln: Her Life and Letters.* New York: Alfred A. Knopf, 1972.

Villard, Henry. *Lincoln on the Eve of '61: A Journalist's Story.* Edited by Harold G. and Oswald Garrison Villard. New York: Alfred A. Knopf, 1941.

Wallace, Joseph. *Past and Present of the City of Springfield and Sangamon County, Illinois.* Chicago: S.J. Clarke Publishing Co., 1904,

Weik, Jesse. *The Real Lincoln.* Boston: Houghton Mifflin, 1922.

White, Ronald C., Jr. *A. Lincoln.* New York: Random House, 2010.

Whitney, Henry C. *Life on the Circuit, with Lincoln.* Caldwell, ID: Caxton Printers LTD, 1940.

Williams, C.S., comp. *Williams' Springfield Directory, City Guide, and Business Mirror for 1860–61.* Springfield, IL: John S. Bradford, 1860.

Willis, John Randolph. *God's Frontiersmen: The Yale Band in Illinois.* Lanham, MD: University Press of America, 1979.

Wilson, Douglas L., and Rodney O. Davis, eds. *Herndon's Informants: Letters, Interviews and Statements about Abraham Lincoln.* Urbana: University of Illinois Press, 1998.

Wilson, Rufus Rockwell, ed. *Intimate Memories of Lincoln.* Elmira, NY: Primavera Press, 1945.

———. *Lincoln Among His Friends: A Sheaf of Intimate Memories.* Caldwell, ID: Caxton Printers, Ltd., 1942.

Winkle, Kenneth J. *The Young Eagle.* Dallas, TX: Taylor Trade Publishing, 2001.

Wood, Thomas J. "George and Eliza Wood: Neighbors of Abraham Lincoln." Unpublished paper, 2014.

Wood, William Ray. Unpublished ms., Sangamon Valley Collection, Lincoln Library, Springfield, IL.

Zeitz, Joshua. *Lincoln's Boys: John Hay and John Nicolay, and the War for Lincoln's Image.* New York: Viking Press, 2014.

Newspapers

Columbus Dispatch
Danville Weekly News
Decatur Herald
Galesburg Evening Mail
Illinois Daily Journal
Illinois State Democrat
Illinois State Journal
Lincoln Herald
Missouri Democrat
New York Times, February 1938
New York Tribune
Register
Springfield Journal
St. Louis Post Dispatch
Washington Star
Waterloo Evening Courier
Woodstock Sentinel

Springfield Census and City Directories

Index

H

I

ABOUT THE AUTHORS

Bonnie E. Paull

Bonnie E. Paull has devoted her entire professional career to the field of education. She is a professor emeritus of English and the humanities from the College of Alameda in northern California. In addition to her forty years as a classroom teacher, she has been a dean of students, consultant, writer, researcher and public speaker.

Her research into American educational history and her concern about the vanishing basics such as phonics led her to establishing an award-winning program called "The Little Red Schoolhouse for Adults" and creating a PowerPoint presentation, "What Happened to American Reading?"

Among her published works are: *Will the Real Teacher Please Stand Up*: *A Humanistic Primer in Education*; *The Crooked Journey: The Story of a Woman's Fight against Scoliosis*; and a four-part series including *Winning with Grammar, Parts One and Two*; *Winning with Words*; and *Winning with Writing*. Among her awards are the Edpress Award for Feature Writing, the Danforth Foundation's Harbison Award for Gifted Teaching, the Teacher of the Year award from the Peralta Community College District and the Excellence Award from the National Institute for Staff and Organizational Development at the University of Texas–Austin.

Ms. Paull grew up in northern Minnesota, the daughter of a writer and labor lawyer. Her father was known as "the attorney for the people," and his hero was Abraham Lincoln, whose portrait hung in their Duluth home. She has been a student of Lincoln, his life and times, for many years. She is a member of the Abraham Lincoln Association and the Elijah P. Lovejoy Memorial Society. Currently, she is an educational consultant.

Richard E. Hart

Richard E. Hart was born in Ottawa, Illinois. He was raised in Springfield, where he attended school. He received his BA in 1964 and his JD in 1967 from the University of Illinois at Champaign–Urbana. He was admitted to practice law in 1967 and has been a practicing attorney in Springfield, Illinois, for the last forty-six years. He is a partner in the firm of Hart, Southworth & Witsman.

Mr. Hart is a past president of the Abraham Lincoln Association and member of the Illinois Abraham Lincoln Bicentennial Commission. He is a past president and board member of the Sangamon County Historical Society, past chairman of the advisory board of the Lincoln Legal Papers and past president and member of

the board of directors of the Elijah Iles House Foundation. Mr. Hart was largely responsible for raising the funds and managing the day-to-day restoration of the Elijah Iles House and the Strawbridge-Shepherd House, two 1840 Greek Revival residences. For at least the last ten years, Mr. Hart has been editor of *For the People*, a newsletter of the Abraham Lincoln Association, and the *Iles Files*, a newsletter of the Elijah Iles House Foundation.

Mr. Hart is also past president of Springfield Preservation, Ltd., a for-profit corporation that has restored and leased five Lincoln-era houses in Springfield's German Settlers Row. He suggested the format for the Looking for Lincoln project in Springfield and donated his personal historical research and ideas to that project.

Mr. Hart and his wife, Ann, were also responsible for proposing the design for the City of Springfield's streetscape. Their design proposal and advocacy was adopted in lieu of another proposal for a more contemporary design. As a part of their advocacy, the Harts purchased and donated the first period lights for Springfield's streetscape. Since that first donation, the use of the design has spread throughout downtown Springfield and is now moving into several neighborhoods, including the Iles Park Neighborhood.

In 1999, Mr. Hart was given the City of Springfield's Preservationist of the Year award. In 2012, he was presented with the Logan Hay Medal. The bronze medal is awarded infrequently and is the highest honor given by the Abraham Lincoln Association to recognize individuals who have made noteworthy contributions to the mission of the association. Presently, Mr. Hart is vice-chairman of the board of Oak Ridge Cemetery and a member of the board of directors of the Springfield Illinois African American History Foundation Museum and the Elijah Iles House Foundation. In 2013, he received the Lifetime Achievement award from the Illinois State Historical Society.